PENGUIN BOOKS

CHILDREN'S DRAWINGS

ADVISORY EDITOR: DR CHRISTINE TEMPLE

MAUREEN COX

Maureen Cox trained as a teacher, taking Fine and Applied Art as one of her main subjects. After three years of teaching in primary school she read Psychology at Hull University, gaining a first class Honours degree and then a PhD. She is Senior Lecturer in Psychology at the University of York where she teaches Developmental Psychology and carries out research on the development of children's pictorial representation. Her many articles and books include The Young Child as Artist, Visual Order and The Child's Point of View. She is currently involved in cross-cultural work on children's human-figure drawings and is writing a book on that topic. Maureen Cox lives in the heart of the medieval city of York with her partner, whose research involves the analysis of conversation, and their daughter Amy, whose children's drawings have inspired much of her research.

Children's Drawings

◆

MAUREEN COX

PENGUIN BOOKS

PENGUIN BOOKS

Published by the Penguin Group
Penguin Books Ltd, 27 Wrights Lane, London w8 5tz, England
Penguin Books USA Inc., 375 Hudson Street, New York, New York 10014, USA
Penguin Books Australia Ltd, Ringwood, Victoria, Australia
Penguin Books Canada Ltd, 10 Alcorn Avenue, Toronto, Ontario, Canada m4v 3b2
Penguin Books (NZ) Ltd, 182–190 Wairau Road, Auckland 10, New Zealand

Penguin Books Ltd, Registered Offices: Harmondsworth, Middlesex, England

Published in Penguin Books 1992

4

Filmset in Monophoto Ehrhardt
Printed in England by Clays Ltd, St Ives plc

This book is dedicated to the many students who, over the years, have so generously helped in the enjoyable but time-consuming task of collecting drawings from children of all ages.

Contents

Acknowledgements

Every effort has been made to contact copyright holders for their permission to reprint the figures in this book. The publishers would be grateful to hear from any copyright holder who is not here acknowledged and will undertake to rectify any errors or omissions in future editions of this book.

The following individuals and organizations have given their permission to reproduce illustrations in this book:

Figure I.5: The Houghton Library, Harvard University, USA.

Figures I.7a, 6.17, 8.24a and b: The Vincent Van Gogh Foundation, Vincent Van Gogh Museum, Amsterdam, The Netherlands.

Figure I.7b: The Fogg Art Museum, Harvard University, USA. Bequest of Meta and Paul J. Sachs.

Figure 1.5: Dr Desmond Morris, Oxford, UK.

Figures 1.6, 10.11 and 10.12: Professor Howard Gardner, Harvard University, USA. First published in Gardner, H. (1980) *Artful Scribbles*, London: Jill Norman.

Figures 2.6 and 8.28: Dr John Willats and Cambridge University Press, UK.

Figure 3.3: The Plenum Publishing Corporation, USA. First published in a paper by Bassett, E. M. (1977) 'Production strategies in the child's drawing', in Butterworth, G. (ed.) *The Child's Representation of the World*, New York: Plenum Press.

Figures 3.10, 4.8, 4.21, 4.22, 4.23a and 8.2: Professor Jacqueline Goodnow, Macquarie University, Australia.

Figures 4.7 and 4.26: Dr Glyn Thomas, University of Birmingham, UK.

Figure 4.14: Dr Karen Pfeffer, University of Ife, Nigeria.

Figures 4.18, 4.19 and 10.10: Professor Brent Wilson, Pennsylvania State University, USA.

Figures 6.3 and 8.15a: Éditions Delachaux and Niestlé, Lausanne, Switzerland.

Figures 6.4, 8.6, 8.11 and 8.15b: Macmillan Publishing Company, USA. First published in Löwenfeld, V. and Brittain, W. L. (1964) *Creative and Mental Growth*, New York: Macmillan.

Figure 6.6: Dr Norman Freeman, University of Bristol, UK.

Figure 6.10: Dr Jan Deṛegowski, University of Aberdeen, UK.

Figure 6.13: Universitätsbibliothek, Heidelberg, Germany (cog 848, Codex Manesse, fol. 13ʳ).

Figure 6.14: Australian Consolidated Press Limited, Australia, for this cartoon by Harvey. First published in *The Bulletin*.

Figure 6.16: Ronald Sheridan Photo Library.

Figure 6.18a: © DACS, 1992.

Figure 6.18b: Musée Picasso, Paris, France. © DACS, 1992.

Figure 6.23: Dr Gillian Harris, University of Birmingham, UK.

Figure 7.5: Musée Picasso, Paris, France. © DACS, 1992 (photo: Bridgeman Art Library).

Figure 7.8a: Caroline Hunt, York, UK.

Figure 7.9: Richard Jolley, University of York, UK.

Figure 7.11: MacGregory, A. J. and Perring, W. (1971) *The Runaway*, Loughborough, UK: Ladybird.

Figure 7.16: © DACS, 1992.

Figure 8.13: Mrs Ida Neal, Long Sutton, UK.

Figure 8.17: Library of Congress, Washington DC, USA.

Figures 8.30 and 8.31: Dr Karen Littleton, University of York, UK.

Figure 9.10: Drs Pia Broderick and Judith Laszlo, Murdoch University, Australia. First published in *Journal of Experimental Psychology*, 45, pp. 18–27.

Figures 10.3, 10.4, 10.5 and 10.6: Professor Ellen Winner, Boston College, Massachusetts, USA.

Figure 10.7: Professor Tu Mei Ru, Nanjing Normal University, People's Republic of China.

Figure 10.14: Kunstmuseum Bern, Bern, Switzerland. © DACS, 1992.

Figures 10.15, 10.16, 10.17, 10.18 and 10.19: Academic Press, USA. First published in Selfe, L. (1977) *Nadia – A Case of Extraordinary Ability in an Autistic Child*, London: Academic Press.

Figures 11.3 and 11.4: Grant Cooke, Brycbox Arts in Education Team, Royal Borough of Kingston, 1986, UK.

Figure 11.5: Ashton Scholastic Pty Ltd, Gosford, NSW, Australia. First published in Deacon, J. (1984) *The Drawing Book*, Gosford: Ashton Scholastic.

Figures 11.6, 11.8, 11.9, 11.10a and b, 11.11 and 11.12: Professor Betty Edwards, California State University, USA. First published in Edwards, B. (1986) *Drawing on the Artist Within*, Glasgow: Fontana/Collins.

ACKNOWLEDGEMENTS

My thanks go to the following individuals for providing me with particular references:

Peter Barnes, Open University, UK: Riddel, J. (1911) 'On the teaching of drawing', in Laurie, A. P. (ed.) *The Teacher's Encyclopaedia*, London: Caxton.

Dr Jane French, York, UK: Books for teachers by E. A. Branch, published by Evans Brothers, London.

Professor Tu Mei Ru, Nanjing Normal University, People's Republic of China: Chinese primary school textbook.

I also wish to thank Chang Shu Yi for her help in translating sections of the Chinese primary school textbook; Dr Lorna Selfe for her help in negotiating permission to publish the Nadia drawings, and the colleagues and the many students who have collected data for me or with me over the years, in particular Dr Poonam Batra, Claire Howarth, Glyn Jarvis, Richard Jolley, Dr Karen Littleton, Ann Martin, Martin Nieland, Stephanie Osmond, Charmi Parkin, Dr Karen Pfeffer, Kathryn Shaw, Doug Sommerville and John Stone. Finally, thanks go to my companion, Dr Tony Wootton, for his comments and advice on the manuscript, and to my daughter, Amy, for her enthusiastic production of a great many drawings.

A Note on Gender

In most books on child development the pronouns 'he', 'his' and 'him' are used to refer to the child. In the interest of equality, in this book the gender of the child alternates from one chapter to the next.

Introduction

Parents and teachers are frequently fascinated by young children's pictures and wonder why children draw in the way they do. Why is it that in their early attempts at the human figure the arms and legs seem to be attached to the head (see Figure I.1)? Why are their chimneys in imminent danger of toppling off the roofs (see Figure I.2)? And why is there a big gap of 'nothingness' between the ground and the sky (see Figure I.3)? One of my purposes in writing this book is to describe the way that children draw – how they begin and how they develop – and to suggest some explanations for the curious features that are so common in their pictures.

The study of children's drawing began about 100 years ago. One rainy day in the 1880s, or so the story goes, an Italian named Corrado Ricci ran for shelter into a covered alley-way. As he waited for the rain to abate, his attention was drawn to the graffiti on the walls. He saw some charming and rather awkwardly drawn pictures which anyone would recognize as the products of a child's hand. Nothing unusual about that, except that Ricci became intrigued by

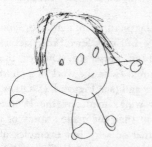

Figure I.1: *Mummy* by Gareth, aged 4 years 7 months. This figure seems to have no body and the limbs protrude from the head.

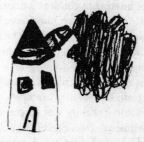

Figure I.2: A house by Amy, aged 5 years. The chimney seems to be toppling off the roof.

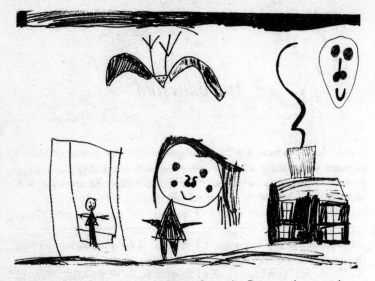

Figure I.3: A scene by Amy, aged 5 years 8 months. Between the ground and the sky there is a large expanse of 'nothingness'.

these pictures and began to wonder what it was about them that made them so different from conventional adult art. And so began his interest in and study of children's art. Although he was not the first person to take the subject seriously, it was his small booklet *The Art of Little Children*, published in 1887, which created an explosion of interest in children's drawing.

Now, children must have been drawing pictures for centuries – on walls, on paper, on slates or in the dust – but very few of their actual drawings, or copies of them, have been preserved. One of the exceptions is a drawing on a slate presumed to be the work of a child in the Minoan period, about 3,000 years ago (see Figure I.4). Other, relatively recent, examples are the drawings made by the Brontë children. Emily was 10 years old when in 1829 she made a study of a whinchat (see Figure I.5). Why is it that so very few examples of child art before the nineteenth century have survived? One reason may be that our ancestors regarded the period of childhood very differently from the way we understand it now. In general, children's thinking and understanding as well as their skills were considered

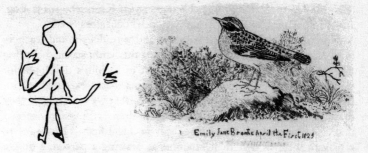

Figure I.4: This figure drawn on a slate is presumed to be the work of a child in the Minoan period, about 3,000 years ago.

Figure I.5: *The Whinchat* was drawn in 1829 by Emily Brontë, aged 10 years.

imperfect and inferior to those of adults and therefore not worthy of recording or preserving. Of course, the drawings of ordinary adults, if indeed they made any, have also been discarded. Only the works of famous artists or accomplished amateurs have endured. And these works have provided a yardstick by which all works of art tend to be judged. Presumably, anything which fell significantly short of this standard was deemed unworthy of preservation.

The shift away from this lack of interest in childhood began during the eighteenth century. A new psychological climate was spearheaded by, among others, the philosopher and educationist Jean-Jacques Rousseau (b. 1712, d. 1778), who regarded childhood as a distinct and important stage in our development towards adulthood. Rousseau said, 'The child is a child, not an adult', implying that children are different from adults and have their own ways of thinking and solving problems which are not necessarily inferior to those of adults. Of course, little was known about the way children actually behave or the way that they develop, and so some eminent writers set about making detailed records – often of their own children. No less a person than Charles Darwin published in 1877 an account of the development of his son, nicknamed Doddy. These kinds of studies, or 'baby biographies' as they were known, continue to be valuable sources of information for anyone interested in child development, and those which concentrate on children's drawing

(e.g. Major, 1906; Dix, 1912; Luquet, 1913; Krötzsch, 1917; Eng, 1954) still inspire both psychologists and art educators alike.

Most young children draw willingly and with delight and teachers in nurseries and in schools capitalize on this enthusiasm, believing that artistic activity is an important part of a child's development. Children's drawings, boldly and unselfconsciously executed, adorn the classroom walls and charm us all. However, even though they draw readily and without inhibition, children are most concerned that the objects in their pictures can be identified. They want to satisfy themselves that their attempts at drawing a person, a dog, a table, and so on, should 'look right'. They may group these objects on the page in a bold and decorative way, and it matters little to them that no attention is paid to the body proportions, the relative sizes of the objects, the angles of the table, and so on (see Figure I.6). In *Doing the Ironing*, Amy's parents are dwarfed by the huge ironing board; Amy herself is even smaller. Note also the disproportionately large heads of the figures. The surface of the ironing board has been tilted towards us and the cup of water on the left and the iron on the right seem to be precariously balanced on its upper edge. To get as far as this, children actually need little if any *formal*

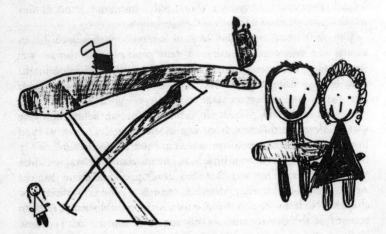

Figure I.6: *Doing the Ironing* by Amy, aged 5 years 8 months. The ironing board is disproportionately large and its top has been tilted towards us; the iron and cup of water seem to be precariously balanced on the upper edge.

tuition. Most of them either pick up or invent their own ways of drawing a variety of common objects. In fact, they often develop a sort of formula or *schema* for each object and, calling on a reasonably large repertoire of these well-practised schemas, they can enjoy putting together the kinds of charming pictures that we recognize as the characteristic hallmarks of childhood art.

Sadly the charm fades and by late childhood and early adolescence most children become reluctant to draw. Their efforts are often fussy and laboured, with much use of the ruler and the eraser in evidence. Eventually they give up altogether. Indeed, if you ask ordinary adults to draw a picture you will find that most of them are unwilling, usually claiming that they are no good at drawing. They are often mildly embarrassed, perhaps apologetic, and almost certainly dismissive of their own efforts. While we would not expect their drawings to emulate those of great artists, at least we might expect some reasonably competent level of skill. Clearly though, most adults realize that they are lacking in drawing skill. In most cases, of course, they do not regard this deficiency as a major handicap and rarely exhibit any distress at their poor performance; after all, they can get by in life quite well without it. In contrast if they couldn't read or write or add up, their lives would be much more problematic. They would certainly not admit their deficiencies so readily and would perhaps go to considerable lengths to conceal them; they might even seek remedial help, although in a discreet way.

Why is it that an activity which seems to be both educationally valued *and* pleasurable should eventually peter out? Is this a natural decline or can we (and indeed should we) do something about it? Can we help more people to become good drawers or is it a gift that only a few of us are blessed with?

What seems to happen is that beginning around the age of 8 or 9 years children's expectations become much greater. They want their pictures to be not merely recognizable but *visually realistic*. They think that the picture of a person ought to look like that particular person and that one of a still-life or a landscape should look like the real thing. Above all, they believe that a really good artist should be able to draw from life. This desire for visual realism is not surprising given the wealth of realistic and photographic images that surround us in our day-to-day lives. Talented artists seem able to pick up the necessary techniques quickly and effortlessly, but most children recognize that they need help and will often ask for it in direct and

indirect ways – 'I can't draw it', 'I can't make it look right', 'How *do* you draw tables?'. In order to progress, most will need more directed and structured teaching, but because the majority do not receive the help they need, and consequently never learn how to meet the new and demanding criteria they set themselves, they conclude that they can't draw.

There are a number of reasons why children don't receive formal tuition. First of all, teachers and parents themselves may lack the necessary skills and therefore have no confidence or interest in helping them. Secondly, artistic ability is often regarded as a *gift*, something you either have or haven't got; consequently, tuition may be offered at a much later stage only to those children who have already displayed an artistic aptitude or precocious ability. Thirdly, in Western society at the present time we do not regard it as important for ordinary people as a matter of course to be able to draw in a realistic way. This attitude does not prevail in all societies – we are frequently astounded by the technically sophisticated drawings of very young children in China (see Figures 10.3–10.7 in Chapter 10); nor has it always been so extreme in the West – the formal teaching of drawing was part of the basic school curriculum in the UK until the Second World War.

Yet a further reason for the lack of tuition has to do with adults' beliefs about the nature and purpose of artistic activity, particularly in primary school. One of the most influential beliefs is that the main purpose of artistic activity is to allow children an opportunity for *self-expression*, this self-expression having more to do with the emotional than with the rational side of a child's nature. It is therefore considered important that the teacher should not direct or interfere in this process lest self-expression be inhibited.

As well as providing opportunities for self-expression, the pictorial arts are also thought to serve as important vehicles for children's *creative development*. As with self-expression, it is believed that creativity may also be stifled if adults start to interfere with what is seen as a child's natural and spontaneous output. Quite often *any* teacher involvement, even in response to a child's request, is regarded as a hindrance. The notion that a teacher might *show* a child how to draw something or at least *discuss* how something might be drawn is dismissed as 'too teacher-directed'. The fear is that children will adopt as stereotypes the schemas provided by the teacher instead of working out their own solutions. It seems contradictory that these

attitudes apply to art education but not to other subjects such as English or music; I have not heard it argued that a basic grounding in grammar or musical notation will stifle creativity and lead to stereotyped work.

So far, I have presented a somewhat extreme version of the beliefs that many adults hold about the value and purpose of children's art, but I think it reflects a view which in varying degrees is widespread in our educational system. The positive side of this view is that the pictorial arts do at least provide an *opportunity* for children to invent and try out their own ideas and do not force them or constrain them to follow adult ways of drawing. The way is left open for genuine creativity to take place. The negative side of this view, though, is its failure to recognize that, sooner or later, most of us actually require tuition in order to give substance to our ideas; without it we quickly lose interest, thus ensuring no improvement, no self-expression and no creativity. In sum, my view is that drawing is not simply a matter of spontaneous self-expression; we have to learn basic skills and techniques. In the early years we manage to pick up a good deal with little or no formal tuition. But later on, our standards of what constitutes a good drawing far outstrip our skills. Without tuition most of us cannot draw; we lose interest and give up altogether.

If we are to offer children more guidance and possibly more tuition in drawing, we need to know something about the way that drawing develops: what kinds of skills are involved, which skills children will evolve on their own and which they will need to be taught. In this book I shall begin at the beginning with an account of how the child discovers that the marks he produces can actually stand for real objects; it turns out that his meaningless scribbles are not so meaningless after all. He begins to grapple with the problem of how differently shaped objects can be best represented by different kinds of lines and shapes on the page. He discovers, for instance, that circles are good for heads, and possibly for bodies, but that straight lines are better for arms and legs. He learns what lines can be used for and builds up a repertoire of schemas or ways of drawing things.

The human figure is one of the earliest and most popular things that children draw. Curiously, it first appears in a rather bizarre form looking like a tadpole. I shall discuss this intriguing phenomenon and go on to trace the child's development of the more conventional human figure and how he becomes more open to other people's ways of drawing, often copying or assimilating the styles of

other children. I shall also assess the value of some of the diagnostic tests based on human figure drawings that have been devised by psychologists and psychiatrists in order to reveal a child's intellectual maturity, personality and emotional adjustment.

During early childhood up to about the age of 8 children produce charming but awkward compositions in which parts of a scene normally hidden from view seem to be twisted round so that we can see them. Indeed, it looks as if they are more concerned that the objects they depict should be clearly recognizable than that they should be drawn 'correctly' from a particular point of view. Children are not insensitive to this distinction, however, and in some circumstances, they will choose to present the scene in a more realistic way.

Instead of drawing a number of separate objects on the page, they may try to put them together so that they make up a scene. Their early efforts to plan the picture often begin with the setting out of a groundline and a skyline, with the 'action' taking place in between. Many children eventually attempt to unify the scene by adopting a single viewpoint, as if taking a photograph. In order to do this they become involved in grappling with the techniques of perspective drawing, regarded by many as notoriously difficult. Some gifted children nevertheless seem to glide effortlessly over these problems and some autistic children artists, such as Nadia (see Figures 10.15–10.18 in Chapter 10), appear to have bypassed the normal developmental stages of drawing altogether and have drawn exactly what they can see from the beginning.

Although frowned on by many teachers, our ability to copy is important in the acquisition of many basic skills. In the absence of specific tuition in drawing some older children widen their repertoire of schemas by adopting a cartoon style, often copying from comics and cartoon stills. Indeed, gifted artists also copy the work of others, and the exceptional pictures produced by Chinese children are largely achieved through a process of copying. Since I believe that copying does have a role in art education I have included a chapter on the topic in this book. Finally, the last chapter suggests ways in which we, as parents, teachers and others interested in children and their development, can help to encourage their interest and expertise in drawing. These practical ideas arise from our present understanding of the way in which children normally develop and of the points at which they need our indirect or direct intervention.

I have chosen to concentrate on *drawing* rather than on the other

pictorial arts such as painting or printing for two reasons. One reason is that children engage more often in drawing than in any other pictorial activity. Pencils, crayons and paper are readily available in nurseries, schools and most homes, and children can easily draw without adult assistance. Although the opportunity for painting and printing is provided in most nurseries and schools, where a painting corner is often set up on a semi-permanent basis, it is not surprising that many parents resent the disproportionate amount of time it takes to prepare the necessary materials at home compared with the amount of time the child actually spends painting or printing – not to mention the mess.

My second reason for concentrating on drawing is that good draughtsmanship is arguably the basis of all the pictorial arts. Most of the great artists acquired and perfected their expertise during an apprenticeship to an already established artist, when they were regularly required to copy existing works. Van Gogh, developing late as an artist, recognized his relative lack of skill in drawing and sought to improve his technique by copying the works of acclaimed

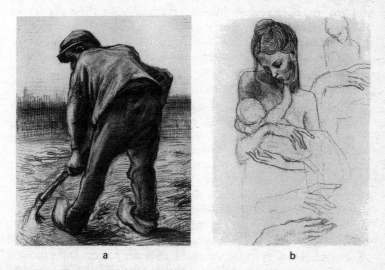

a b

Figure I.7: *Peasant Digging* by Van Gogh (a) and *Mother and Child* by Picasso (b). Great artists have recognized the importance of skilled draughtsmanship.

masters such as Daumier and Millet (see Figure I.7a); his progress is recorded in meticulous and enthusiastic detail in his letters to his brother Theo. Even Picasso, who became well-known for his non-realistic and 'childlike' pictures, first learned to draw in a conventionally realistic way (see Figure I.7b).

A message running through this book is that the ability to draw in a realistic style is not something which naturally and automatically comes as we grow up, otherwise we would all be drawing effortlessly and skilfully. Drawing is an *artful* activity, requiring the mastery of particular techniques which, as in the field of music, even great artists have had to *acquire* and practise. The rest of us may never be as talented as the truly great artists, but far more of us could learn to draw a tolerably good picture. We should be able to teach children the basic techniques of drawing, and we could do this without sacrificing their creativity and without falling into the trap of having them produce only fixed solutions and stereotyped images.

CHAPTER I

Children's First Pictures

UNDERSTANDING PICTURES

Although you will have no difficulty in recognizing the objects depicted in Figure 1.1 below, drawings, and in particular line drawings, are peculiar in a number of ways. To start with, in reality, things do not have lines around them; indeed many do not have any lines on them at all. Despite this lack of correspondence between drawings and what they represent, however, we can easily interpret them. Another curious thing is that whereas objects (and I take this to include living things) usually have substance – they take up space and are three-dimensional – the substance of an object depicted in a drawing is often a blank space. Yet, as Ellen Winner (1982) has pointed out, we don't see a wire figure, we mentally fill in the solid matter enclosed by the line. A further distinction is that line drawings do not have the same 'richness' as objects or even photographs of those objects – they may lack, for instance, colour, light and shade, or perspective; yet, again, we can understand what they are meant to represent.

Confronted with these degraded and rather odd images, we might expect that young children need to have some experience with them

Figure 1.1: Although line drawings are very different from the objects they depict we have no difficulty in recognizing what they are meant to represent.

before being able to identify the objects they are supposed to depict. In fact, however, they have little if any problem with recognizing them, and there are at least two pieces of evidence which suggest that no special learning is necessary for the recognition of objects depicted in line drawings.

Two researchers (Hochberg and Brooks, 1962) studied a little boy who from birth had almost no opportunities to see any pictures at all. If he did occasionally glimpse a picture on a baby-food jar, there was no mention of it and he was given no instruction about it. At 19 months the boy was tested with some line drawings and some photographs of objects that he knew the names of, such as a car, a shoe, a doll and a key. In each case the line drawing was always presented before the photograph. The child's success in naming the objects was similar whether they were depicted in drawings or in photographs.

The second piece of evidence suggesting that we don't need prior experience of pictures before we can recognize the objects in them comes from cross-cultural work. John Kennedy and Abraham Ross (1975) studied a small tribe of people called the Songe, living in Papua New Guinea. Although the Songe created geometrical patterns on bark cloth for use in their ritual dances, they did not make, and probably had never seen, line drawings used to denote objects. They were shown line drawings of familiar objects, such as a palm tree, a canoe, and some human figures, as well as some less familiar ones – a car, a cow and a horse. Despite their lack of experience with pictures, they had little difficulty in recognizing what the drawings were meant to represent.

SCRIBBLING

During her first year my daughter Amy had witnessed on many occasions my attempts to draw a person, a cat or a house and seemed both delighted and intrigued to see these schematic forms taking shape on the page. Of course, when I first gave *her* a crayon and a piece of paper she had only the vaguest idea of what to do. She brought the crayon into contact with the page and made, almost accidentally, some rather tentative marks. It didn't take long, however, before she was holding the crayon much more confidently and was able to tackle the paper as if she meant business (see Figure 1.2).

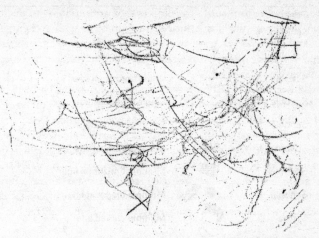

Figure 1.2: A confident scribble by Amy, just after her first birthday.

Most children, like Amy, get a great deal of enjoyment out of this activity we call *scribbling*. It used to be thought that the enjoyment stemmed solely from the rhythmic movement of the arm and that the appearance of the marks on the page was not really important to the child (Bender, 1938). In fact, these marks *are* important and if children are given a pencil-like instrument which doesn't leave a mark, they quickly lose interest in the whole activity (Gibson, 1969). They seem unconcerned, however, to preserve their work and frequently obliterate earlier marks by scribbling over them.

As the child's arm moves back and forth, she usually produces wavy scribbles. She seems somewhat surprised at these marks, indicating that their form was not intentional, but with practice she develops sufficient control to be able to produce this effect deliberately and is able to confine her scribbling within the edges of the paper. Later, the large sweeping movements of the whole arm give way to more controlled movements of the lower arm and hand and eventually to the very precise and deliberate movements of the fingers. Gradually, although there may be little noticeable change in the form of the marks on the page, there is a great change in the control that the child has over their production. Deliberate and repeated scribbling may indicate that she is in the process of mastering particular forms and

| Scribble 1 | • ' | Dot |
| Scribble 2 | \| | Single vertical line |
| Scribble 3 | — | single horizontal line |
| Scribble 4 | \ / | Single diagonal line |
| Scribble 5 | ⌒ | Single curved line |
| Scribble 6 | ⋏⋏⋏⋏ | Multiple vertical line |
| Scribble 7 | ≋ | Multiple horizontal line |
| Scribble 8 | ⫽⫽ | Multiple diagonal line |
| Scribble 9 | ⌒ | Multiple curved line |
| Scribble 10 | ⌇ | Roving open line |
| Scribble 11 | ⌇ | Roving enclosed line |
| Scribble 12 | ⋀⋀⋀ | Zigzag or waving line |
| Scribble 13 | ℓ | Single loop line |
| Scribble 14 | ℓℓℓ | Multiple loop line |
| Scribble 15 | ◎ | Spiral line |
| Scribble 16 | ● | Multiple-line overlaid circle |
| Scribble 17 | ◐ | Multiple-line circumference circle |
| Scribble 18 | ◌◌◌ | Circular line spread out |
| Scribble 19 | ⬭ | Single crossed circle |
| Scribble 20 | ⬠ | Imperfect circle |

Figure 1.3: Rhoda Kellogg identified twenty different basic scribbles among her large collection of children's drawings.

her activity should certainly not be discouraged.

As children continue to explore the medium, then, they find that they can make different kinds of marks and they may build up quite

a repertoire of scribbles. In fact, Rhoda Kellogg (1970), a researcher who compiled a very large collection of children's drawings, identified twenty different basic scribbles, although each child does not necessarily produce all types (see Figure 1.3).

Many children go on to combine these different kinds of scribbles into more complex shapes and forms. Kellogg suggested that there might be an orderly progression from their basic scribbles, through a series of increasingly more complex forms she called *diagrams*, *combines* and *aggregates*, to their first construction of the human figure, and that when children begin to draw representational figures their constructions resemble these previous forms more than they resemble the objects they are supposed to depict (see Figure 1.4).

This 'building-block' idea of the development of drawing is neat and rather compelling. But there are many problems with it. One is that, as Kellogg herself said, not *all* children exhibit these different intermediary forms; many continue to produce basic scribbles until eventually they draw representational pictures. Criticizing Kellogg's

Figure 1.4: Rhoda Kellogg suggested that children's basic scribbles evolve into more complex forms which, in turn, are developed into human figures. The evidence for such a development, however, is not very strong.

claims, Claire Golomb (1981) points out that, in fact, no more than 4 per cent of Kellogg's children drew the sun figures which are supposed to precede the first human forms; furthermore, those who did draw the sun figures drew them at the same age as they had produced their first human figures. In her own study of 250 2- to 7-year-olds, Golomb found that only 4 per cent drew the forms that Kellogg described as *diagrams* before going on to representational forms. If the production of these forms is such an important step, there seem to be very few children who actually produce them.

A major problem that Golomb notes is the difficulty that she and her colleagues had in trying to identify the scribbles according to Kellogg's criteria; the different forms are simply not as obvious as Kellogg would have us believe. In the end Golomb and her colleagues could agree on just two categories of scribble in the children's pictures: (1) whirls, loops and circles, and (2) multiple, densely patterned parallel lines. When Golomb asked her scribblers to draw a figure, nearly 40 per cent of the 2-year-olds and 80 per cent of the 3-year-olds produced representational drawings without having gone through Kellogg's sequence of pre-representational forms. It appears, then, that the different kinds of forms described by Kellogg are not *necessary* steps towards the onset of representational drawing and so we should not be concerned if children do not produce these patterns.

There is also other evidence that children do not need to go through an elaborate scribbling period. Children in our own and in other cultures who have not had an opportunity to draw miss out these 'intermediate' steps and very quickly start to draw representational forms (e.g. Alland, 1983; Gardner, 1980). Some of them may try out some very basic scribbles to start with, but others go straight into representational drawing. Susanna Millar's (1975) work with blind children has also shown that they may create representational forms without any previous experience of scribbling.

Representational drawing does not necessarily have to be preceded by a period of scribbling and scribbling, of course, doesn't necessarily lead to representation. Chimpanzees brought up in captivity and given the appropriate materials can also scribble and their efforts show some of the same characteristics as those of young children. The 'art work' of Congo (see Figure 1.5), a young chimpanzee at London Zoo, was studied by Desmond Morris (1967). Congo started to make marks on the page at the age of 1 year 6 months, at the same

Figure 1.5: A multiline scribble by Congo, a chimpanzee at London Zoo.

age as most children. He progressed from relatively tentative and uncontrolled scribbling to bolder and more confident productions. Finally, Congo exhibited some of the diagrams – crosses and circles – described by Kellogg. But there the development stopped; Congo never produced any representational pictures.

A chimpanzee who managed to get further than this was Moja, who was studied by Allen and Beatrice Gardner (1978). Now, chimpanzees cannot speak because they lack the necessary vocal

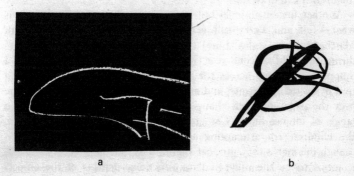

a b

Figure 1.6: (a) A bird and (b) a berry by Moja, a chimpanzee.

apparatus, but they can be taught to use sign language. They may not be able to use it in quite the same creative way as humans, but at least they can use it to name things. One day Moja drew a less exuberant scribble than usual, but when asked to carry on, she put the chalk down and signed 'finish'. In reply to 'What's that?' she signed 'bird' (see Figure 1.6a). Later on, she often named her scribbles and one could see some resemblance between them and the real object; radial scribbles were flowers and rounded shapes were berries (see Figure 1.6b). As far as I know, Moja never announced beforehand what she was going to draw, so she probably never intended her drawings to be representational at the outset. Nevertheless, it does seem that she was on the edge of representational drawing and that her ability to name things using symbols may have encouraged this development.

THE FIRST REPRESENTATIONS

Dennie Wolf and Martha Davis Perry (1988) have described how very young children of only 12 or 14 months will roll up a crayon inside a piece of paper and call out 'bye bye' or 'hot dog', using the drawing materials in a symbolic if unconventional way. In these *object-based representations* the crayon and the paper are made to stand for relationships and events in the real world. The idea that something can stand for something else (a line can stand for an arm, for example) is essential for representational drawing, yet children already understand at least something of this notion long before they themselves can draw.

Another unconventional but impressive early use of symbolism is what Wolf and Perry call *gestural representation* and what John Matthews (1984, 1989, 1991) calls *action representation*. It appears during the child's second year. Wolf and Perry describe how one child 'hopped' a felt-pen across the page, saying 'bunny' and creating a trail of dotted footprints, and another hummed as she wound a line over the page and then changed to crashing noises as she made a tangle of intense lines, 'Car going, going, going, CRASH!' Again, the children are attempting to commit meaning to paper even though the marks they produce do not look like the objects involved; it seems to be the movement or functional aspects of the objects which attract them and which they are intent on representing.

Figure 1.7: Aidan, aged 2 years 7 months, announced, 'I'm drawing a man. That's Mummy. That's Daddy. That's Angela.'

Figure 1.8: *Mummy and Daddy* by Simon, aged 3 years 2 months.

Beginning around the age of about 20 months, young drawers will begin to make marks to stand for a whole object or person. Some of them name these scribbles either before or after they have produced them, and yet no resemblance to the real object can be seen either by adults or by the children themselves if they are asked about their drawings later. When Aidan, aged 2 years 7 months, was asked to draw a person he made a definite circular scribble and said, 'I'm drawing a man'. He made a spirally scribble overlapping the first and said, 'That's Mummy', then another ('That's Daddy'), and then another ('That's Angela') (see Figure 1.7). Simon, aged 3 years 2 months, separated his scribbles, naming them 'Mummy' and 'Daddy' (see Figure 1.8).

Perhaps these children are simply attempting to imitate what they have seen adults do, constructing a form on the page and naming it. In the children's case, of course, they don't know *how* to construct the figure, but at least they have picked up the idea that the scribbles can be given names. At this stage they frequently supplement their drawings with verbal statements about them; it is not clear, though, whether they themselves realize that the drawings are not recognizable without this additional information.

Even if they don't know how to construct the shapes of objects themselves, children pick up a good deal of knowledge about the business of making pictures. They know, for example, that each object or each part of an object can have its own mark or shape. They also have a good grasp of how the shapes should be arranged on the page; for example, the eyes side-by-side and above the nose,

and the nose in turn above the mouth. Because very young drawers may have difficulty in organizing this spatial knowledge at the same time as remembering which parts to include, they can be helped in various ways. Bill Ives and his colleagues (Ives, Wolf, Fucigna and Smith, unpublished manuscript) dictated the components that make up a face to some 2- and 3-year-olds and asked them both to draw the face and to construct it from felt pieces. Freed from the burden of having to decide and remember the different parts for themselves, many of these young children scribbled them in the correct arrangement, and more of them constructed the face correctly using the felt pieces, even though they could not draw distinct shapes for each of the facial features. Another technique that researchers have used to tap children's underlying knowledge is to ask them to add features to incomplete figures (e.g. Freeman, 1977). When my daughter was almost 2 years old, I drew a head and body for her and asked her to finish the figure; she successfully put in the arms and legs in the appropriate places.

Sometimes children notice in their spontaneous scribbles a chance resemblance to something that they know. On one occasion Amy,

Figure 1.9: Amy, aged 2 years 11 months, recognized a tree-trunk and some apples in her scribble.

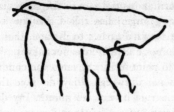

Figure 1.10: A bird by Amy, aged 2 years 10 months.

aged 2 years 11 months, was asked to draw a person but after she had produced the scribble she said, 'Oh, a tree. Lots of apples and a trunk!' (see Figure 1.9). We don't know if she had *really* intended to draw a person, but if she had, she then re-interpreted the picture when it turned out rather differently from what she had expected. On another occasion she was surprised and delighted by a shape she had just drawn, 'Look! That's a bird!' (see Figure 1.10). She then said, 'He needs an eye' and added a dot. Next, 'They have legs, don't they? Five legs!' Having accidentally drawn the basic shape of the bird she was able, intentionally, to add further features to it.

One of the early scholars of children's drawings, Georges-Henri Luquet (1913, 1927), referred to this stage of development as *fortuitous realism*. However, the child can also be encouraged or prompted to discover a resemblance between the shapes she produces and real objects by parents and others assuming (genuinely or not) that the picture might actually represent something – 'Are you drawing Daddy?', 'Is it a dog?', etc. The next step is for her to draw that likeness *intentionally*. To do this she will need to practise the kinds of lines and shapes that have produced a successful likeness before and will also need to develop a repertoire of lines and shapes that she can use for drawing new objects.

The form that the child draws is not just an arbitrary symbol that stands for an object in the same way that a word can represent an object; there must be some resemblance between the drawing and what it represents. As I mentioned earlier, for very young children this resemblance may be to do with an object's movement or function; but increasingly children are concerned with a *visual* resemblance between their drawing and what it stands for, the problem they are engaged in solving is how to construct the marks

on the page in such a way that we can recognize their meaning. Jacqueline Goodnow (1977) has called this the 'search for equivalents', an idea put forward earlier by Rudolf Arnheim (1974), and I shall discuss this in more detail in the next chapter.

It is important to point out that even when children have begun to make representational drawings, they do not necessarily give up scribbling. At the age of 2 years 10 months my daughter produced three representational figures on three consecutive days. After that she produced nothing but scribbles for about seven or eight weeks before producing the next representational picture. Over the succeeding months she would sometimes 'lapse' again into scribbling periods when no representational drawings were even attempted. Helga Eng (1954) also reported that her niece, Margaret, had a three-week period of scribbling after she had drawn her first human figure and before she attempted another. Sometimes children may give up drawing altogether for quite long periods of time; several of the case studies written in the early twentieth century note that they often pause during the summertime but then take up drawing again, often with renewed energy, in the autumn.

We should not be surprised at nor alarmed by this pattern of events, in the same way that we are not surprised at the fact that children do not cease to babble when they are trying out their first 'real' words. The production of a representational form is a demanding business; the child deserves and probably needs some respite from the taxing problems it poses. Scribbling may continue to be a valuable activity for some time, not least because she experiences satisfaction in practising an already well-mastered skill. But it may also be that it provides her with an informal and flexible activity with which to experiment and develop new ways of using lines which can then be incorporated into the more constraining activity of constructing a representational form.

CHAPTER 2

What Do the Lines Stand For?

The very young child who is just beginning to draw representational figures can perhaps manage a straightish line and a roughly enclosed circular form. As well as having this limited repertoire he may be hampered by difficulties in recalling the different components that make up the object he wants to draw and in coordinating them in the correct spatial arrangement on the page. His drawing is likely to be fairly minimal, depicting only a few features necessary for suggesting the object.

Another difficulty he will have to face is drawing three-dimensional objects or, in other words, objects that have volume. As Johann Heinrich Pestalozzi (b. 1746, d. 1827) pointed out, 'Nature gives the child no lines, she only gives things', and the problem that confronts

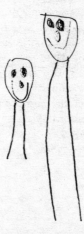

Figure 2.1: Sarah, aged 4 years 4 months, uses an enclosed region for the heads of her figures but single lines for their legs.

the child, therefore, is how to use the lines and shapes he has mastered to bring about some resemblance to the real objects.

John Willats (1985, 1987) has given an account of how children might do this, taking as an example their early drawings of the human figure. According to him, although most body parts are three-dimensional, we don't actually *think* of all of them as extending in all three dimensions. We think of arms and legs, for instance, as long things essentially extending in one dimension; the palms of the hands are flatter areas, mainly extending in two dimensions; the head and torso are bulkier, extending in all three.

Now, the very young child of about 3 or 4 years of age usually draws only the head (which may turn out to be a head *and* a body combined), the legs, and perhaps the arms, to represent a human figure. Faced with the task of depicting the bulky mass of the head and distinguishing it from the longer shapes of the arms and legs, he has recourse to different solutions to represent each body part. Willats describes how the child uses a region (by which he means an

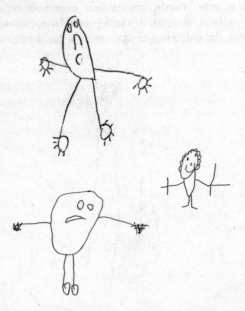

Figure 2.2: There is a variety of ways in which hands and feet can be depicted.

24

area encompassed by a boundary line) for the head but a single line for an arm or a leg (see Figure 2.1).

A problem arises when the child wants to draw the flattish two-dimensional areas of the body, such as the hands. If regions are being used for the bulkier body parts and lines for those defined by their length, what should be used for hands? Willats points out that, in fact, some children use regions and others use lines (see Figure 2.2). Perhaps their choice depends on which aspect they focus on: a region might be better for suggesting the palm of a hand, whereas lines might be more appropriate for fingers; some drawers, however, include both. Similarly, feet can be thought of as bulky blobs or as flat areas, or, indeed, as lengths, and so again we see a variety of solutions used; occasionally, children use lines to indicate the toes, but these are not depicted very often. Some children use the same schema or 'graphic unit' (Goodnow, 1977) to represent hands *and* feet.

Sometimes it is difficult to see whether a line is being used to denote the whole object or whether it is being used as a boundary for a region. The transitional human figures that some 3- or 4-year-olds draw before they go on to the more conventional forms are good examples. In those depicted in Figure 2.3 the circle is used to depict the head only and the arms have been moved lower down the figure; the torso is understood to be between the vertical lines which also act as its boundaries. But further down the figure the lines are no longer boundaries; each is used to depict a whole leg.

Later on children can vary the shape of a region, making it longer, for instance, so that it can then be used for those body parts defined by length. In Figure 2.4 the arms and legs of the figures are

Figure 2.3: In these transitional figures the circle depicts the head only and the arms have been moved lower down the figure.

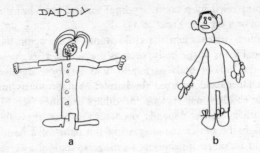

Figure 2.4: (a) *Daddy* by Samantha, aged 5 years 10 months; (b) self-portrait by Andrew, aged 5 years 11 months. Most of the body parts have been depicted by regions; single lines are reserved for hair, eye-lashes and shoe-laces.

represented by regions instead of single lines. Single lines tend to be reserved for features such as strands of hair, shoe-laces, eyelashes and so on, features which are more line-like in themselves. As lines can depict long objects, so dots can be used to depict small rounded objects such as eyes and buttons.

The solutions described above are not necessarily adopted by *all* young drawers: occasionally a child will use a line instead of a region to depict the torso, regions instead of dots for the eyes, or even a densely scribbled mass to indicate these different features. Some body parts, such as hands, feet and even noses, are more difficult to characterize and there are consequently variations in the way that they are drawn. Nevertheless, the range of solutions adopted by young children cannot be expected to be as wide as that adopted by older ones. This is, I believe, because the young child is basically on his own when he comes to representing certain qualities of objects, such as their bulkiness, flatness or length, and, in a sense, these qualities suggest solutions which he can find in his own restricted repertoire. He does not need to look to the way other children or adults draw these objects, thereby discovering other solutions, but can provide satisfactory solutions himself.

Older children and adults also use regions and lines to denote objects in their drawings. Single lines may be used to denote whole objects where appropriate – when drawing strands of hair, for example – and sometimes adults will use stick figures as a shorthand version of the human form. Increasingly though, older children use

Figure 2.5: Most adults draw a circle to depict a ball and some use shading to indicate its convex surface. The circle represents only the part of the ball that we can see and no more than this.

regions. We should be careful, however, when interpreting what is actually meant by these regions and also be aware that the older child's and the adult's meaning might differ from that of younger children. If asked to draw a ball, for example, adults will no doubt draw a circle. They may also use lines to shade the area in order to suggest the convex surface of the ball (see Figure 2.5). Although when we look at Figure 2.5 we assume that the artist has represented a complete ball, the picture is in fact a surface representation, showing only the front part of the ball which would be visible if it were actually placed before us. The circle is used as an *occluding contour* (a term used by David Marr, 1977) denoting the outer extent of the ball against its background as seen from our particular viewpoint; the region enclosed by the line represents the surface face of the ball.

A young child will also draw a circle to represent the ball, but we may be wrong in jumping to the conclusion that it is only the visible surface of the ball which is being depicted. John Willats (1985) tells a very revealing story (told to him by Dennie Wolf) about a young girl's problems in drawing a ball. After she had drawn the circle (see Figure 2.6a), she wanted to include the seam line but she didn't know how to do it. First, she drew a line around the outside of the circle (see Figure 2.6c) saying, 'I can't draw it here because it's not outside the ball.' Then she drew a line inside the circle (see Figure 2.6d) but said, 'I can't draw it here because it's not inside the ball.' Finally, she superimposed a line on top of her original one (see Figure 2.6e) but was still unhappy about it, 'I can't draw it here because it won't show up. So I can't do it.'

For an adult the solution is easy: if the circle represents the front part of the ball, then the seam can be drawn across from one side to the other (Figure 2.6b). For the girl the task was problematic because the circular line had a different meaning: the line itself stood

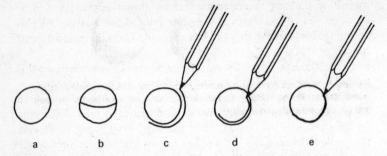

a b c d e

Figure 2.6: After she had drawn a circle to depict a ball (a), a young girl made several attempts at drawing the seam line (c – e); she could not decide where to put it. The problem is that for a young child the circle may represent not just the visible surface of the ball but its total volume. To an adult the solution is easy (b).

for the whole surface of the ball but the space within it stood for the interior of the ball. She could not draw a line within the circle because that would mean that the seam was *inside* the ball. The best place for the seam was on the circle itself but, as she pointed out, it would not show up.

There may be similar difficulties in our interpretation of children's drawings of other objects. If asked to draw a box, a competent adult may draw something like that in Figure 2.7. Again, when we look at this figure we assume that the artist has depicted a complete box even though we see only three sides of it; if asked to draw a pattern on its far side, the artist would probably say it is not possible because that particular face of the box cannot be seen from the position we are in. The regions in the drawing correspond to the three faces of the box and each line denotes a real edge where one

Figure 2.7: An adult's drawing of a box. The edges of the three visible faces of the box are indicated by straight lines. The outer edges of the figure also separate it from the background.

surface of the box meets another at an abrupt angle. As well as denoting real edges, however, the outer lines of the drawing are also occluding contours, so that the box appears to be silhouetted against its background.

Young children below the age of 7 or 8 years do not construct this perspective configuration for a box but draw a single square (Mitchelmore, 1978; Cox, 1986, 1991). However, we would be wrong to assume that this square corresponds to a particular face of the box. In the same way that the circle in the story cited above represents the whole volume of the ball and not just its visible front surface the square may represent the whole of the box. To test this idea, Vanessa Moore (1986a) showed a group of 7-year-olds and a group of 9-year-olds a cube with differently coloured faces. When the children had examined the cube it was placed on the table in front of them in such a way that they could see three faces – the top, the front and one side. They were provided with paper, pencil and felt-tip pens and were asked to draw a picture of the cube exactly as they saw it from where they were sitting.

As had been found in Mitchelmore's and Cox's research, some of the younger and, indeed, older drawers represented the cube with a single square. But the way the two age groups used the colours was very different: the older children used only one colour, to indicate the front face of the cube; the younger ones used all six colours in horizontal or vertical stripes to indicate all six faces of the cube. The latter apparently intended to represent the *whole* cube, not just the part that they could see best.

Moore also found, as previous researchers had done, that some of the younger children drew more faces than the three they could actually see. These, however, were not meant to represent the whole volume of the cube but were representations of its surface and, unlike those in older children's or adults' drawings of a cube, the outer edges in these children's drawings were not meant to be occluding contours.

There seems to be, then, a developmental progression in the way that children use lines. As they learn to alter the shape of their regions they use these where appropriate instead of single lines. However, the meaning of these regions is often not the same as that of those drawn by older children and adults: at first a region may be used to denote the whole volume of the object and it is only later that it may be used to denote some or all of its surface area; later still

Figure 2.8: Some children aged 7 years and below often use a single square to represent a cube (a); others show more sides of the cube than they can actually see (b). Although, by the age of 12, most children restrict themselves to three sides, they may have difficulty in fitting them together in a convincing way (c).

the region comes to be used as an occluding contour, showing us only that part of the object's surface which can be seen from our particular angle of view (see Figure 2.8). Emiel Reith (1988) has provided further evidence which supports this pattern of development and has shown that the understanding of occluding contour lines and the ability to use them in a controlled way is rare before the age of about 8 or 9 years. This development of the use of a line as an occluding contour is a considerable achievement as it enables children to represent objects in terms of the visual image they present to the eye which is, of course, essential if they want to draw a realistic picture.

CHAPTER 3

The Emergence of the Human Figure

One of the first recognizable forms that children draw is the human figure, and it remains one of the most popular topics they choose to draw until at least the age of 10 years (Maitland, 1895; McCarty, 1924; Märtin, 1939). The very early human figure drawings which appear around the age of 3 years (Cox and Parkin, 1986) are rather curious to adult eyes (see Figure 3.1). Usually there is a single line enclosing a roughly circular area which may contain facial features. This shape is set upon what appear to be two legs. Arms may or may not be present. If they are, they are often attached to what appears to be the head. The figures are most of the time very simple, but occasionally hair and other features may be added.

These quaint forms have been called *cephalopods*, tadpole figures or simply *tadpoles*. (In French they are *hommes-têtards* or tadpole-men, and in German *Kopffüssler* or 'head-feet persons'.) As far as

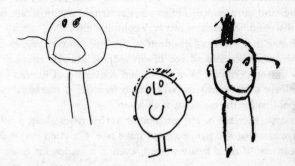

Figure 3.1: Around the age of about 3 years children draw tadpole figures; there appears to be no body and the arms protrude from the head.

we know, most children go through a tadpole phase (Freeman, 1980), although for some this can be as short as a few days and for others as long as many months (Cox and Parkin, 1986).

IS THERE A BODY?

Researchers have argued about which body parts are actually included in the tadpole figure. Some (e.g. Gibson, 1969; Freeman, 1975, 1980) have assumed that the tadpole has a head but that the trunk is missing. Others (e.g. Arnheim, 1974) have insisted that the trunk is included but is not differentiated from other body parts; that it may be, for example, that the 'head' contour actually includes both the head and the body.

Sometimes children give us a graphic clue by drawing a tummy button on the figure (Cox and Batra, unpublished manuscript). At times it appears within the 'head', suggesting that this contour may indeed combine the head and the trunk, or it appears between the 'legs' of the figure, suggesting that the trunk may be located below the head. Spontaneous clues, though, are actually quite rare. Out of 100 tadpole drawers, aged between 2 years 10 months and 4 years 10 months, we found that only one child had drawn a tummy button on her figure. Furthermore, when we asked the children to name the body parts that they had drawn, none of the remaining ninety-nine mentioned a body or a tummy. Incidentally, it doesn't matter what terminology is used as long as the children are familiar with it; we have compared the terms 'body' and 'tummy' and found that we get the same kind of response. Terms such as 'trunk' or 'torso' are not at all familiar, and 'stomach' is not very common either.

We know that nearly all children of this age can correctly point to their own tummies, and all 100 of our tadpole drawers could draw a tummy button correctly on a pre-drawn conventional human figure. The concept of a tummy, or where it is located, is therefore clearly not a problem for the majority of children.

Of course, the lack of any graphic or verbal clues about a tummy doesn't mean that the figure *doesn't* have one. Children may call the main segment of their figure a head, even if it stands for more than that.

When we simply asked the same group about the whereabouts of the tummy in their drawings, ninety-three of our 100 children either

pointed to a place on the figure or actually drew in a tummy. Only seven said that they didn't know where the tummy was, or couldn't draw one, or that their figure didn't have one.

THE LOCATION OF THE BODY

When we examined where the children thought the tummy should go in their drawings, we found that half had placed it within the 'head' region and half had placed it between the 'legs'. Did this mean that children didn't really know where to put the tummy on a tadpole form, and that half guessed that it was located inside the contour and half that it was outside? We decided to follow up Jacqueline Goodnow's claim (1977) that children place the tummy in whichever part is the longer, the circle or the 'legs'. Like her, we found a strong relationship between the location of the tummy button and the size of the part where it is located: the tadpole drawers who located the tummy in the 'head' had drawn it longer, and those who located the tummy between the 'legs' had drawn them longer.

Did the children draw the 'head' longer in the first place because they *intended* it to contain a tummy (and similarly for those who drew the legs longer)? Or did they decide where the tummy should go *after* they had seen which part looked more spacious and accommodating? In order to find out, Glyn Jarvis and I (unpublished data) asked thirty-one tadpole drawers aged between 3 years 5 months and 4 years 3 months to include the tummy in their free drawings and then to draw in the tummy on two pre-drawn tadpole figures. In one of these pre-drawn figures the 'head' was longer and in the other the 'legs' were longer.

Most of the children who had placed the tummy in the 'head' of their free drawings went on to place it within the 'head' of these pre-drawn figures; similarly, most of those who had placed the tummy between the 'legs' of their free drawings did the same again with the pre-drawn figures. Their location of the tummy was consistent throughout and did not vary depending on the relative sizes of the 'head' and 'legs'. This suggests that they had a prior idea of where the tummy should go and they were not deflected by the proportions of the figure.

We gave a further nineteen children some pre-drawn figures in

which the facial features had already been included. The location of these features was either in the upper part or in the centre of the circle. Although those who drew the tummy within the 'head' of their free drawing also positioned the facial features higher up, they were not persuaded to shift the tummy out of the circle if the facial features were placed lower down; they continued to place the tummy in the circle even if it meant putting it above the mouth. Similarly, those children who normally placed the tummy between the 'legs' were not persuaded to place it within the circle even if there was enough room below the facial features.

We analysed the free drawings of a further twenty tadpole drawers, with an average age of 3 years 7 months. We asked them to draw in the facial features, the tummy and the arms if any of these parts had been omitted. Two very distinct types of figure were identified. In one, the 'head' was drawn longer than the 'legs' (see Figure 3.2a); the tummy was located within the circle, usually below the facial features which were placed relatively high up; the arms were placed on the sides of the 'head'. In the other type, the 'legs' were longer than the 'head' and the tummy was located between them; the facial features were centrally placed within the 'head' and the arms tended to be attached to the 'legs' (see Figure 3.2b).

This second type of tadpole figure seems to be a later development (Cox and Parkin, 1986) in that the circle stands for the head only and features such as the tummy and the arms are shifted lower down. Other researchers have noted this kind of form (Luquet, 1927; Arnheim, 1974; Freeman, 1980) and it has been suggested

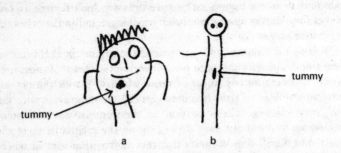

Figure 3.2: The 'head' contour of the tadpole figure may also stand for the body (a); later, the body and arms are shifted to a lower part of the transitional figure (b).

(Cox and Parkin, 1986) that it be regarded as a *transitional* form between the tadpole and the conventional forms.

Our findings, then, indicate that children know about bodies and tummies and that they know where they are located, both on real people and on conventional drawings of the human figure. It is not absolutely clear whether their own tadpole figures actually include a body, but if asked to indicate it, they are quite willing to do so and they will also draw in the tummy. Those who draw the 'head' longer than the 'legs' tend to place the facial features higher up in this segment and also place the tummy within it. The arms are attached to this head/body contour. Other children, who may be at a slightly later stage, draw the 'legs' longer than the 'head' and locate the tummy between the 'legs'. The arms also tend to be placed on the 'legs', leaving the circle to stand for the head only.

WHAT IT TAKES TO DRAW A PERSON

Most adults in our culture will recognize quite a simple schema as being representative of the human form. We usually think that a head, body, legs and arms are essential and sometimes even sufficient to represent a complete person. Conventionally, the head is a round, enclosed shape or region and the arms and legs are single lines or elongated regions. The torso is often round or oval, or it may be a vertical line as in a stick figure. Sometimes in schematic figures facial features are included, but often we don't add details like hands and feet. The inclusion of these rather depends on what the figure is being used for; for some purposes they may be relevant but for others they may be quite unnecessary. Most adults would have little or no difficulty in drawing these schematic figures.

Although the young child is quite knowledgeable about the human figure and can correctly point to a range of different features, in order to draw the figure she has to find out which parts are conventionally included and which parts are optional, know how each part is drawn, be able to recall all these parts as she is drawing and do so in an appropriate order, know where each part goes in relation to the other parts, and be able to fit the parts together on the page. She must also have a reasonable amount of control over the fine movements she makes so that the marks go where she intends them to go.

The seemingly simple task of making a schematic drawing of the human figure turns out to involve a complex coordination of knowledge and skill. It is therefore not really surprising that lack of knowledge can lead to problems: for instance, the child might not know how to draw a particular feature, or where to put it in relation to other features. Even if this knowledge is available to her, however, she might have too many things to think about and to coordinate and this performance overload might result in a part of the figure being omitted altogether or left undifferentiated from another part.

What if we help fill the gaps in the child's knowledge or reduce her performance overload? Will she then be able to produce a more conventional figure? As the ability to draw a person involves a number of processes, some occurring in sequence and some simultaneously, we can intervene in a number of different ways and to a greater or lesser extent. We can even remove all potential problems about how each body part is conventionally depicted by providing her with ready-made body parts, thereby reducing her task to selecting the appropriate parts and assembling them in the correct spatial order.

We asked six tadpole drawers aged from 2 years 11 months to 3 years 5 months to construct a person out of a number of ready-cut

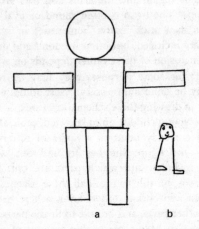

a b

Figure 3.3: Although Robert, aged 4 years 9 months, can construct a conventional figure when the pieces are provided for him (a) he draws a tadpole figure (b).

pieces of card (Cox and Parkin, 1986). We used a smaller and a larger circle (meant to represent respectively a head and a body) and two longer and two shorter limbs. Only one child, however, constructed a conventional person.

Elizabeth Bassett (1977), in contrast, obtained much better results: all twelve of her tadpole drawers produced conventional forms, apparently placing the arms on the trunk (see Figure 3.3). However, there was a difference between our manikin pieces and hers, which may have been crucial. She used a round shape and an oblong shape which children typically used as a head and a trunk, respectively, whereas we used a smaller and a larger circle. Perhaps our children did not so readily recognize what these were meant to represent.

Steph Osmond and I (unpublished data) compared the two sets of manikin pieces and confirmed that Bassett's pieces produced better results: 85 per cent of tadpole drawers successfully constructed a conventional figure whereas only 54 per cent were successful with the Cox and Parkin pieces.

In another manikin study by Claire Golomb (1973) all the tadpole drawers produced conventional figures. Again, the body parts, as in Bassett's study, were easily distinguished and, in fact, had facial features, clothing, etc., to help the children identify each piece.

In order to get children to produce a conventional figure it seems therefore sufficient to provide ready-made body parts for them to assemble, as long as it is clear what each part is meant to be. This reduces the demands of the task in that the child does not have to recall the body parts needed and does not have to decide how each part should be drawn.

These findings suggest that tadpole drawers do not have a problem with their conception of the human figure: they can assemble the six basic segments – head, trunk, two arms and two legs – in the correct spatial arrangement.

DICTATING THE PARTS

Even though tadpole drawers can assemble the manikin correctly, the drawing task itself still presents them with a problem: only one part can be drawn at a time, and, furthermore, if one part in the sequence – say, the trunk – is forgotten, then other parts may be joined in the wrong places. One thing we can do to help is to dictate

the body parts to the children as they are drawing. They will then be freed from the effort of having to decide which body parts to include and to recall them in the correct sequence. What they will still have to decide is how to draw each part, where it goes in relation to other parts, and how the parts fit together.

When Claire Golomb (1973) asked twenty-seven children with an average age of 3 years 10 months to draw a person, nineteen of them produced a tadpole figure. When the body parts were dictated to them, however, all but one produced a more advanced figure (see Figure 3.4). Unfortunately it's not completely clear from Golomb's report what these 'more advanced' figures were like. Children may have included a body in their drawings, but this does not necessarily mean that it was placed separately and below the head.

When we gave a dictation task to our six tadpole drawers, aged 2 years 11 months to 3 years 5 months, we found that only one produced a figure in which the body was conventionally placed; the arms, however, were attached to the 'head' (Cox and Parkin, 1986). Four children produced their usual tadpole figures and seemed to ignore the instruction to draw a body; in one figure the arms were omitted, but in the other three they were attached to the 'head'. Another child simply scribbled when the name of each body part was spoken.

We were concerned that the children might not have listened

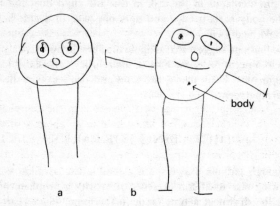

body

Figure 3.4: Paul, aged 3 years 2 months, draws a tadpole figure (a), but can add extra parts when they are dictated to him (b).

carefully to the name of each body part; in fact, we had the impression that they largely ignored our instructions and were keen to get on with drawing their standard tadpole figure. John Stone and I repeated the experiment (unpublished data), but this time we made sure that all children waited and listened for each instruction. We also had a much larger sample of tadpole drawers – twenty-five children with an average age of 3 years 2 months. Only one child ignored the body; all the others included it in their figure. Eighteen placed the body inside the 'head' contour and only two placed it below the head as part of a conventional figure. The remaining four children drew the 'legs' of the figure when the *body* was mentioned, and then drew a body in between the 'legs' when the *legs* were mentioned. Nearly all of them placed the arms on the 'head' contour.

These findings suggest that most children will indeed add the body to their figure when it is dictated to them, but that most of them have not learned the convention that the body has its own separate contour below that of the head. They also show that the bodies that children do draw, although enclosed contours, are not large segments like those drawn by older, conventional drawers.

COPYING THE FIGURE

What if the tadpole drawer is asked to copy an adult's conventional drawing of a human figure? All the parts of the conventional figure are there in full view throughout the task and they are all in their appropriate spatial locations. We presented a complete human figure to our six tadpole drawers and asked them to draw it (Cox and Parkin, 1986). No child succeeded. One drew distinct shapes but no representational forms on the page; the other five drew tadpoles, one with the tummy between the 'legs'.

Perhaps it is not surprising that even though the complete figure is available, children may not know how to go about achieving the same configuration themselves. J.M. Baldwin (1903) tried to get round this problem by drawing a human figure for his child 'H', naming each part as it was drawn (see Figure 3.5a). This did not help her at all at the age of 1 year 7 months when, presumably, she was at the scribbling stage. But at 2 years 3 months H did much better and included a line for the body (see Figure 3.5b). A few days later, the body was drawn as an enclosed region (see Figure 3.5c).

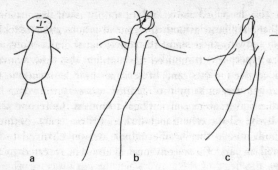

Figure 3.5: Provided with the model of a figure (a), at the age of 2 years 3 months 'H' made a reasonably good attempt at copying it (b). A few days later, she drew an enclosed contour for the body instead of a single line (c).

In another study I asked twenty-two tadpole drawers to watch the human figure being drawn and to listen for each part being named (unpublished data). This group was called the *whole figure* group. Twelve of the children (55 per cent) drew a conventional form when they were asked to copy the model. Another group of twenty-two children copied each segment of the figure after the experimenter had drawn it. This was called the *segment* group. Fifteen of them (68 per cent) drew a conventional form. Yet another group of children, eighteen of them this time, copied three of these segment-by-segment figures. This was called the *repeated segment* group. By the third figure, thirteen children (72 per cent) drew a conventional form. A control group of twenty-two tadpole drawers all drew tadpoles. A further control group of fourteen were asked to draw three more figures but these were also all tadpoles, confirming that simply repeating the drawing task without tuition would not lead to a conventional figure being produced.

This copying task indicates that children need to see how each body part is drawn and how it is fitted into the total figure, and the results demonstrate that paced copying will help to show tadpole drawers how the human figure is conventionally drawn.

But, this task accomplished, do these children then adopt the conventional figure as their usual way of drawing people, or do they revert to their old style? In order to find out the answer to this we visited all those who had taken part in the copying study two days

after the exercise described above and we simply asked them to draw a person. All the children in both the control groups drew tadpoles. In the *whole figure* group, seven of the conventional drawers reverted to drawing tadpoles, which reduced the number who drew conventional figures to five (23 per cent). The same thing happened in the *segment group*. It was only in the *repeated segment* group that the majority of the figures were conventional forms on the second visit: ten of the thirteen now-conventional drawers (77 per cent) continued with their conventional forms, one tadpole drawer changed to the conventional form, and three conventional drawers reverted to the tadpole form.

DON'T FORGET THE ARMS

So far, I have concentrated mainly on the problem of the body in the tadpole figure. This is because one of the most striking things about the figure is that it may be bodiless, and many researchers have puzzled over this issue. Whether or not the tadpole does have a body, another feature which is often clearly omitted is the arms. These are usually the last to be drawn on the figure, after the 'head' contour, facial features and legs. And this is precisely why they may be left out – they have simply been forgotten. Even among conventional drawers, many children may omit the arms until as late as 5 years of age (Partridge, 1902; Gesell, 1925; Hurlock and Thomson, 1934).

If a tadpole drawer does include the arms, they are attached to the sides of the 'head' contour. If we assume that the figure has a body and that it is included in the 'head' region, then the position of the arms is quite reasonable. On the other hand, if the tadpole lacks a body, the positioning of the arms on the head is rather bizarre.

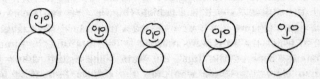

Figure 3.6: When asked to add some arms to these pre-drawn figures, children draw the arms on to the larger circle.

Perhaps we could find out where the tadpole drawers *intend* the arms to go. Norman Freeman (1975) did this by asking a group of them to draw the missing arms on to some pre-drawn figures – figures which had a head *and* a trunk (see Figure 3.6). He found that his tadpole drawers and also some scribblers could draw the arms on to the figure. But a curious bias emerged: the location of the arms shifted depending on which part was the larger, the head or the body. Freeman called this the *body-proportion effect*. The effect was even there when he drew the children's attention to the trunk by asking them to draw in the tummy button first (Freeman and Hargreaves, 1977). It is possible, then, that the placement of the arms is not fixed, but is affected by the arrangement or proportion of the figure already drawn. Claire Golomb (1981), however, has argued that although the *researcher* may define the top circle as the head and the one below as the body, the *child* may not necessarily agree, especially if the proportions do not look right. When a child attaches arms to a large 'head', she may simply have redefined the larger circle as a head/body conglomerate and ignored the smaller circle.

DO TADPOLE DRAWERS THINK THAT CONVENTIONAL FIGURES ARE BETTER?

Young children must see innumerable pictures of the human figure, and very few of these look like their own tadpole drawings. But do tadpole drawers regard conventional figures as better than their own attempts? In Claire Golomb's study (1973) tadpole drawers thought that a conventional figure was better, but this was probably because the one presented was more detailed than the other forms and was also clothed, ''cause he has everything', as one particular child explained.

John Stone and I (unpublished data) asked twenty-five tadpole drawers which of the three figures in Figure 3.7 was the best and which the silliest. As well as a tadpole (Figure 3.7a) and a conventional figure (Figure 3.7c), we included a transitional form (Figure 3.7b) in which the arms were attached to the 'legs' and the tummy button was between the 'legs', this form being usually drawn by children older than those who draw the tadpole form (Cox and Parkin, 1986). None of the figures was clothed. The drawings were on cards which were shuffled and placed in a different order for each

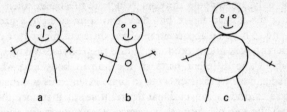

Figure 3.7: When asked to pick out of a tadpole (a) a transitional (b) and a conventional figure (c) which is the best drawing of a person, tadpole drawers choose their own style.

child. Twenty-one of the children thought that the best of the three was the tadpole figure. Fifteen thought that the silliest was the conventional figure and the other ten that the transitional form was the silliest.

In contrast in the same study twenty-two out of thirty transitional drawers preferred the conventional figure; twelve of them simply said that it was the best and ten that it was the way that grown-ups drew them. Only eight of the transitional drawers preferred their own style. All but one of the children thought that the tadpole was the silliest picture. We also asked eight conventional drawers what they thought; all of them chose the conventional figure as the best and thought that both the tadpole and the transitional figures were silly. In a similar study Marjorie Taylor (Taylor and Bacharach, 1981) asked children to choose out of three figures which one looked most like a real person. Like us she found that the tadpole drawers tended to select the tadpole form. Interestingly, she discovered that conventional drawers *and* scribblers tended to select the conventional figure.

John Stone and I also asked our children to tell us which picture was drawn by a very young child and and which by an older child. Nineteen of the twenty-five tadpole drawers couldn't answer these questions at all and four of them gave inappropriate answers. Only two children said that the tadpole was drawn by a younger and the conventional figure by an older child. Twenty-eight of the thirty transitionals thought that the tadpole was drawn by a younger child and the conventional figure by an older one. Only two thought that the transitional figure was drawn by a younger child but they also said that the conventional form was drawn by an older child. All the conventional drawers answered correctly.

Not only are tadpole drawers reluctant to change their way of drawing the human figure but they also seem to have a preference for it and to have no appreciation of the different forms that children at different ages might produce. While they obviously know a good deal about the different parts of the human body and while this knowledge informs their drawing to some extent, this is not sufficient for them to draw a conventional figure; it seems that once they have adopted the tadpole form they regard it as a perfectly appropriate way to depict the human figure.

MOVING ON

In 1974 Rudolf Arnheim discussed two kinds of tadpole figure. One is the classic tadpole, in which the arms are attached to the 'head' contour and any other body features are included in this region, and he maintained that in this type the head and trunk share the same boundary. In the other form the 'head' region represents only the head; the 'legs' represent an undifferentiated trunk and legs, and the arms are attached to these vertical lines. This second form is the figure that I have already referred to as a *transitional* form, which is drawn, as we saw in the previous section, by children who seem to have a more 'mature' idea compared with tadpole drawers about the different ways that human figures can be drawn, and who aspire to a conventional figure, preferring it to their own style.

Although children who draw the transitional form are slightly older than those who draw the classic tadpole, not all of them go through this transitional phase. Some seem to go straight on to drawing the conventional form. Furthermore, these different forms

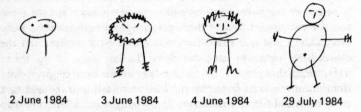

2 June 1984 3 June 1984 4 June 1984 29 July 1984

Figure 3.8: Amy's tadpole phase lasted three days and she quickly moved on to drawing conventional figures.

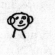

May 1984 June 1984 August 1984 October 1984 February 1985

Figure 3.9: Aidan produced a mixture of tadpole, transitional and conventional figures over a period of months before drawing only conventional forms.

don't necessarily appear in clearly distinct stages. Charmi Parkin and I (1986) collected drawings from six children over a period of one year, from the time when they were simply scribbling to the time when they produced conventional figures. We also collected the spontaneous figures they had produced at home and at nursery, as well as the ones we specially requested every two months.

We found that the pattern of development was very variable. Some drawers went through a very short tadpole phase and then produced conventional figures (see Figure 3.8). Others seemed to go through a much longer period of some months in which they drew tadpoles, transitional and conventional forms (see Figure 3.9); of course, the conventional form eventually became dominant. It is interesting that the three forms can co-exist in the same child, who is clearly capable of drawing a more mature form but often doesn't. I suspect there may be at least two reasons for this. One is that when such a child draws a tadpole she is not bothering to try very hard and dashes off a shorthand version of a person; when she does bother, or can be persuaded to bother, she will draw a conventional form. The other reason, related to this, is that when the human figure itself is the main topic of the picture, as it often is in a test situation, the child makes more effort to make it the best person she can. In contrast, when the human figure is only incidental to the scene the child's efforts are concentrated on other aspects and she makes do with the shorthand tadpole form.

Jacqueline Goodnow (1977) suggested that children might change from drawing a tadpole to drawing a conventional form by adding a cross-line to the legs of the figure (see Figure 3.10). Claire Golomb (1973) notes some similar cases in her study. Although some drawers develop their figures in this way it is clear that others do not; they

45

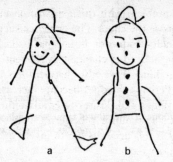

a b

Figure 3.10: Some children may draw a conventional figure by adapting their tadpole form. Two weeks after drawing a tadpole form (a), a young girl added a cross-line between the 'legs' and moved the arms further down the figure (b).

draw a very bold, rounded contour for the body of the conventional form and then attach legs and arms to it, as Amy did in her figure (see Figure 3.8).

Exactly why children eventually relinquish the tadpole form is not really known. One possibility is that at first any vaguely representational figure is acceptable but that increasingly the drawings are criticized by others, and this external pressure may lead to a growing awareness of how other people draw. The extent to which adults or other children actually show tadpole drawers how to draw a conventional form is not known, but we know that in some cases they do intervene. The first representational figure drawn by a little boy called Joe (Cox and Parkin, 1986) was, in fact, a conventional form, although it had no facial features and no arms (see Figure 3.11). Joe said proudly, 'Alistair showed me [how] to draw giants.'

Figure 3.11: Joe drew his first recognizable figure at 3 years 8 months. He said proudly, 'Alistair showed me [how] to draw giants.'

But there is a problem with this explanation in that it locates the main impetus *outside* the child. The evidence suggests however, that the entrenched tadpole drawer is not particularly open and is, in fact, very reluctant indeed to change to a conventional style. It seems to me that something must also happen *inside* the child which induces change. Perhaps she does become increasingly aware of how other people do things and desires to emulate them, but it may also be that she eventually requires a 'better fit' between her drawing and her model, and that this prompts her to invent or to search for a new and more satisfactory form.

CONCLUSIONS

Tadpole drawers have little or no difficulty in producing a conventional human figure if all the body parts are provided, ready-made, and can be easily identified. All the tadpole drawers in at least two research studies have been able to assemble a person under these conditions. They know which pieces to select and where each part should go.

A problem arises in the drawing task itself. The child does not necessarily select separate and distinct schemas for each of the main body segments, and does not necessarily include all of the segments. Conventional drawers produce separate schemas to represent at least six essential body parts – head, trunk, two arms and two legs. Tadpole drawers produce fewer forms to represent the same parts: the trunk and head or the trunk and legs may be combined into a more global form; some parts, such as the arms, may be omitted altogether.

If we dictate the body parts while the tadpole drawers are drawing, they will include them, but they don't necessarily locate them in the conventional places. The tummy may be inside the 'head' region and the arms may be placed on what appears to be the head. Even when they are shown how to draw each part and where it fits into the figure as a whole, they seem reluctant to relinquish their tadpole form. It has clearly served them well.

Eventually, however, they do move on. This may be partly a reaction to criticism from others, but is more likely to be a positive, self-motivated action in search of better representational forms. As one of Claire Golomb's children remarked, 'I found out a new way ... I thinked, and I thinked, and I just thinked it up' (1973).

CHAPTER 4

Developing the Human Figure

As children develop, their drawings of the human figure become more differentiated and, by the age of 5 years, most of them draw a trunk which is clearly distinguishable from the head of the figure (Koppitz, 1968). They also draw more body parts – adding, for instance, the hands and the feet on to the arms and legs. Not only do they draw more of the main body parts, but they also add more details, including eyebrows and eyelashes, and clothing features such as pockets and shoe-laces.

BOUNDARIES AND CONTOURS

Each of the body parts of a child's early conventional figures tends to have its own line, or boundary. In Figure 4.1 the head and the

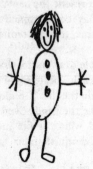

Figure 4.1: Stephen, aged 5 years 5 months, has used separate circles for the head and body of his figure and single lines for the arms and legs.

Figure 4.2: The head and body of Simon's figure have a shared boundary at the 'neck'.

trunk are bounded by separate circles which touch at the 'neck'; arms and legs are represented by single lines. In Figure 4.2, the head and trunk again have separate regions, but at the 'neck' they have a shared boundary. Nearly all children draw a bounded region for the trunk; the stick figures often drawn by adults as a kind of shorthand are not particularly common in very young children's drawings (Kellogg, 1970) and continuous outlines for the whole figure are also rare.

Typically, very young children use single lines to represent arms and legs, but by the age of about 6 years most of them draw pairs of lines to bound a region (Koppitz, 1968; Papadakis, 1989). Interestingly, the legs are usually outlined in this way earlier than the arms (Partridge, 1902). As more features are added, they have their own separate or shared boundaries, so that the various regions of the figure are clearly delineated (see Figure 4.3). As Jacqueline Goodnow (1977) has noted, young children seem to be at pains to give each feature its own space and they are very reluctant to have other items cross the boundaries.

By the age of about 8 or 9 years, children attend more to the shape of the trunk, and introduce shoulders into the body shape. Often the neck and shoulders are run together, forming a continuous outline; the arms also open out into the body segment (see Figure 4.4). When the figure is clothed, the neckline and cuffs will form distinct boundaries, but the arms and trunk are usually run together.

Figure 4.3: As more body parts are added they have their own bounded regions.

Figure 4.4: Amy, aged 8 years 7 months, has used a continuous outline for the neck, shoulders, arms and torso of her figures.

49

The sketching of the contour of the whole figure (called *threading* by Goodnow, 1977), or of major parts of it, is characteristic of older children (Fenson, 1985; Reith, 1988), and this shift from depicting bounded regions to contour sketching is, according to Goodnow (1977), an intellectual as well as an artistic shift. The reason for it is that the older child constructs not simply a mental list of parts to be drawn, but a number of interacting relationships between the parts.

Two further reasons why the child may change his style of depiction have been suggested by Larry Fenson (1985). The first is that he strives for realism, and this necessitates the abandonment of a segmented style, as the component parts of a figure are not readily apparent in real figures or in realistic paintings of them. The second reason is that he becomes more interested in depicting the figure engaged in some activity (see Figures 4.21, 4.22 and 4.23). This is particularly true of boys, whose figures are often shown playing football or fighting. This emphasis on activity and, often as a consequence, on a profile form leads the young drawer to discover more flexible modes of representation. Incidentally, when children first draw a figure in profile, they may draw the head and the feet pointing in the same direction but show a frontal view of the trunk. Most profile figures point to the left (Guillaumin, 1961), presumably because most people are right-handed and find it easier to orientate the figures in this way.

By early adolescence, most children have developed a way of drawing the human figure that they can produce fairly automatically. If asked to draw a person from imagination, they can draw a well-practised and acceptable figure without having to think about it very carefully. The picture, though, may fall a long way short of photographic realism and, if the drawer has been asked to draw from an actual model, may fail to look anything like that individual person. Although most of us would wish to be able to draw in a more realistic way, our development usually stops at this point. We do not bother, and usually do not need, to pursue the problem further.

Those older children who do try to improve their drawing do so in one of two main ways. The first is by copying the style of other artists, and quite often these may be caricature and comic-strip artists. Close examination and practice can result in a huge repertoire of facial expressions and figures in a variety of postures and activities (see Chapter 10).

A second way they may try to improve is by concentrating on

drawing from life and, in doing so, by trying to solve the problems of proportion, contour and modelling in light and shade. By this time they have usually abandoned an interest in the whole figure in favour of concentrating on the head (see Figure 11.11 in Chapter 11). The emphasis on drawing from life means that the picture is drawn from a particular viewpoint. The outline of the figure is clearly meant to be an occluding contour, one which denotes the boundary of the figure against its background as actually seen by the artist. Occluding contours are also used within the outer contours. For example, although a nose has no real edge, the line of the nose in the drawing indicates its extent against the background of the face. Two-thirds of adolescents' portraits are drawn in full- or part-profile, as Earl Barnes noted in 1892.

PLANNING PROBLEMS

One of the very noticeable characteristics of young children's drawings of the human figure is their rather bizarre proportions. Certain parts such as the head, legs or hands may be disproportionately large in comparison with the rest of the figure. In fact, it is highly unlikely that very young children pay much attention to the realistic proportions of a figure; it would probably be difficult for them to monitor the relative size of each feature as it is drawn. The ability to deal

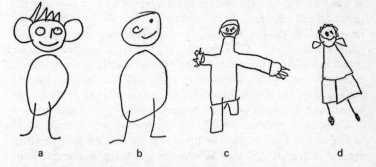

Figure 4.5: (a) Alistair, aged 3 years 9 months: 'He's got big ears!'
(b) Amy, aged 3 years 6 months: 'He's a bit silly without a neck, isn't he?'
(c) Ben, aged 5 years 3 months: 'One leg is too short.' (d) Jenna, aged 5 years 5 months: 'Oops, look at his arms!'

with proportion in a representational task doesn't begin to emerge until at least the age of 8 years, according to Jean Piaget and Bärbel Inhelder (1956). Younger children may, however, comment on their figures after they have drawn them – 'They're funny big feet', 'Got baby legs', 'He's got big ears' – indicating that they are aware of the proportions (see Figure 4.5).

Both Florence Goodenough (1926) and Dale Harris (1963) have found that young children tend to draw the head disproportionately large, and others (e.g. Löwenfeld, 1939; Lark-Horovitz, Lewis and Luca, 1973) believe this is a reflection of its relative importance to them. (The ratio of head height to total figure height is usually taken to be 1:8 for the adult male figure.) But the head may need to be large if it is to contain facial features and have hair and possibly ears attached to it; in contrast, if children don't wish to add features such as clothing to the trunk, then there is no need for this contour to be large at all. Young drawers may therefore be making a planning decision indicating that they are thinking ahead and making adequate provision for things to come.

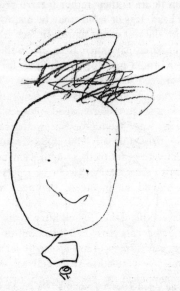

Figure 4.6: Richard, aged 3 years 7 months, drew a large head too near the edge of the paper and then had to squeeze in the remaining body parts. He said, 'Only room for a little tummy and little legs.'

Figure 4.7: When children draw the heads of their figures first (a) (c) and (e) they draw them disproportionately large. The proportions are more realistic if they begin with the trunk (b) (d) and (f).

We have some evidence that this is so. When Julie Henderson and Glyn Thomas asked some children aged between 4 and 7 years to draw a person with large teeth, they drew the head of the figure much larger than they normally did in order to accommodate a larger mouth complete with teeth (1990). Conversely, when they asked the children to draw the back view of a person, implying that no facial details should be included, the head was smaller than usual.

There is another explanation for children's disproportionate figures, although it again concerns their planning or lack of it. If the head, for instance, is drawn first (and it usually is) and takes up a lot of space, there may be very little space left for the trunk and the legs. When this happened to Helga Eng's niece, Margaret, she simply said, 'I hadn't any more room' (1954). When I asked a little boy called Richard to draw a person, he drew a huge head rather near the edge of the paper; he then drew a smaller 'neck' and as he

squeezed in a few more lines commented, 'Only room for a little tummy and little legs' (see Figure 4.6).

Glyn Thomas (Thomas and Tsalimi, 1988) also investigated the possibility that the order in which the body parts are drawn may put constraints on their relative sizes (see Figure 4.7). He found that, when asked to draw the head on a pre-drawn headless figure, 5- to 8-year-olds drew it much closer to the real proportion in relation to the trunk. The same effect was observed when children drew their own figures but were asked to begin with the trunk. Frequently, those who began with the head did not leave enough space to draw the body in proportion. Given that most children normally do begin with the head, perhaps because they recall the body parts in a top to bottom order, this overestimation of the head – or, rather, underestimation of the trunk (Allik and Laak, 1985) – is very common.

The child may also alter the size or position of a particular body part if another part is already occupying that space. Having noted that children are reluctant to have one body part impinge on another's space (the 'each to its own space' rule), Jacqueline Goodnow (1977) gave a group of them some pre-drawn figures with long hair and asked them to draw in the arms. As the hair had already taken up the space normally reserved for the arms, where would the arms go? Figure 4.8 shows some of the varied and ingenious solutions the children came up with.

Figure 4.8: Young children are reluctant to infringe the 'each to its own space' rule. When asked to draw arms on to a tadpole figure which already has hair, they point the arms downwards at a steep angle or place them on the 'legs' of the figure.

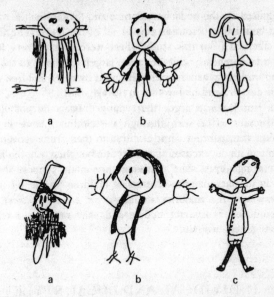

Figure 4.9: Transparency drawings of a woman wearing a long skirt (upper row) and a man wearing a coat (lower row). There are three types of transparencies: scribble (a), line-on-line (b) and outline (c).

The clothing of the figure, as well as the body parts themselves, may present a planning problem. Clothing generally blocks the view of the body part which it covers. Older children and adults will begin with the clothing and then attach visible parts of the body, for example, hands, feet, etc. Younger children, however, may sometimes start with the body and then clothe it. This sequence is likely to result in a *transparency* effect (Goodenough and Tyler, 1959).

However, these transparent figures do not appear very often in children's spontaneous drawings. In order to elicit them, Belle Mann and Elyse Lehman (1976) gave 4- to 9-year-olds very specific instructions. They asked them to draw a woman wearing a long skirt (see Figure 4.9, upper row) and a man wearing a coat (see Figure 4.9, lower row). Thirty-three per cent of the drawings were transparencies, and three particular types were identified: (1) scribble, in which the clothing is represented by scribbled lines covering some or all of the body; (2) line-on-line, in which the clothing boundary is

superimposed on the body boundaries; and (3) outline, in which the clothing boundary surrounds part or all of the body. The following results emerged from this study: there were actually very few line-on-line transparencies; scribbles were largely confined to the 4-year-olds; and outline transparencies were used by older children (by girls up to the age of 7 and by boys up to the age of 9).

Mann and Lehman argue that young drawers do not *intend* the body structure to be seen through the clothing; however, having produced a transparency some children in their study recognized the problem and made 'excuses', such as 'She bought a size too large', or 'She's wearing a grass skirt'. Although one might suppose the task in this study to maximize the chances of children producing transparency drawings, the majority in fact drew *non-transparent* figures: many produced a separate bodice and skirt or drew a triangular skirt-body for the woman.

INDIVIDUAL AND LOCAL STYLE

Some children may have a distinct way of holding the pencil or crayon which affects the kinds of strokes they make, and their drawings may be characterized by a neatness or raggedness of line, light or heavy pressure on the pencil, and by an attention or lack of attention to detail. Adults can certainly recognize the styles of individual 5-year-old children, although they may need some practice in order to do this (Hartley, Somerville, Jensen, von Cziesch and Eliefja, 1982).

As well as these characteristics which give an individual child's drawing a noticeable style, children generally have a fairly stable idea of the size in which a particular figure should be drawn. M.A. Wallach and M.I. Leggett (1972) found a high degree of consistency over a five-week period, as did Jüri Allik and Tiia Laak (1985) over two weeks. The same basic schema may be repeated for each figure (Luquet, 1927, called this *type constancy*). Amy's people are very similar and illustrate the way she drew all figures when she was 5 years old (see Figure 4.10).

If the human figure were a more angular geometric form, it might be easier to draw in the sense that the ways that it could be depicted would be fairly obvious and limited. As it is, however, this irregular

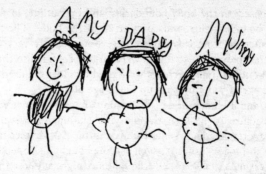

Figure 4.10: Amy, aged 5 years 2 months, has used the same basic schema for all three figures.

and rather lumpy figure presents problems, and there are many ways in which it can be depicted. The particular way of drawing each body part may be an invention by each individual child. The ways that hands can be drawn, for instance, are quite diverse (see Figure 2.2 in Chapter 2), not to mention noses (see Figure 4.11). G.W. Paget (1932) counted fifty-three different symbols for a nose among 295 English 5- to 9-year-olds.

Some children may maintain and develop their own style with little influence from other children; others, in contrast, may copy the way others draw. This influence may spread through a classroom or become even more widespread so that a local style becomes observable. I well remember, when I was about 5 years old, some older girls showing us how we should draw people; these figures had triangular bodies and rather curious wing-like arms. This style was adopted by me and my classmates and persisted for quite some time. I eventually relinquished it when my mother persuaded me that arms 'don't go like that'.

The spreading of a particular style through a local area was what particularly interested G.W. Paget (1932). He collected over 60,000 drawings from children living in remote areas of Africa and Asia and compared them with the drawings of European and American children. Drawings in which the body parts have a boundary line were quite common worldwide, although the shapes of the segments varied. Paget noted that, whereas the 'cottage-loaf' way of representing the human figure (see Figure 4.12) characterized the drawings of

Figure 4.11: Children around the world use many different symbols for a nose in their figures.

many Western children, children in other cultures had different solutions to the problem. He gave examples of triangular body shapes (see Figure 4.13); in a separate study Brent and Marjorie Wilson (1984) also reported the typical rectangular 'Islamic' torso found in many Middle Eastern countries (see Figure 4.14).

In some non-Western areas Paget found that the 'stick figure', in which the body segments are not drawn as bounded areas and

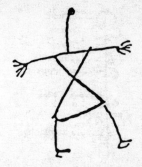

Figure 4.12: This self-portrait by Amy, aged 5 years 11 months, shows the 'cottage-loaf' construction of the human figure common among Western children.

Figure 4.13: This drawing of a man was drawn by a Bergdama boy, aged 7 years, in South-West Africa. It shows a triangular construction of the figure typical of that region.

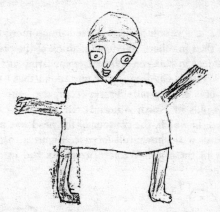

Figure 4.14: This self-portrait was drawn by a Yoruba boy, aged 10 years, in Nigeria. The rectangular body is a typical feature of drawings produced in many Islamic countries in the Middle East and in Africa.

therefore cannot accommodate features within a contour, was common. This raises a problem about where, for example, to put the facial features. One solution was simply to omit them altogether. Another solution was to string them out along the vertical line of the figure (see Figure 4.15). There were many cases in which the facial features were in the correct spatial arrangement but there was no boundary encompassing them (see Figure 4.16).

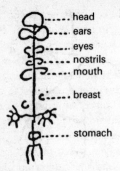

Figure 4.15: This drawing of a woman was done by an Indian boy, aged 6 years. All the body parts have been strung out along the vertical line of the figure.

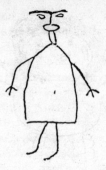

Figure 4.16: This drawing of a woman was done by an Iranian girl, aged 7 years. There is no boundary encompassing the facial features of the figure.

It seems that the profile form occurred much more frequently in some cultures than in others. We tend to think of the profile as being a late development in children's drawings appearing at about the age of 9 years in Western children, but Paget found that 61 per cent of Maori 5-year-olds drew profile figures (compared with only 5.2 per cent of 5-year-olds in North America). In Africa, a curious mixed profile emerged, in which, the contour of the head was in profile, but the facial features were shown full-face (see Figure 4.17).

What many of these non-Western examples had in common was

Figure 4.17: These figures drawn by 9-year-old African children show a mixed profile. The head is in profile; the facial features are separate from the head and are full-face.

that although different body parts were linked together, none of them was included within the contour of another. Where, for instance, a head contour was drawn, it was separate from the facial features. It is possible that the children were following Goodnow's 'each to its own space' rule according to which the head, being a separate item from the eyes, the nose and the mouth, must have its own space. Another possibility is that the space within the head circle represents the *volume* of the head and not simply the outer surface on which facial features can be placed. To place the facial features within the head contour might imply that the features are *inside* the head and the children may have wished to avoid this interpretation of their figure.

Paget also investigated the geographical distribution of different ways of drawing the nose. According to his research the two-dot nostril form was very commonly used by North American, Canadian Indian, Norwegian and English children. In contrast, it did not appear at all in the drawings of children from India, Palestine and Burma; in these countries the predominant forms were those which showed the wings of the nostrils and/or the continuity of nose and eyebrows. These forms were very rare in Paget's European and American samples. In present-day Nigeria, the continuity of the nose and eyebrows (see below) is very common among low income, but not among middle income, children.

Another discovery was that Chinese children commonly employed forms which do not emphasize the wings of the nostrils; the triangular nose (see below) was also a favourite with English children:

In Egypt and Palestine, however, this form was very common:

Certain schemas may seem more appropriate than others for particular body parts – circular regions for the head and trunk and

Figure 4.18: The complicated leg structure of these figures was typical of the figures drawn by Spanish-speaking Californian children during the early 1920s.

single lines for the limbs, for example. Nevertheless, since the human figure could be represented, more or less satisfactorily, in a number of different ways, we should not be surprised to find a considerable variety of forms. And, indeed, we do find diversity among different cultures and localities, and among individuals drawing for the first time. Yet, certain forms or styles of drawing do characterize particular groups or areas. Paget acknowledges that physical differences between peoples may account for a different choice of schemas – for the different schemas used to represent the nose, for instance. He also acknowledges that in some cases, such as Western adults' schematic drawings of the two-dot nose symbol, children may copy or be influenced by adult solutions. He argues, though, that the child is overwhelmingly influenced by other children's drawings, that these become the accepted tradition among the children of a particular locality and that the style is picked up by succeeding generations of children.

Brent and Marjorie Wilson (1985) studied the drawings made over the last 100 years by children from many different countries and were fascinated to find that some features are unique to particular

groups of children. For example, nearly all of a sample of Spanish-speaking Californian children whose human figure drawings were collected between the years 1917 and 1923 had a very complex way of drawing legs. These were formed by two intersecting, diagonally orientated rectangles (see Figure 4.18) and, judging by the erasures in some of the pictures, must have been difficult to draw.

Another interesting feature occurred in one particular school in Los Angeles during the 1920s – back-mounted arms were drawn by nearly a third of the boys (see Figure 4.19). Brent Wilson noted that this characteristic was also evident in the drawings of Italian children collected by Corrado Ricci in the 1880s (see Figure 4.20). It turned out that this Californian school had received a large influx of Italian immigrant children during the 1920s, so that the back-mounted arms might well have migrated with the Italian children and then passed on to the other children in the school.

From time to time, young drawers may invent a new way of depicting an item or, like the Italian children, may introduce their style to a new population. What we don't know is what determines

Figure 4.19: Back-mounted arms were drawn by children in a Los Angeles school in the early 1920s. This style may have been imported by Italian immigrants.

Figure 4.20: Back-mounted arms drawn by Italian children in the 1880s.

whether a new style will catch on or not. Although initially its popularity may have something to do with the personality or forcefulness of the individual child-innovators themselves, the style itself must also be particularly apt to be adopted by succeeding waves of children over a number of years.

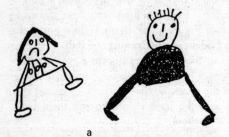

a

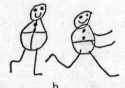

b
d

c
e

Figure 4.21: Children become increasingly able to modify their figures in order to show them walking (left in each pair of figures) and running (right).

FIGURES IN ACTION

Most human figures in children's drawings are placed perpendicularly to the ground whether they face the viewer or are in profile. (The child may draw an explicit groundline or use the lower edge of the paper or an implied groundline. See Chapter 8.) Jacqueline Goodnow (1978) wanted to see how children would modify these upright and rather rigid figures in order to show them engaged in various activities. She asked 5- to 10-year-olds to draw a person walking and a person running. The youngest children maintained an upright posture for both their figures and simply spread the legs to indicate running (see Figure 4.21a). Slightly older ones bent the legs (see Figures 4.21b and c), but only at ages 9 and 10 did children begin to alter the trunk of the figure as well (see Figures 4.21d and e).

Goodnow also asked 4- to 10-year-olds to draw a person picking up a ball. Not surprisingly, the youngest children showed the least change from their usual figures. Often the figure and the ball were placed side by side, sometimes with no contact at all (see Figure 4.22a). Some children solved the contact problem by elongating one arm (see Figure 4.22b); others raised the position of the ball on the page (see Figure 4.22c). At 6 or 7 years, the figure was still rigid but the arms were placed sideways (see Figure 4.22d). It was not until after the age of 7 years that the children bent the figure at the knees or at the waist, or both (see Figure 4.22e).

a b c d e

Figure 4.22: Age differences in children's ability to modify their figures in order to show them bending to pick up a ball: at around 4 years figure and ball are simply side by side (a), one arm is elongated (b) or the position of the ball raised (c); at 6 or 7 years the figure is still rigid but the arms are placed sideways (d); after 7 the figure is bent at the knees or waist (e).

MOVING FIGURES

Unlike a video or film, a picture is still and the action or movement it depicts is frozen. Occasionally, children will include in their pictures some indication or clue that the figure is in motion or is about to move from one place to another. As well as the adaptations of the legs and trunk referred to in the previous section, they may place the figure in profile. They may also add 'flowing' hair and clothes (see Figure 4.23).

Older children may use the conventions of comics and cartoons, adding movement lines (Goodnow, 1977) or using dotted lines to

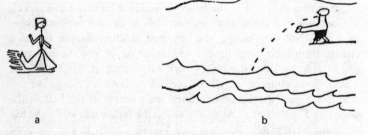

a b

Figure 4.23: Children sometimes add movement lines to their figures (a) or indicate intended movement by a dotted line (b).

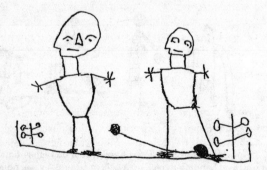

Figure 4.24: *The Football Players* by a boy, aged 11 years 7 months. The initial position of the ball at the right and its end position at the left are linked by a line.

Figure 4.25: *Departure for the Summer Holidays* by a boy, aged 9 years. The picture consists of a sequence of scenes rather like a comic strip.

indicate the trajectory of movement. In *The Football Players* (Löwenfeld, 1939) the artist, aged 11 years 7 months, has shown the flight of the ball by depicting its beginning (at the right) and end (towards the left) positions and by linking these with a line (see Figure 4.24). In addition the player on the left has two noses to indicate that he at first faced away from the ball (profile nose on left of head) but then turned to face it (frontal nose). (This boy regularly drew the head of his figures with a nose in profile but with two eyes.)

It is also not unusual to see a 'comic strip' picture as in *Departure for the Summer Holidays* (Löwenfeld, 1939), in which a set of temporal sequences is shown in the same drawing (see Figure 4.25).

NON-HUMAN FIGURES

Children's early versions of both humans and animals look very much alike because the same formula is often used to serve both purposes (Graewe, 1935). Often the animal form is also placed in the same upright posture as the human figure (see Figure 4.26). But, generally, children come to lay the figure out horizontally. Although characteristic animal features, such as pointed ears and a tail, may be added, the same basic units and features may still be used as for the

67

Figure 4.26: The girl who produced these figures, aged 4 years 1 month, has drawn the dog (left) in the same upright posture as the man (right).

human figure. The problems of which way to orientate the head and where to place the legs may take some time to solve. Here are Amy's solutions to these problems, drawn when she was between 3 years 6 months and 4 years 6 months (see Figure 4.27). Whether the face is eventually shown from the front or in profile seems to depend on whether the animal itself has a flat or elongated head. Bill Ives (Ives and Rovet, 1982), for instance, found that whereas horses are drawn in profile, owls and cats are drawn full-face by children aged between 9 and 13 years (see Figure 6.7 in Chapter 6).

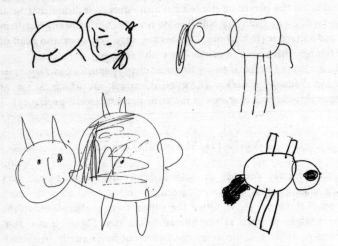

Figure 4.27: Amy's attempts at orientating the facial features and legs of her animal figures.

CONCLUSIONS

Up to the age of about 12 years children gradually add more details to their drawings of the human figure. In general there is a development from drawing a distinct boundary for each body part to sketching an outline for the whole figure. Planning problems may result in certain parts of the figure, for instance the head, being disproportionately large, and more realistically proportioned figures are not drawn by most children until at least the age of 8 years. The early figures are rather stiff and stereotyped and may serve to depict animals as well as humans. Children can, however, be persuaded to adapt their figures to show movement and action. Indeed, it may be that their later interest in portraying action actually facilitates the appearance of figures in profile.

The way that each body part is depicted may reflect each child's individual style, but children are also influenced by the local style used by other children or adults in the community. It is interesting that whereas tadpole drawers seem to be entrenched in their own particular style of drawing the human figure, the older conventional drawers are more open to the influence of others. Although there has been little cross-cultural work on tadpole figures, my guess is that the tadpole figures drawn by children in different cultures will be rather similar, whereas the conventional figures of older children will show more differences in style. The reason for this is that the tadpole drawer is grappling with the basic problem of how a real, three-dimensional object might be represented in a two-dimensional medium. This basic problem is likely to be the same for all children, regardless of culture. Having discovered that single lines and enclosed shapes can be used to stand for different body parts, the older child begins to consider which shapes among the many possibilities are most appropriate for the different body parts. Appropriate solutions are more varied for some body parts than for others and the child may experiment on his own and also become interested in other people's solutions to the same problems.

CHAPTER 5

The Diagnostic Use of
Children's Drawings

Most of the early scholars of children's drawings were interested in their general characteristics, in why these occurred and in how they changed over time. But there is another tradition which grew in the 1920s, at a time when psychological tests were being constructed for use in educational and clinical contexts; this tradition concentrates on what drawings may be able to reveal about an *individual* child's capabilities or state of mind. I shall discuss some of the work which has made use of drawings as indicators of a child's intelligence or intellectual maturity, her personality and her emotional adjustment. In the main, this work has concentrated on children's drawings of the human figure.

INTELLECTUAL MATURITY

In 1926 Florence Goodenough developed a test based on the child's ability to draw a man and regarded it as a test of intelligence. This test was revised and extended by Dale Harris in 1963. Harris, and indeed Goodenough, came to regard the Draw a Man test (or DAM) as a measure of intellectual maturity and not of intelligence, as it is meant to measure the child's actual rather than her potential level of functioning. In practice, however, most teachers and psychologists will talk in terms of intelligence or IQ. The drawer is credited with points according to the number of body parts included, their proportions and the way that they are attached to the main figure.

The 5-year-old girl who produced the drawing of a man seen in Figure 5.1 has been credited with having drawn a head containing eyes, nose and mouth but the following features were also taken into account: the pupils of the eyes are shown and the ears are

Figure 5.1: The girl who drew this man, aged 5 years, scores close to average for her age in intellectual maturity.

appropriately positioned and proportioned; the figure has hair; hands, complete with fingers, have been added to the arms; there are feet as well as legs; both the arms and the legs are attached to the trunk; the head is in reasonable proportion to the body and there is some indication of clothing. In total the figure scores 19 points which are then converted to a standard score – in this case, 105. This score expresses the child's relative standing compared with other children in her age group. The average score for each age group is 100, so this particular girl has scored close to average for her age.

The drawing of a man seen in Figure 5.2, produced by a girl aged 9 years 6 months, is credited with 34 points. Not only are there more body parts compared with the 5-year-old's figure – for instance, a neck, wrists, ankles and shoulders – and more detailed clothing, but the proportions of the figure are better and the control and co-ordination of the lines are more confident. When the points are converted, though, this figure has a standard score of 104, which again is close to the average of 100.

Although there are reckoned to be no major sex differences in the way boys and girls draw, girls tend to add more details than boys. This may reflect the fact that the maturation rate for the sexes differs – in favour of girls (Scott, 1981). In order to compensate for this difference in the Draw a Man test there are separate tables for

Figure 5.2: The girl who drew this man, aged 9 years 6 months, scores close to average for her age in intellectual maturity.

converting the points to standard scores. The 5-year-old girl who drew the man in Figure 5.1 scored 19 points and this was converted to a standard score of 105. Had she been a boy, the 19 points would have been converted to a standard score of 110.

Elizabeth Koppitz (1968) developed another mental test based on children's drawings of the human figure. Her Draw a Person test (or DAP) was based on the human figure drawings of nearly 2,000 children aged between 5 and 12 years. Koppitz scored each figure according to thirty developmental items derived from the Goodenough–Harris test and according to her own experience of studying children's drawings (see Table 5.1). These developmental items were grouped into four categories for each age level: (1) expected, (2) common, (3) not unusual, and (4) exceptional. Legs, for example, are expected items in a 6-year-old's figure. If a 6-year-old has drawn legs, then she scores + 1; if the legs are absent, then a score of − 1 is recorded. Exceptional features will occur only in the figures of children with above average mental maturity. As in the Goodenough–Harris Draw a Man test, a child's total score in Koppitz's test can be converted into an IQ score (the average IQ for any age is 100).

These kinds of tests are reliable and correlate reasonably well with other tests of intelligence. Harris, for example, took the Draw a Man

1. Head	16. Arms correctly attached to shoulders
2. Eyes	17. Elbows
3. Pupils	18. Hands
4. Eyebrows or eyelashes	19. Fingers
5. Nose	20. Correct number of fingers
6. Nostrils	21. Legs
7. Mouth	22. Legs in two dimensions
8. Two lips	23. Knees
9. Ears	24. Feet
10. Hair	25. Feet in two dimensions
11. Neck	26. Profile
12. Body	27. Clothing: one item or none
13. Arms	28. Clothing: two or three items
14. Arms in two dimensions	29. Clothing: four or more items
15. Arms pointing downwards	30. Good proportions

Table 5.1: The thirty developmental items in Koppitz's Draw a Person test.

scores of 100 children tested by Goodenough and correlated them with these children's scores on the Stanford–Binet intelligence test, a well-known and established test widely used by psychologists. The resulting correlation was substantial, indicating that the Draw a Man test is quite a good measure of the child's intellectual performance. It should be pointed out, however, that *some* good drawers do not perform particularly highly intellectually, and that some 'bright' pupils are not very good at drawing. In fact, the correlations between Koppitz's DAP and the Stanford–Binet test and between the DAP and the WISC (Wechsler Intelligence Scale for Children) intelligence test, another well-known and established test, are not particularly high, even though they are still positive (see Koppitz, 1968). It should also be pointed out that although the accretion of detail is related to children's intellectual development, this relationship is less strong after the age of about 12 years, when children tend to cease adding more details to their figures.

It is important that the child's drawing used for these tests should be a 'best effort' – a drawing in which she intends to make the best figure she can. This is likely to be, but is not always, the first drawing she produces in a session and one in which the figure is the main focus of the picture. Figures drawn spontaneously and those which are part of a larger scene may not be suitable for scoring

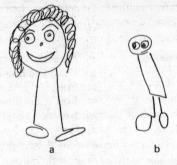

a b

Figure 5.3: Gemma, aged 5 years 1 month, has drawn a tadpole figure (a), whereas Dean, aged 5 years 9 months, has drawn a more conventional figure (b). The conventional figure may be regarded as more mature in structure even though it is less detailed and less confidently drawn than the tadpole form.

because they may not be the most detailed that the child can draw. When administering these tests, it is worth checking that the figures children draw compare favourably with their usual productions and do them justice.

Because these tests are easy to administer and fairly easy to score they are useful in providing an *estimate* of the child's level of intellectual development. Nevertheless, because they are based on a composite score, in turn based on the details included in the figure, much information regarding the structure of the figure is lost. For example, two children can both score the same number of points even though their figures are very different. Imagine a detailed tadpole figure and a rather plain conventional figure drawn by two children of roughly the same age. The tadpole usually appears earlier in a child's development than does the conventional form and might reasonably be regarded as less mature, yet according to the DAM test the children who drew these two figures are about equal in intellectual maturity (see Figure 5.3).

CHILDREN WITH LEARNING DIFFICULTIES

By definition most children are normal, and as they get older they know more and become more intellectually mature. Of course, some

children's intellectual maturity far outstrips their chronological age, and they are regarded as more gifted; their figure drawings resemble those of an older age group. Conversely, some children's intellectual maturity lags far behind their chronological age. Although in the past these were referred to as 'subnormal' or 'retarded' children, nowadays they are called 'children with learning difficulties'. Their difficulties may be mild or severe.

A number of researchers (Kerschensteiner, 1905; Burt, 1921; Goodenough, 1926; Earl, 1933; McElwee, 1934; Israelite, 1936) have emphasized the differences between the drawings of normal children and those of children with learning difficulties. They stressed the deficiency of detail, lack of organization, faulty proportions and inclusion of bizarre or irrelevant details found in the drawings of the latter. The emphasis here is on a difference in the *kinds* of drawings produced by the normal children and those with learning difficulties. In contrast with this view, Georges Rouma (1913) claimed that children with learning difficulties produce the same kinds of drawings as normal children, although the latter produce them at a younger age. This idea suggests that the child who has learning difficulties is not producing figures which are particularly aberrant, but is simply proceeding through the stages of drawing at a slower pace than the normal child. Claire Golomb and Tracy Barr-Grossman (1977) note these contradictory views and consider that it is not possible to establish from these early studies which conclusions are more likely to be correct because the studies suffer from a variety of methodological shortcomings.

Golomb and Barr-Grossman themselves compared the construction of the human figure by children with non-specific learning difficulties (chronological age 4 years 4 months to 13 years 1 month; IQ 40 to 76) and by normal children (chronological age 3 years to 5 years 10 months; IQ approximately 100 to 110). The mental ages of the two groups were similar, although, of course, the normal children were younger. The authors do not give any illustrative examples of the figures drawn by the children, but they do say that the structures of the figures drawn by the two groups were very similar; the only difference was that the children with learning difficulties with a mental age of 4 and 5 years drew more details than did the normal children of that age. Apart from this difference there were no noticeable problems of organization or proportion, nor any addition of bizarre details. The structure of the figure, then, seems

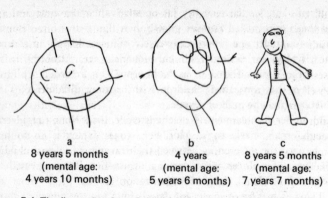

a	b	c
8 years 5 months	4 years	8 years 5 months
(mental age:	(mental age:	(mental age:
4 years 10 months)	5 years 6 months)	7 years 7 months)

Figure 5.4: The figure drawing of a child with severe learning difficulties (a) is similar to one drawn by a younger child at nursery (b) and much less mature than a normal child's figure (c).

to be related to the child's intellectual level, but there is some indication that the added experience that comes with extra chronological years results in attention to detail.

The findings of a recent study (Cox and Howarth, 1989), like those of Golomb and Barr-Grossman, also suggest that children with learning difficulties exhibit a developmental delay rather than a disorder or deviance in their drawing ability. Our group of such children had an average chronological age of 9 years 2 months, but their average mental age was 3 years 9 months. We compared their human figure drawings with those of two groups of normal children: a primary school group which also had a chronological age of 9 years, and a younger nursery group whose mental age was similar to that of the children with learning difficulties. Our study showed that the figure drawings of the children with learning difficulties and those of the nursery children were very similar and that both groups produced less advanced drawings than the normal 9-year-olds (see Figure 5.4).

PERSONALITY

Although we all have our ups and downs from time to time, we may describe ourselves and others as *generally* happy, miserable, lively,

dull, cautious or headstrong. These relatively stable and enduring traits are regarded as one's personality. Although we often think of children as well as adults in this way – 'She's a happy little thing', 'He's a born worrier' – childhood personality traits are difficult to assess. Questionnaires, such as the *Junior Eysenck Personality Inventory* (Eysenck, 1965), have been devised for use with adolescents, but it is debatable whether they can be used reliably with younger children, the problem being that it is difficult for young children to speculate about their own typical behaviours. There is no doubt in some people's minds, however, that an activity such as drawing, which appears to be so natural and spontaneous, can provide an insight into a child's general and basic nature.

The Draw a Person test introduced by Karen Machover in 1949 was considered a very useful way of assessing personality, being based on the assumptions that 'the drawing of a person represents the expression of self, or the body, in the environment' (1951) and

Figure 5.5: This drawing by Peter, aged 8 years, was analysed for indications of his personality adjustment.

'the composite image that constitutes the figure drawn is intimately tied to the self in all of its ramifications'. The child is asked to draw two figures: the first one is interpreted as an expression of self and sex-role identification, and the second (the opposite sex from the first) is interpreted as revealing something about the child's relationship to other important people in his life. Machover's interpretation of the drawings takes into account the particular body parts included, their size and shape, the quality of the line, the amount of erasure, their position on the page, and so on. However, it is heavily influenced by a psychoanalytic orientation, imbuing almost every line and segment of the drawing with symbolic meaning and taking no account of the way that perfectly normal young children draw.

Figure 5.5 shows a picture drawn by 8-year-old Peter which Machover has used to illustrate her method of investigation. I don't have space to give all the details which Machover provides about this drawing, so a few of them only must suffice. She considers that the male figure in the picture represents the child himself and believes that, although the stance of the figure is wide and assertive, the shading and erasure on the chest area indicate a sense of weakness. The oversized head denotes intellectual aspiration and the heavy pressure of the pencil line a need for social participation. The pronounced ears reflect an oversensitivity to social opinion and criticism. The omission of the pupils from the eyes is a sign of self-centredness. The meticulous and manly clothing (particularly, the oversized tie) indicates an accent on social appearances and a father replacement drive. Sexual anxiety and conflict are represented by the extra shading on the trousers and the strong belt which cuts off the genital area. The small feet denote insecurity and effeminacy.

Machover's Draw a Person test became one of the most frequently used psychological tests in clinics and hospitals and is still widely in use today. But how justified is its use? In 1957 Clifford Swensen reviewed a great many studies which had used the test in order to assess Machover's claims. He was sceptical: 'the evidence does not support Machover's hypotheses about the meaning of the human figure drawings. More of the evidence directly contradicts her hypotheses than supports them' (p. 460). And he concluded, 'Since in clinical work the reliable diagnosis of the individual case is of paramount importance, this lack of consistent evidence ... suggests that the DAP is of doubtful value in clinical work' (pp. 460–1).

Some years later, in 1968, Swensen reviewed the more up-to-date

evidence and his review coincided with another one by Howard Roback. Both authors were essentially in agreement: they could not find sufficient evidence in support of Machover's claims. They both agreed that the main, and probably the only, justification for the use of the test is that it can provide a fairly reliable *global* impression of a child's adjustment; however, according to them, judgements based on *single* signs in the drawing, such as line quality or the way a particular body part is drawn, are much less reliable. The value of this test, then, is severely limited; it can act as little more than a rough screening device for determining the gross level of a child's personality adjustment.

EMOTIONAL ADJUSTMENT

Another way of thinking about ourselves and others is how well or badly we react to or adjust to changing circumstances. These more temporary feelings and reactions are features of a person's emotional adjustment rather than enduring personality traits.

In the same way that drawings have been used to reveal the child's personality they have also been used to assess emotional adjustment or disturbance. Various writers have specified a number of indicators of disturbance in a child's figure drawing. These range from the omission of items which normal children would include (trunk, arms, mouth, etc.), the inclusion of items such as genitalia which rarely occur in normal children's drawings (in Western cultures, at least), the exaggeration or diminution of certain body parts, unconnected or scattered body parts, unusual proportions of the figure, shading, and grotesque forms.

Joseph DiLeo (1973) shows us a figure drawn by a boy aged 6 years 10 months (see Figure 5.6). The figure has no arms and the boy is described as being excessively cautious and non-aggressive. It is true that at this age most children include the arms, but many of them do not; without first of all checking to see what the *normal* developmental trends are it would probably be erroneous to assume that the omission of a certain body part reflects some emotional problem. Nevertheless, DiLeo says that the omission of the arms indicates timidity and passivity and may also be interpreted as an expression of guilt feelings.

To be fair, DiLeo himself does recognize that the use of children's

Figure 5.6: It has been claimed that the omission of arms from this figure, by a boy aged 6 years 10 months, is an indication of his timidity.

drawings as data for diagnosing emotional disturbance is potentially problematic. As Florence Goodenough and Dale Harris (1950) also point out, 'Many of the reputedly abnormal features in the drawings of single children or of small, selected groups lose their apparent significance when the age and sex of the subjects and the conditions under which the drawings were made become known'.

Elizabeth Koppitz (1968) is another cautious researcher who, in addition to her thirty developmental items, lists thirty emotional indicators by which a child's emotional adjustment or disturbance may be assessed (see Table 5.2). These indicators include the absence of certain parts from the body (eyes, mouth, legs, feet, neck), a figure height of more than 9 inches or less than 2 inches, a slant of more than 15 degrees from the vertical, very long or very short arms and the inclusion of extra items such as clouds. Koppitz compared the emotional indicators in the human figure drawings of two groups of children, (1) seventy-six children in ordinary schools and judged by their teachers to be well-adjusted in all ways, and (2) seventy-six children who were patients at a child guidance clinic. Whereas the well-adjusted children produced twenty-two emotional indicators, the clinic children produced 166.

1. Poor integration of parts	17. Hands cut off
2. Shading of face	18. Legs pressed together
3. Shading of body and/or limbs	19. Genitals
4. Shading of hands and/or neck	20. Monster or grotesque figure
5. Gross asymmetry of limbs	21. Three or more figures spontan-
6. Slanting figure	eously drawn
7. Tiny figure	22. Clouds
8. Big figure	23. No eyes
9. Transparencies	24. No nose
10. Tiny head	25. No mouth
11. Crossed eyes	26. No body
12. Teeth	27. No arms
13. Short arms	28. No legs
14. Long arms	29. No feet
15. Arms clinging to body	30. No neck
16. Big hands	

Table 5.2: The thirty emotional indicators in Koppitz's Draw a Person test.

The degree of adjustment or disturbance is assessed according to the *total* number of emotional indicators in the child's drawing. Koppitz gives a clear warning, which echoes the criticisms of Machover made by both Swensen and Roback, that it is not meaningful to make a diagnosis on the basis of one single indicator because problems and anxieties may be expressed in different ways by different children and in different ways by the same child on different occasions. It is nonsense, then, to say, 'This figure has no arms, therefore the child must be anxious or disturbed.' Furthermore, Koppitz urges us not only to consider the *total* number of indicators but to analyse them on the basis of the child's age and social and cultural background and, in addition, to evaluate them together with other available data.

It is curious that having given such a clear warning Koppitz herself goes on to make interpretations of individual indicators: large figures indicate aggressiveness and immaturity, tiny figures indicate timidity, short arms reflect children 'too well-behaved for their own good', long arms reflect aggressiveness, omission of the mouth indicates 'feelings of intense inadequacy, resentment and withdrawal'. These kinds of interpretations abound both in Koppitz's book and in the work of many other writers. Whether there is any real basis for

them is another matter. In truth, very few have been tested in any rigorous way.

TESTING THE CLAIMS

Before jumping to the conclusion that the many odd features of a child's drawing are attributable to some emotional problem or personality defect we should check that they are not simply solutions to the usual planning problems that any child or adult has to deal with in representing a person – which body parts to include, how best to represent them, how to fix them together, how to get the proportions right, and so on. Norman Freeman (1972, 1980) has pointed out that any analysis of children's drawing cannot ignore the effects which result from the drawing process itself.

One claim that crops up again and again is that children exaggerate the size of a body part which is important or has particular significance for them. In Chapter 4 I described Glyn Thomas's investigation of this issue and gave two reasons for the disproportionately large heads on the figures drawn by most children below the age of about 8 years: first of all, the outline of the head is drawn large in order to accommodate the facial features and, secondly, the head gets more than its fair share of space because it is normally drawn first. If children are asked to include details on the *body* of the figure, they will then make the outline of the torso bigger; if they are asked to draw the back view of a person (which has few detailed features) the head size is much less exaggerated (Henderson and Thomas, 1990); if they are asked to draw the body first and then the head, or to draw a head onto a pre-drawn body, the head size is again much less exaggerated (Thomas and Tsalimi, 1988).

Another claim also to do with size is that a large figure is supposed to indicate an important or dominant person in the child's life (Sechrest and Wallace, 1964), whereas a small figure may represent a threatening person (Craddick, 1963). There may be something in this interpretation, but it may also be the case that the size differences reflect planning problems in the organization of the group on the page. Again, the order in which each figure is drawn and the space available may be important considerations. The first figure may be at an advantage in that there are fewer constraints on

space, and subsequent figures may be smaller because there is less space.

Tania Fox and Glyn Thomas (unpublished manuscript) investigated the size of figures in the drawings of 4- to 9-year-olds. First of all, they asked the children to draw one picture of their mother and one of an ordinary woman; half the children drew their mother first and half drew the ordinary woman first. On another occasion they were asked to draw their father and an ordinary man. Each drawing was made on a separate sheet of paper. Most of the children made larger drawings of their parents than they did of the ordinary people, whether the pictures of their parents were drawn first or second.

Now it may be that the parent figures were drawn larger because the children were intending to include more details in their outlines, irrespective of whether the parents were important figures. Thomas carried out another study (Thomas, Chaigne and Fox, 1989) in which children aged 4 to 7 years were asked to copy only the outline of a figure, and therefore did not have to consider the amount of space that would be needed for any extra features. Next, they were asked to copy the figure again, but this time they had to imagine the figure to be *either* a very nice person 'who is kind and caring' *or* a very nasty person 'who steals sweets and things'. The children drew the nice person larger and the nasty person smaller than their neutral figures; another group of them, who drew the neutral figure twice, did not vary the size of their drawings significantly. This size effect occurred again when children were asked to draw a nice and a nasty magic apple, showing that it is not confined to animate objects.

The story does not end quite yet, however. Further studies by Thomas have revealed, rather surprisingly, that the size effect is actually reversed if the child is asked to draw or compare two figures on the same page: the nasty figure is then the larger and the nice figure is the smaller one. Clearly, the size effect is an important one, but its direction is strongly related to the actual method of collecting the drawings. Glyn Thomas is investigating why this should be so. Obviously it is important that when clinicians or therapists use children's drawings they should find out the exact conditions under which they have been made.

Until recently the claim that the size of the figures in a child's drawings reflects the importance or significance that those people have for that child in real life had been largely unsubstantiated. Now, Glyn Thomas's findings provide quite strong evidence in

support of this claim even when the child's planning problems, such as the order in which the figures are drawn or the need to draw a larger outline in order to accommodate more details, have been taken into account. This kind of work is an example of the rigorous way in which the claims made about children's drawings should be investigated. Nevertheless, Thomas's intriguing results, in particular the fact that the size effect can be reversed, show how the answers are not as clear-cut as we might have hoped.

CONCLUSIONS

Drawing seems to be such a natural and spontaneous activity that it is perhaps not surprising that many clinicians and therapists use it as a means of getting children to express themselves and to talk about the things that concern them. This is a perfectly reasonable use of the drawing activity. Many writers, psychologists and clinicians, however, have gone further and have regarded drawings as a potential source of information about the individual child. Often they are considered to be a direct reflection of the child's state of mind. Since the human figure is one of the earliest and most ubiquitous topics in children's free drawings it has been the basis of a number of famous tests designed to assess the child's intellectual maturity, personality or emotional adjustment.

The usefulness of such tests depends on whether or not they measure what they say they measure. The available evidence suggests that they are reasonably reliable and can therefore help to make a *global* assessment of a child's intellectual level or adjustment; however, they cannot give any indication of *specific* strengths or weaknesses. The danger of interpreting single features of a drawing such as the quality of the line or the way that a specific body is drawn cannot be overemphasized. Frequently, the occurrence of these features is unreliable and the interpretations suspect. Yet, despite the fact that many of the 'classic' interpretations have been discredited or have not been adequately assessed, these tests are still widely used. Happily, researchers are now beginning to use more rigorous methods of evaluation and, even when we are required to abandon explanations in terms of the emotional significance of a feature, we may find other, no less interesting, explanations for the way children draw their figures.

CHAPTER 6

Recognizable Objects

One of the very curious and striking features about young children's pictures is the rather jumbled way that the objects are drawn. Amy's picture of a dog (see Figure 6.1), drawn when she was 4 years 5 months, has a characteristic horizontal axis, yet the face is shown from the front and the body seems to have been turned over so that we see its underside.

Whereas many young children draw a single square to represent a house or a cube (Cox, 1986), slightly older ones often draw more sides than one could actually see from any given viewpoint (see

Figure 6.1: A dog by Amy, aged 4 years 5 months. Although we see a frontal view of the face the body seems to have been turned over to give us a view of its underside.

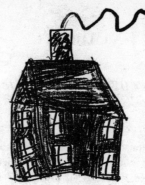

Figure 6.2: The sides of these houses seem to have been folded out and laid flat on the page.

Figure 6.3: Horse and cart drawn by Simonne, aged 7 years 7 months. We have a side-view of the horse but an aerial view of the cart; the occupants seem to be lying down.

Figure 6.4: *Playing Checkers* by a boy aged 7 years.

Figure 6.2, and Figure 2.8 in Chapter 2); it is as if the surface of the house or the cube has been spread out flat on the table. Furthermore, each face is shown as a square or an oblong.

We also get the impression of a mixture of viewpoints when a number of objects are drawn together as part of a scene. In Figure 6.3 we see a side view of the horse, but the cart itself is shown from above and its two wheels have been splayed out on either side; the driver and the passengers have been tipped back so that they seem to be lying down.

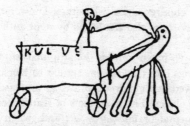

Figure 6.5: In this figure by a child aged 6 years 5 months both the horse and the cart have been drawn from the side.

In *Playing Checkers* the chairs are seen in profile, the people are facing us even though their involvement in the game is indicated by an arm extended to the board, and the checkerboard itself has been up-ended instead of lying flat on the table (see Figure 6.4).

These jumbled viewpoints seem odd because they do not conform to the way that we think single objects or whole scenes should be drawn, that is from one *particular* viewpoint. Even though the drawing in Figure 6.5 (Eng, 1954) is still very childish, the orientation of the horse and cart seems more natural and acceptable.

DRAWING WHAT YOU KNOW

So, why is it that young children draw different parts of the same object or different objects in a scene in a jumbled fashion, showing us an overall view which would actually be impossible to see? Corrado Ricci (1887) put forward the idea that the drawings children produce are not an attempt to show the actual appearance of objects but are expressions of the children's knowledge about them. Slightly later Georg Kerschensteiner (1905) developed this idea further, arguing that children include in their drawings the features which are central to their concept of a particular class of objects. Because they are intent on displaying this knowledge they pay little attention to how a model actually looks. In fact, if a model is presented, children appear to ignore its individual details and its particular orientation and simply draw their usual schema or formula for that kind of object. Their concepts and not the actual objects, argued Kerschensteiner, are their models. Although he appreciated that young children will be hampered to some extent by a lack of skill and therefore will not be able to express everything they want to, he maintained that 'children draw what they know rather than what they see', a famous axiom also attributed by some authors to Georges-Henri Luquet.

Luquet's theory, based on his longitudinal study of his own daughter's drawings (1913), was very similar to Kerschensteiner's in that he also believed that children's drawings are based on their idea or concept of the object. The main facts or features of the object are contained in a mental or *internal model* and, when asked to draw something, it is the internal model that children draw from. This explains why a particular child's drawings of, say, the human figure,

look very similar to each other but not very much like the actual models. In the picture of her family (see Figure 4.10 in Chapter 4), drawn when she was 5 years 2 months, Amy used the same basic schema for all three figures, with no concession at all to the individuality of each person.

Luquet maintained that the internal model contains information which is *central* to the child's idea of the object. For a very young child the internal model of a person's face, for instance, is likely to have two eyes, a nose and a mouth. These central facts about a face define it for him. If he is asked to draw a person who happens to be in profile, after a cursory glance in the model's direction he will most probably draw his usual full-frontal figure, including two eyes, a nose and a mouth. It is the internal model and not the actual model that has guided the child's drawing.

Subject's Age	Imagined Cup	Copied Cup
5 years		
5 years 5 months		
6 years		
6 years 2 months		
7 years 4 months		
7 years 5 months		
8 years		
8 years 6 months		

Figure 6.6: Nearly all children include a handle on their cup when they draw from imagination. When they copy a cup whose handle is out of sight most children below the age of 8 years add the handle.

This idea was also supported by Norman Freeman (Freeman and Janikoun, 1972), who asked some 5- to 9-year-olds to draw a cup from imagination; all the cups in their drawings had handles. Then the children were shown a real cup with its handle turned away from them and they were asked to draw it; those below the age of 8 years tended to include the handle in their drawings, whereas the older ones were more inclined to leave it out (see Figure 6.6). This particular cup had a flower painted on the front and the older children included a flower in their drawings but, interestingly, the younger children did not.

The fact that the younger children included the handle in their drawings of the cup even though they couldn't see it and that they omitted the flower which was directly in front of them clearly is evidence in support of Luquet's idea. It shows that children are inclined to draw from their internal model which contains central, defining facts about the object – in the case of a cup, the handle is clearly one of these. The flower is not a central fact about a cup – some cups have them and some don't – and its omission from the young children's drawings indicates that either they weren't attending to the real model or, if they were, that they didn't feel it necessary to include this optional feature. This kind of drawing, in which the defining features of an object are presented and ensure that the object is clearly recognizable, is sometimes referred to as a *canonical* view. Other researchers have used the term *array-specific* or *object-centred* because this kind of picture emphasizes the facts about an object; the contrasting terms *view-specific* and *viewer-centred* may be used to describe a more realistic picture which has been drawn from a particular viewpoint.

Many objects are drawn in a typical or canonical way so as to show their important and defining characteristics. Up to the age of about 7 years almost all children, at least in Western societies, draw the human figure from the front; after that, there is an increasing tendency to draw a profile figure, particularly if the figure is in motion. At first the basic human schema – in an upright and frontal posture – may also be used to depict animals (see Chapter 4). Defining animal characteristics like a tail and pointed ears may be added. Later, the bodies of animals are laid horizontally on the page; it may take some time, however, to re-orientate the facial features and to place all the legs below the body (see Figure 4.27 in Chapter 4). Eventually, a distinction is made between those animals with

flatter heads, such as cats, and those with longer, pointed heads, such as horses – cats are usually drawn full-face whereas horses are drawn in profile (see Figure 6.7). Houses are normally drawn from the front but motorized vehicles are depicted from the side (Ives, 1980; Ives and Houseworth, 1980; Ives and Rovet, 1982).

This idea of the drawing being informed by the child's knowledge prompted Luquet to refer to this drawing stage as *intellectual realism*. It occurs roughly between the ages of 4 or 5 to 9 years. Of course, it does not mean that the child necessarily puts into the drawing *everything* he knows. Four-year-olds, for example, know a good deal about the human body; they can name and point to many different body parts. Yet, in their drawings they frequently omit some of these parts, typically the arms, hands and feet, neck, ears, and so on. Kerschensteiner (1905) recognized that the child might be prevented from drawing all he knows because of his lack of drawing

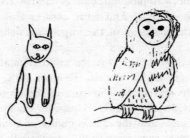

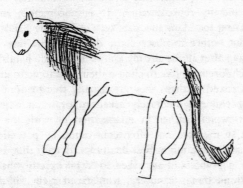

Figure 6.7: Animals with pointed heads tend to be drawn in profile, whereas those with flatter heads are drawn full-face.

skill. But there are also a number of other reasons. One is that the child may actually intend to add more parts, but fails to recall them all. Another is that he may intend to draw more parts, but gets the order wrong so that there is no room to include them all; if the legs are drawn immediately after the head, for instance, there will be no room for the torso. A further reason is that the child simply may not intend to put in all the body parts he knows; if he has devised an adequate and recognizable schema to denote the human figure, he may see no need to include every body part. As my daughter said on one occasion, 'That's how *I* draw people.'

A CONFLICT OF VIEWS

What seems to be going on is that young children are more concerned with depicting what an object *is* rather than how it happens to look. They want to draw something that is clearly recognizable as a person, a dog, or a table. And what ensures that the drawing is recognizable is the inclusion of the important, defining features of the object.

It does not follow though that the child is *totally* unconcerned with the appearance of his models. To start with, his choice of a certain schema to represent all or part of the object may well be related to the way the object looks. Hands, for example, both *are* and *look* like flattish areas and the child's choice of a circular region to depict the hand owes something to the *visual* similarity between the real hand and its representation. It is not merely an arbitrary symbol. Having found an adequate way of drawing hands, the child may well not bother to observe the details of the next pair he is asked to draw; after all, he already knows 'how to do hands'.

Usually children are free to choose their own topic to draw, or if a topic is suggested to them they are usually free to draw it as they like. Young children are rarely asked to draw an object from a particular viewpoint either in imagination or with the help of a model, and so they are not often confronted by potential conflicts about how something might best be drawn. Even if they are shown a real person in profile and are asked to 'draw exactly what you see', they may think that a canonical front-faced view will fit the bill nicely; after all, what they see is a person and the canonical view is how they normally draw people. In other words, the orientation of

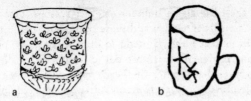

Figure 6.8: An adult's drawing of a cup with its handle turned out of sight
(a) and Amy's drawing from the same viewpoint (b). She said, 'I can't
see the handle, but I'm going to draw it anyway. It makes it look better.'

this particular figure may not be noticed; few children have had
practice at drawing real models from different angles.

Luquet himself, however, as Alan Costall has recently been at
pains to point out (1989), reckoned that at least by the age of 6 years
children do sometimes recognize that there is a problem regarding
how something should be drawn. I asked my daughter Amy, when
she was 4 years 11 months, to draw a cup, but I placed the cup so
that its handle was turned out of sight. Amy drew the bowl of the
cup, looked at the drawing, then at the cup, and then drew in the
handle on her picture (see Figure 6.8). She said, 'I can't *see* the
handle, but I'm going to draw it anyway. It makes it look better.'

Obviously Amy knew that she couldn't see the handle, but when
she added a handle to her drawing of the cup what did she mean by
'It makes it look better'? I suspect that without the handle the cup
did not look like a cup and could be mistaken for something else.
The handle is likely to be one of the central defining features of a
cup and it must be very compelling to put it in. Although she opted
for the canonical view, Amy appeared to be weighing up the problem
before deciding to draw in the handle; even then, she didn't seem to
be completely satisfied with the solution and felt the need to explain
why she had put the handle in. So, although young children may opt
for the canonical view – or *intellectual realism*, to use Luquet's term
– they are not totally unaware of the actual appearance of the object
– *visual realism*.

LOOKING AT THE MODEL

Sometimes children seem aware of the conflict between these differ-
ent ways of drawing and will attempt a more realistic depiction,

Figure 6.9: Alyson Davis asked children to draw a pair of cups, one with its handle turned out of sight (a) and the other with its handle visible (b).

especially when there is something so striking or relevant about an object that they feel it has to be included in the drawing. When Lena Partridge (1902) asked a group of them to draw a person who had on a feathered hat and some rather gaudy rings, many included these accoutrements in their drawings even though they weren't part of their usual schemas.

In another study Alyson Davis (1983) asked thirty-two 4- and 5-year-olds to draw some cups. First of all, she asked them to draw a cup with its handle turned out of sight, and she found that twenty-four included the handle in their drawing. The group was then shown a pair of cups, one in its canonical orientation with its handle at the side and the other with its handle turned away (see Figure 6.9), and twenty-one then drew the handle on the canonical cup but omitted it from the other cup.

The reason why the children included the handle in their first drawings, even though they couldn't see it on the real cup, was probably that they didn't realize that the orientation of the cup was important. The obvious thing about the pair of cups was their contrasting orientations and the children had no difficulty in marking this contrast by omitting the handle from the appropriate cup.

Davis also included another group of thirty-two children who were shown the paired cups first and then the single cup with its handle turned away. Twenty-five omitted the handle from the appropriate cup in their first drawing and twenty-four omitted it again when they saw the single cup. Obviously, their attention had been drawn to the difference in orientation of the pair of cups and when they then saw the next cup on its own they were sensitive to its orientation too.

Instead of presenting two cups, in a second experiment with thirty-six children aged between 5 years and 6 years 6 months, Davis presented a cup with its handle turned away and a sugar bowl. Even though the children knew that the cup had a handle and the sugar

bowl didn't, the two actually *looked* very similar, and Davis was interested to know whether they would still leave the handle off the cup. There were twelve children who had included a handle in their drawings of a single cup but had omitted it (from the relevant cup) in the paired cups scene. Seven of these now reintroduced the handle on the cup in this cup-and-bowl scene; the other five omitted the handle but tried to make the two objects distinguishable in other ways, such as by making one larger than the other or putting a rim on the bowl but not on the cup.

The next thing Davis did was to present the bowl and the cup (with its handle out of sight) again to a different group of children of the same age, but to give the bowl a black spot to distinguish it from the cup. This time all the children omitted the handle from the cup in their drawings, but included the spot on the bowl. It was clear which was meant to be the cup and which was meant to be the bowl.

Children usually draw a canonical view if there is no reason to do otherwise; they will also draw this view if they think a realistic view might lead to some doubt about an object's identity. They will, however, attempt to make their drawings more realistic if there is a good reason to do so and if it can be done in an unambiguous way. It is difficult to say at what age they begin to be able to make these modifications to their drawings, and no doubt this will vary enormously from child to child; in the studies I have described, which have tried to provoke this change, it can be seen operating in children as young as 4 years. It is my guess, though, that there is a developmental trend from an earlier, more rigid stage during which the child is unwilling or unable to draw anything other than a canonical view to this later, more flexible stage during which modifications to the canonical form can be elicited. Modifications in children's spontaneous drawings probably come much later still.

THE NAME IS THE THING

One of the main reasons why children often draw the canonical view of an object even if they actually see a different view is that they are concerned to make the drawing look recognizable. They may think, for instance, that a cup will not look like a cup unless you give it a handle. But Marjorie Taylor (Taylor and Bacharach, 1982) has

suggested that researchers may actually bias children towards this response in the instructions they give. She believes that one reason why the young children in Norman Freeman and R. Janikoun's study (1972) may have included the handle in their cup drawings but omitted the flower decoration is that they were asked to draw a cup from imagination to begin with; the canonical view that most of them produced may have influenced what they drew next. Another reason is that the cup was named but the flower was not; the naming of the cup may have suggested to the children that they should make the drawing look like a cup, and that would entail putting in the handle, but the absence of any mention of the flower may have indicated that the inclusion of the flower wasn't important. Taylor and Bacharach didn't test these ideas directly in their own study; however, they did omit the prior drawing from imagination and they refrained from naming any part of the scene. In one of their experiments most of the 5-year-olds included the flower (a non-defining feature), and in a second experiment most children omitted the handle from their cup drawings when it was not visible in the scene. So, Taylor and Bacharach didn't replicate Freeman and Janikoun's findings.

We don't know for sure whether it is the absence of naming the object drawn or the absence of the first drawing (from imagination) which was responsible for Taylor and Bacharach's more realistic drawings. There is, however, another study which, as well as omitting the prior drawing, has tried to assess the effect of naming the object. When Gavin Bremner and Susannah Moore (1984) asked twenty-eight 6-year-olds to draw a coffee mug with its handle already out of sight they didn't allow any prior inspection of the mug, so the children never actually saw the handle. Half of them were asked to name the object only *after* they had drawn it; the other half were asked to name the object *before* they drew it. Nearly all the children (thirteen out of fourteen) in the first group omitted the handle from their drawings, but only two in the second group omitted the handle. Naming the object before it was drawn therefore led to an inclusion of the hidden handle, whereas the absence of naming led to a more realistic picture.

You might argue that the children in the first group omitted the handle because they didn't know that it was there or because they thought the object was a pot or a vase. These are unlikely explanations, though, when we know that nearly all of them did identify the

object correctly as a mug whether they named it before or after they did the drawings. Although we don't know this for certain, we suppose that the children assumed the handle really was there even though it was not visible.

It is possible, then, that when researchers name an object for the young child it conjures up or suggests to him a *canonical* view of this object, which he then depicts in his drawing. On the other hand, when the object is not named it seems that he is less likely to draw the canonical view and more likely to draw a more realistic picture.

OTHER TIMES, OTHER CULTURES

It is tempting to believe that there has been a historical progression in the way we depict objects – from an early, primitive stage during which viewpoints were mixed to a later and more sophisticated stage in which a single viewpoint is adopted. We can find examples of peculiar or jumbled viewpoints in the art of earlier ages and in other so-called primitive cultures. We have examples of fold-out drawings

Figure 6.10: This stylized bear, produced by the Tsimshian Indians of British Columbia, is an example of a split drawing. The bear seems to have been split along its back and then flattened on to the page.

Figure 6.11: Figures in the sepulchral chamber of Seti I, XIX dynasty, at Karnak. The eyes of these profile figures have been drawn from a front view.

of animals, rather reminiscent of young children's pictures, in which all the important body parts are shown. The stylized bear seen in Figure 6.10, produced by the Tsimshian Indians of British Columbia, is symmetrical about the vertical axis; it is as if the bearskin has been split along its back and then folded out flat. There are other examples of this fold-out style found in the art and rock paintings in the Sahara, in Siberia and in New Zealand. It is well known that the artists in Ancient Egypt depicted human heads in profile but drew the eyes from the front (see Figure 6.11). When children begin to draw their figures in profile, they too frequently draw a front-view of the eyes (see Figure 6.12).

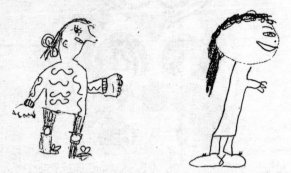

Figure 6.12: When children first begin to draw profile figures, they often draw the eye from a front view.

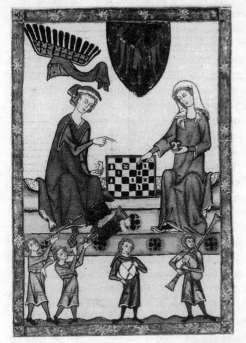

Figure 6.13: Margrave Otto IV of Brandenburg plays chess with a lady, c. 1310–40. The chessboard has been upended so that we can see the position of the pieces clearly.

Figure 6.14: 'It's the way they draw these wretched tables!' This modern cartoon captures a potential practical problem suggested by the mediaeval depiction of flat surfaces.

There are numerous examples in early mediaeval art of tables up-ended in the same fashion as the one in Figure 6.4 drawn by a 7-year-old boy. In Figure 6.13 Margrave Otto IV of Brandenburg plays chess with a lady. A modern interpretation of these depictions is nicely captured in the cartoon in Figure 6.14. As well as giving us a clear idea of what the object is, another advantage of the mediaeval artist's orientation of the table is that it provides a larger surface area for all the things to be displayed on; the objects can be spread out without much masking of one by another.

We might be tempted to think that this historical progression has gone hand-in-hand with a progression in human kind's intellectual development – the idea being that we today must be more cognitively advanced than the 'primitive' cultures both past and present. We make comparisons between the art work of these cultures and the work of children and, seeing similarities, jump to the conclusion that their pictures are the childish productions of childish minds. But is it really the case that there has been such a smooth change over historical time? The evidence in fact does not fit neatly, as Margaret Hagen (1985, 1986) has demonstrated. The extraordinarily realistic pictures of bison and reindeer found in the caves of Altamira and Lascaux were painted at least 15,000 years ago by very 'primitive'

Figure 6.15: Bison from the cave of Altamira, Spain. The cave paintings of so-called primitive peoples are extraordinarily realistic.

Figure 6.16: A Greek vase, *c*. 540 B.C. Because the whole scene is depicted from the side it is difficult for us to identify the particular board game that is being played.

peoples; the animals are seen in profile with the nearer legs partly occluding those on the far side; the artist has adopted a particular viewpoint and there is no indication of the fold-out style we see in some other cultures or in some young children's work (see Figure 6.15).

Similarly, on the Greek vase of about 540 B.C. (pictured in Figure 6.16) we see a profile view of Achilles and Ajax playing a board game; there is no attempt to up-end the board as in mediaeval painting or in a young child's drawing. Although it may be more visually 'correct', this sideview of the board makes it very difficult for us to identify the game or to see what's going on.

As these examples show, many cultures in the past have adopted a particular viewpoint when depicting a single object or a whole scene; it is not a recent phenomenon. In contrast, if we take a leap forward into modern times, we see many examples of mixed viewpoints. In the drawing by Van Gogh pictured in Figure 6.17, for instance, the tiles of the floor are drawn from a much higher angle than are the boots. The different views juxtaposed in Picasso's pictures are even more dramatic (see Figure 6.18): the faces of the children combine

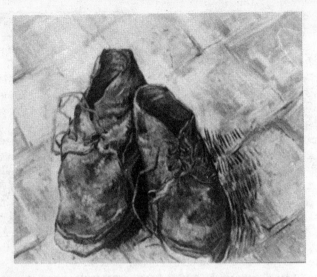

Figure 6.17: *Shoes* by Van Gogh. The artist has adopted two different viewpoints – a higher viewpoint for the tiles and a lower one for the shoes.

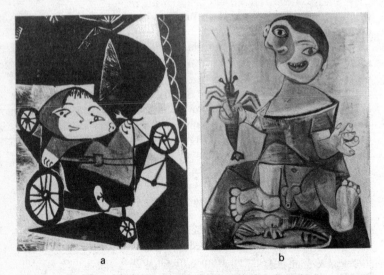

a b

Figure 6.18: *Claude in His Carriage* (a) and *Child and Lobster* (b) by Picasso. These pictures contain a jumble of different viewpoints.

front and profile views, the wheels of the baby's carriage have been separated and are all clearly seen, etc.

Even in our Western culture, therefore, artists in modern times have not stuck to the single viewpoint convention. Nevertheless, even though there has been no straightforward historical progression towards a single viewpoint most of us in Western societies do have a certain idea of how a scene should be depicted. And although we have become more used to seeing discordant views in modern art, most people still regard a picture drawn from one particular viewpoint as a more realistic and perhaps a better picture. The dominance of this system of depiction in Western cultures began at the time of the Italian Renaissance, when artists such as Leonardo da Vinci worked out the mathematical principles of linear or converging perspective – how objects or scenes appear from a particular viewpoint. This system (or a modified version of it) is considered by many to be a truer way of depicting how we actually see things; the invention of photography in the nineteenth century, providing us with pictorial images taken from a single viewpoint, has reinforced this feeling. After at least 500 years of the dominance of this way of drawing pictures, it's perhaps not surprising that the work of artists such as Picasso surprised and shocked so many people.

DRAWING WHAT YOU SEE

Eventually, children do attempt to draw only what they can see. This is relatively easy when all they have to do is to omit a particular feature such as the handle of a cup or to limit themselves only to the number of sides of a cube that they can actually see: by the age of 6

Figure 6.19: A round plate appears as an ellipse when it is tipped away from the observer.

Figure 6.20: Although we know that a cube has square faces, no face of the cube seen in a corner orientation is seen as a square.

they can omit the hidden handle of a cup (Bremner and Moore, 1984) and by the age of 7 they can limit themselves to drawing only the two visible faces of a cube (Cox, 1986). It may be much more difficult, however, to modify the shape of an object or part of an object and to draw, for example, the elliptical shape of a plate tipped away from the viewer (see Figure 6.19) or the trapezoidal shape of a table-top (see Figure 8.25 in Chapter 8). And the putting together of a number of modified shapes into a single object such as the three faces of a cube seen from an oblique angle can be very problematic indeed (see Figure 6.20). Children may simply not realize that in order to effect a realistic depiction they will have to make these kinds of modification of shape; however, even if they have some inkling that modifications are necessary they will most probably not know how to go about effecting them. In his account of the development of visual perspective-taking John Flavell (1974, 1978) has drawn our attention to the fact that children first come to understand *which* objects (or components of objects) a person sees or does not see and that it is only later that they understand *how* these objects are seen (their orientation, their shape, their size, etc.).

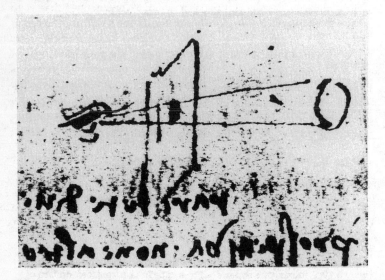

Figure 6.21: This sketch from Leonardo da Vinci's *Notebooks* shows how a three-dimensional object appears on a flat surface.

In order to draw the apparent shape of an object Leonardo da Vinci recommended that artists imagine that they are looking at it through a glass window; by closing one eye they can then trace the outline of the object on to the glass (see Figure 6.21). In fact, I shall describe, in Chapters 10 and 11, how a real 'Leonardo Window' can help artists draw the objects in exactly the way described by Leonardo himself. However, most of us do not have the advantage of this experience and we are usually left on our own to work out the problem of how to make the object 'look right'. We may pick up a few ideas about shading in order to make the object in our picture look more three-dimensional, but we usually carry on having difficulties in drawing the apparent shapes of objects from particular angles of view. And, of course, most of us give up drawing before we master the problems involved.

CONCLUSIONS

Young children, and mediaeval and some modern artists as well as artists in so-called 'primitive' cultures, may share a common aim when they depict objects in their canonical orientation: that is to draw them in such a way that we can clearly see what they are meant to be. The fact that young children generally draw canonical views in their spontaneous pictures, even when this contradicts what they can actually see, is not necessarily due to some cognitive incapacity. They *do* recognize that objects can be seen from different angles and depicted in more realistic ways, but they don't always see the need to do this. After all, to draw an object exactly as one sees it one may have to

Figure 6.22: Guess what this is! Answer: a Mexican hat.

sacrifice some of its critical and defining features, thereby rendering it less easily recognizable, or even ambiguous. Some quizzes in children's comics capitalize on this, the well-known Mexican hat sketch being a good example (see Figure 6.22). One of the crucial features of a Mexican hat – its tall steeple – cannot be shown from this bird's-eye viewpoint; this drawing could just as well represent a fried egg on a plate.

A number of studies have shown that in some circumstances drawers at least as young as 4 years will modify their schemas in an attempt to draw what they see. It would be misleading, then, to

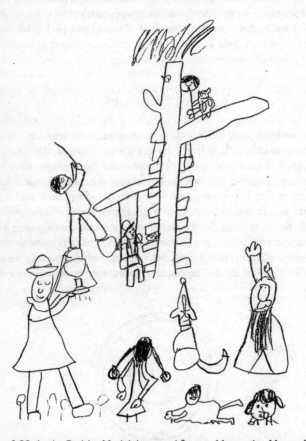

Figure 6.23: *In the Park* by Madeleine, aged 6 years 11 months. Many of the figures and objects have been depicted from unusual viewpoints.

describe children's development as an abrupt stage-like progression from *intellectual realism* to what Luquet called *visual realism*; it is more like a shift in emphasis from one kind of depiction to another depending on what children consider is important.

We know that eventually children want to draw more realistic pictures and that if they are presented with a model, they will attempt to draw what they see even though they may not be very successful. In fact, they may feel quite frustrated that they haven't succeeded in capturing the way it looks. This shift towards visual realism occurs for most children around the age of 8 to 9 years. It is quite unusual to see a spontaneous drawing depicting a particular viewpoint by a child as young as 6 or 7 years, but in Madeleine's picture of the park (see Figure 6.23) we do have the experience of being an observer looking into the scene; one figure on the climbing frame is partly hidden from view, we have a frontal view of the watering can and we can see the backview of the figures in the foreground – note the dog looking up.

It is not clear why many children should become dissatisfied with their efforts. One explanation is that pressure and criticism from others makes them more self-critical and heralds a desire for change. Personally, I doubt that this is so. In this society at least we don't take the acquisition of drawing skills seriously enough to expect and insist on a great deal of improvement from the child. It is my view that change comes mainly from the child himself: he becomes aware of the inadequacy of his own drawings as far as capturing the likeness of real objects is concerned, and may also become sensitive to the mismatch between his own drawings and those he sees around him – on posters, in magazines, and so on. It is at this point that he will need specific instruction, as Georg Kerschensteiner noted in 1905 and Earl Barnes before him in 1892.

CHAPTER 7

Objects Inside or Behind Other Objects

When we look at a scene we very rarely find that the objects in it are neatly spaced out and separate from one another; typically, one object will be inside another, this one will be partly hidden by that one, yet another will be on and partly overlapping the one beneath it, and so on. In fact, our visual world is full of partly seen objects which appear to blend into each other. If we want to draw a scene in a realistic way, we often have to miss out all or part of a contour because the object it represents is hidden from our view by other objects nearer to us. Instead of drawing a set of complete contours, we compose our picture with part-contours which nonetheless have to be fitted together in such a way that they will evoke the idea of a set of complete objects (see Figure 7.1).

How do children deal with the problem of putting objects together on the page in various spatial relationships? First of all, I shall

Figure 7.1: An untrained adult's still-life drawing.

discuss the way that children draw *partially occluded* objects; later, I shall consider the way that they deal with objects which are *totally occluded* in the scene.

PARTIAL OCCLUSION

Sometimes we can see only part of an object because there is another one in front of it in our line of vision, and by moving to a different position, we may well get an uninterrupted view of it. In this case there is no *structural* integration of the objects in the scene itself; it is simply our particular viewpoint which creates the occlusion. An object may also be partially occluded because both it and its occluder *are* structurally integrated in some way; one may be partly *inside*, *on*, or *through* the other. In this case the spatial relationship of the two objects is independent of our viewpoint: if we move to another position, the structurally integrated relationship between the objects still holds. I shall consider these two kinds of partial occlusion separately.

Structurally integrated scenes

In one of the earliest studies of children's drawings, Corrado Ricci (1887) noticed some *transparencies* (also called *see-through* or *X-ray* drawings) in children's spontaneous pictures: we can see the legs and bodies of the men through the sides of the boat and both legs of the rider on horseback (see Figure 7.2).

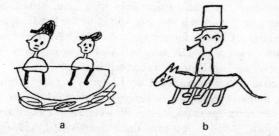

a b

Figure 7.2: In these transparency drawings we can see the legs and bodies of the men in the boat (a) and both legs of the man on horseback (b).

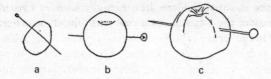

a b c

Figure 7.3: When asked to draw a hatpin through an apple young children draw the whole of the pin (a); later on they omit the middle section of the pin (b); but older children draw the model as they see it (c).

Ten years later, in 1897, A.B. Clark showed children aged between 6 and 16 years a rather unusual model – an apple with a hatpin stuck right through it. Since the two objects in this scene were structurally integrated and not merely placed close together, we might expect that children would try to interrelate them. And, in fact, the youngest of them did produce a typical transparency drawing with the line of the pin drawn right across the enclosed contour of the apple (see Figure 7.3a). It is only at a later age that they began to omit the middle section of the pin and draw its two ends meeting the contour of the apple – the line of the pin had been *partially deleted* (see Figure 7.3b). However, the oldest children noticed that from their angle of view the nearer part of the pin actually overlapped the apple's contour and they drew the scene as they saw it (see Figure 7.3c).

One explanation for these transparencies is that children can't halt their schema for the occluded object – they can't stop the line of the pin going through the contour of the apple. We know from a number of studies, however, that it isn't so and that in some circumstances children can and do halt their schemas; they are not forced to draw the whole figure once they have started. Some as young as 4 or 5 years, for instance, can omit the handle from a cup (see Chapter 6) if this feature can't be seen from their particular viewpoint. That they can also halt their schema for a partially occluded object I shall go on to demonstrate.

A second explanation, based on Luquet's notion of intellectual realism, is that children are *deliberately* showing what they know of the scene – that, for example, the pin went all the way through the apple. Again, I shall demonstrate that although what the child knows about a scene is important she doesn't always intend to draw what she knows.

Evidence in support of this has been provided by Charles Crook (1985): he suggests that it is the way that the child describes the scene to herself that influences how she arranges the objects in the drawing and, in some cases, that leads her inadvertently to produce a transparency. According to him, since the child saw the pin pierce the apple from one side through to the other, she may have described the scene to herself as 'a pin going through an apple' and then repeated this action in the drawing by placing her pencil outside the outline of the apple and drawing it 'through' the outline and out at the other side. When Crook repeated Clark's task with a group of 5-year-olds, piercing a ball with a stick (see Figure 7.4), he also found quite a high proportion of transparencies – 63 per cent of the drawings. However, when he pierced the ball with *two* sticks which made contact in the middle, the transparencies were reduced to 20 per cent; most children drew two lines and not one and, furthermore, began each line at the contour of the ball and moved out. When one half of a single stick was coloured differently from the other half, there were no transparencies produced at all because, in spite of the fact that there was only one stick piercing the ball, its distinctive parts were conceptualized as two components.

Although the models presented by Clark and by Crook are rather unusual, their findings can tell us quite a lot, namely that children sometimes, but not always, draw transparencies when depicting scenes in which two items are structurally integrated. However, they

Model structure	Transparency drawing (%)
	63
	20
	0

Figure 7.4: Five-year-olds tend to draw transparencies if a stick goes all the way through a ball, but transparency drawings are much reduced if there are two sticks which touch inside, and are reduced to zero if the two halves of a single stick are painted different colours.

don't *always* draw everything they know to be there and produce a transparency. When one *is* produced it may be the result of the way the child has described the scene to herself which, in turn, has been informed by her knowledge of the scene's structure; the transparency may not have been intentional at all.

We know, then, that children can halt their schema for drawing a single object (a cup, for example), and Charles Crook has also shown that children as young as 5 years can halt their schema of one object and join up its contour to that of another, occluding, object. Even quite young children are not necessarily intent on drawing everything that is there but not visible in the scene.

As children's drawings are guided by their description of the scene they are attempting to depict, it should be possible to predict the kinds of scenes which are more likely to result in a transparency

Figure 7.5: *Paul as Harlequin* by Picasso.

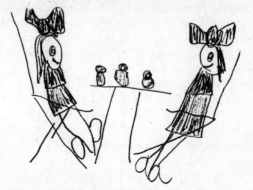

Figure 7.6: *The Tea-Party* by Victoria, aged 6 years 3 months. A transparency results because the chairs were drawn before the seated figures.

and those which are not. Let us take the example of a person sitting down; there are many occasions when children want to draw someone sitting on a chair. When we think about the structure of such a scene, we tend to think of the chair first and then of the person on it. If we follow this order in the drawing, we will draw the chair first and when we place the figure on it, a transparency may result. It takes a considerable amount of pre-planning for an adult, let alone a child, to anticipate which parts of the final scene will be hidden and therefore which contours must be deleted. Most adults draw the seated figure first and then fit the chair around it (see Figure 7.5). They abandon the order in the 'logical' structural description in favour of a drawing rule: 'occluder first and then the occluded'; young children, in contrast, often follow the structural description of the scene. In Figure 7.6 Victoria, aged 6 years 3 months, drew the chairs first and then the seated figures. Amy, aged 9 years, was aware of the transparency problem when she drew her seated figure and was careful to avoid a transparency where the back edge of the seat meets the figure, but she forgot about the front edge of the seat and this goes through the figure's legs (see Figure 7.7). Sometimes children solve the problem by drawing a side-view of the chair (see Figures 7.8a and b). Transparencies can also occur in their drawings of clothed people (see Chapter 4): if they follow the structural description they may draw the figure first and then put clothes on it.

Figure 7.7: Amy, aged 9 years, has deleted the contour at the back of the seat but forgotten to delete the front edge.

Figure 7.8: By drawing their chairs in profile Victoria (a), aged 4 years 5 months, and Amy (b), 7 years 2 months, have avoided producing transparencies.

When the order in the structural description and the drawing rule are the same it should be easier for the child partially to delete the occluded object. For example, with the scene, encountered before, of a hatpin stuck right through an apple, we think of the apple first and then of the pin piercing it, and this is also the order in which the two items are drawn. With this kind of scene transparencies should be avoided earlier than with those scenes in which the drawing rule order is the reverse of the structural description order, as is the case for the scene of a person sitting on a chair mentioned above. My ideas are speculative because, to date, I know of no study which has systematically compared scenes in which the order in the 'logical' structural description and in the drawing rule do or do not correspond.

It is difficult even for many adults to plan which part of a scene to draw first and which to leave until later. However, they may find it easier if they have a model than if they have to work from imagination. Without a model children may not know or may not even consider how each item will appear from a particular viewpoint. Ricci's examples (see Figure 7.2), which presumably were drawn without a model, may therefore reflect the fact that the child didn't think about which aspects of the scene would or would not be visible

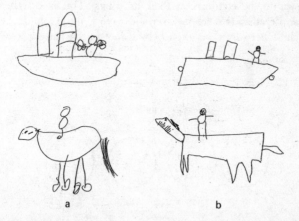

a b

Figure 7.9: After a discussion about what parts of the models he could *not* see, Alex, aged 5 years 3 months, omitted the legs of the man in the boat and one of the legs of the horse-rider (a); Darren, aged 5 years 6 months, had no such discussion and drew the whole man in both cases (b).

from the artist's viewpoint. If she had had access to a real model, she might have attempted to draw more realistic pictures. We know, however, that young drawers often don't examine a model very carefully even if one is provided and they may simply draw their usual schema unless they have a good reason to modify it. In an attempt to elicit more realistic drawings, Richard Jolley and I (unpublished data) presented a group of 4- to 9-year-olds with the models of a man in a boat and a man on horseback (see Figure 7.9). We talked about the models to half the children, asking them which parts of the man could be seen and which parts were hidden; the other half didn't have this additional discussion. It turned out that, compared with those who had had no discussion regarding the appearance of the models, far more children in the discussion group drew realistic pictures. We found this to be true particularly among the 4- to 7-year-olds; the 8- to 9-year-olds drew realistic pictures even without the discussion.

One object behind another

In some scenes an occluded object is not structurally integrated with its occluder but is simply placed behind it from the observer's viewpoint. Since the two objects are quite separate we might expect that children will separate the contours in their drawings. This is exactly what Norman Freeman (Freeman, Eiser and Sayers, 1977) found when he asked children to draw one apple behind another. He had expected that

Figure 7.10: When asked to draw one ball behind another, children below the age of 5 years draw the balls side by side (a); up to the age of 7 or 8 years they place the two balls vertically on the page (b); above the age of 8 they partially delete the contour of the further ball (c).

slightly older children, however, would try to integrate the two contours in some way in order to represent the visual blending of the two objects. Interestingly, rather few did so until the age of about 8 years. Freeman's results may have been influenced by the absence of a model in that the younger children may not have known exactly what kind of arrangement they were being asked to draw. Nevertheless, I found the same pattern of responses when I showed a group of children the model of a ball behind another ball, for example (1978, 1981). Below the age of about 5 years they placed the two objects side by side; from 5 to about 7 or 8 years they placed them one above the other; and from 8 years onwards they began to draw only the part of the occluded object that they could see and combined it with the contour of the nearer object (see Figure 7.10).

Figure 7.11: Very young children understand that the 'unattached' heads of the characters in their picture books indicate that they are hiding or peeping out.

It is not that children below about 8 years don't understand what a partial deletion in a drawing is meant to indicate. Even very tiny children interpret an 'unattached' head in their picture books as someone 'hiding behind a tree' or 'peeping round a corner' (see Figure 7.11). Margaret Hagen (1976) has found that 3-year-olds can

Figure 7.12: When asked to draw a scene in which a robber hides behind a wall, even many 4-year-olds attempt to draw only that part of the robber which they can see (a, b and c). A few children draw the whole robber above (d) or to the side of the wall (e).

match a picture showing one figure partially deleted by another with a scene in which one figure is behind another.

Since very young children often interpret partially deleted figures as people 'hiding' or 'peeping out', I wondered if they would draw a partially deleted figure themselves if presented with a scene of this kind. I told a group aged between 4 and 10 years a story about a robber who was being pursued by a policeman; the story was acted out with Lego characters (1981). The robber ran to hide behind a wall but the policeman knew where he was because he could see the top of his head poking up above it. The children were asked to draw what the policeman could see, a view which corresponded to their own. Most of the 6- to 10-year-olds and nearly half the 4-year-olds halted their schema of a man and drew only part of the robber (see Figures 7.12a, b and c). Those younger ones who didn't draw the scene in a realistic way drew the complete figure, mostly placing it above or to the side of the outline of the wall (see Figures 7.12d and e); very few drew the figure overlapping the outline of the wall.

Many children, especially the younger ones, drew the robber's whole face instead of restricting themselves to the topmost part of

Figure 7.13: Children may draw the top of the robber's head in various ways and position it differently in relation to the wall. They may draw a closed semi-circle and place it on, or slightly above, the wall (a and b) or to the side (c), or just draw a semi-circle and place it above the wall (d). It isn't until 8 years that they attach the semi-circle to the contour of the wall (e).

the head which was actually visible, probably because they had looked at the scene and encoded it as 'the head behind the wall'. Now, the children had a schema for the head and all they had to do in order to make the picture look realistic was to draw it on top of the wall; thus, the two main elements in the drawing – the man's head and the wall – didn't really have to be integrated but merely brought into contact. Nevertheless, some children separated the head and the wall because the two were actually separate in the scene, thereby producing pictures in which the head seemed to be floating above the wall.

In order to draw the top of the head, for which they had no readily available schema, they would have had to look carefully at the scene and draw the outline of the head but curtail it where the top edge of the wall blocked their view of the figure. Some children closed off the bottom of the shape to form a semi-circle; this was sometimes placed on the wall, slightly above it or, in a few cases, to the side (see Figures 7.13a, b and c). Other children drew the half-hoop outline of the head but, again, placed it 'in the air' above the wall (see Figure 7.13d). It was not until the age of about 8 years that children began to attach the half-hoop outline to the contour of the occluding object at what John Willats (1977) calls 'junctions' (see Figure 7.13e).

I was interested to know what it was about this 'cops and robbers' task which had enabled quite young children to attempt a more realistic drawing. I went on to discover that it was not necessary to present the task as a game or even to mention that the man was hiding (1985). Simply placing a man behind a wall reliably elicited partial deletions.

I wondered if any object behind a wall would elicit the same responses and if anything behind a ball would not, so I carried out a study in which a series of pairs of objects were presented one behind the other – ranging from pairs of very similar objects to pairs of very different ones (1991). I found that, at least for children between the ages of 6 and 8 years, the more dissimilar the objects the more likely they were to draw them partially deleted; the more similar the objects (e.g. a ball behind a ball) the more likely they were to separate them on the page.

So far we have no definite explanation for this phenomenon, although we have been able to rule out two possibilities. First of all, we know that the problem is *not* to do with a lack of basic drawing

Age	a	b	c	d	e	f	N
5	81	5	5	4	1	4	78
6	91	0	4	2	1.5	1.5	82
7	92	1.5	4	2.5	0	0	91

Figure 7.14: Most children as young as 5 years have the basic drawing skill to draw one ball partially masking another. The numbers in each column refer to the percentage of children who drew the figure given above. 'N' is the total number of children at each age.

skill. When I showed a group of children a scene in which there was a ball behind another ball and asked them to select a picture from a ready-made set to match it, they picked one in which the balls were separate on the page (1981). However, when I asked another group between the ages of 5 and 7 years to copy the line drawing in Figure 7.14, the vast majority was able to do so successfully (1985). We know then that children *can* draw the required configuration but that for some reason they choose not to do so.

A second reason why children might not use partial deletion to represent one object masked by another similar object is the way that they describe the scene to themselves. If, for example, they describe it as 'one ball and then another one behind it', they may simply repeat their circle schema on the page, placing the second circle higher up (to indicate that it is 'behind'), and may not look carefully at the scene itself to see that, in fact, only part of the further ball is visible. Earlier in this chapter I mentioned how a discussion on the appearance of the models of a man on horseback and of a man in a boat had elicited realistic pictures of them. Martin Nieland and I (unpublished data) tried out a similar procedure by asking some 5- to 8-year-olds to look carefully at the ball-behind-ball scene and to point out which parts of the further ball they could and could not see. For one group this discussion took place before they started to draw; for a second group it took place after they had drawn the first, nearer ball; a third group had no such discussion but was simply asked to draw the scene. It turned out that the discussions had no effect: the younger children drew two separate and complete circles

whereas the older ones produced partial deletions. We still have no clear explanation of this puzzling phenomenon.

TOTAL OCCLUSION

Sometimes children draw objects or parts of objects which cannot normally be seen, either because they are completely enclosed and occluded, or because they are hidden behind another object and occluded. For instance, to include in a drawing of a person (or an animal) the contents of the stomach involves depicting what is essentially a relationship of total enclosure (see Figure 7.15). Unlike the handle on a cup (see Chapter 6) the stomach contents are neither a defining feature of the human (or animal) figure nor one of the usual schemas children use to depict it. If they do choose to include the stomach contents, however, these can be drawn within the outline of the enclosing figure without altering it at all (unless perhaps to make it bigger) and the contours of the enclosing and of the enclosed parts do not need to cross each other. It seems highly unlikely, then, that normally hidden features are drawn accidentally or that they are a by-product of some other process or tendency; on the contrary, their inclusion must surely be intentional. Sometimes we also see the same kinds of transparencies in adult art (see Figure 7.16).

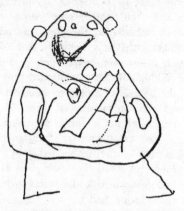

Figure 7.15: In this child's drawing of a gorilla, who has just eaten his dinner, we can see the contents of the gorilla's stomach.

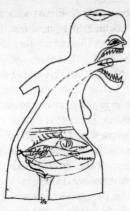

Figure 7.16: *Man-Fish-Man-Eater* by Paul Klee. Sometimes adult artists deliberately produce transparency drawings.

Ann Martin and I (1988) carried out a study to find out whether children omit a hidden feature when there seems to be no good reason to include it in a drawing. We showed ninety-six 5-, 7- and 9-year-olds a pair of black handleless beakers placed side by side on the table. We put a small green cube *inside* one beaker and another green cube *behind* the other beaker; both cubes were totally occluded. The children were then asked to draw the scene on a single piece of paper. Most of them, even the youngest ones, omitted the cubes from their drawings (see Figure 7.17a), as did a group of adults we

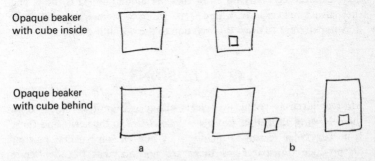

Opaque beaker with cube inside

Opaque beaker with cube behind

a b

Figure 7.17: Children's correct (a) and incorrect (b) drawings of an opaque beaker with a cube placed inside or behind it.

123

tested. Of the minority of children who included them, fifteen included the 'inside' cube and twenty the 'behind' cube. Whereas nearly all the 'inside' cubes (fourteen) were drawn within the outline of the beaker, the 'behind' cubes were more variably drawn: eight were inside the beaker's contour, eleven were beside it and one was above it (see Figure 7.17b). There was much more agreement about the position of the cube in the drawing when it was *inside* the beaker than when it was *behind* it.

These findings suggest that the children were aware of the two different cube–beaker relationships and were grappling with the problem of how to depict them in their drawings. Drawing the cube inside the outline of the beaker is in keeping with the actual enclosure of the cube in the scene; the drawing solution and the facts of the scene are compatible. The 'behind' cube is more problematic. If it is drawn inside the beaker's outline, this risks leading to an erroneous interpretation of its whereabouts; drawing it separate from the beaker at least conforms to the fact that the two objects are separate in the scene. We obtained a similar pattern of results when we used transparent instead of opaque beakers, as did Paul Light (Light and MacIntosh, 1980) when his 6-year-olds were asked to draw a tiny house inside or behind a transparent glass. It is possible to conclude, then, that even when two scenes *look* very similar, children have a tendency to draw a known difference in their spatial organization.

When an object is totally hidden in a scene most children, even as young as 5 years, will omit it from their drawing. There is no uncontrolled desire to include everything 'because it's there'. However, children certainly do know that the hidden object is there, and they also know exactly where it is: those who include it in their drawing attempt to draw it in relation to the occluding object.

CONCLUSIONS

Most children as young as 5 years of age will omit an object from their drawing altogether if it is *totally occluded* in the scene and there is no particular reason to include it. When on some occasions they do produce transparencies these are not mistakes but deliberate depictions akin to cross-sections that show parts of a scene not normally visible. Transparencies also occur when an object is only

partially occluded. Sometimes the child may deliberately draw everything that is there; however, in many cases the transparency is likely to be accidental and a product of the way the child has described the scene to herself. Some scenes, such as those in which the logical structure conflicts with the drawing rule 'occluder first and then the occluded', tend to elicit the accidental transparency treatment more than others.

Whereas transparencies are more common in scenes in which the hidden object and its occluder are *structurally* related – the hidden object is inside, through or under another object – they are rare when the scene to be drawn contains one object *behind* another. In this kind of scene it is the particular viewpoint of the observer which happens to produce the occlusion. When drawing such a scene children will often separate the two objects, drawing the whole contour of the occluded object and placing it above the occluder on the page. However, those as young as 4 or 5 years will modify this strategy in certain circumstances and draw a more realistic picture, if one object is very obviously hidden behind the other or, even, if the two objects have different shapes. Some scenes seem to be particularly resistant to a more realistic treatment, an example being that of two balls which are placed one behind another; it is not until at least the age of 8 years that most children begin to draw such a scene as they see it.

CHAPTER 8

Organizing the Scene

UPRIGHT FIGURES

Children's first drawings often appear somewhat chaotic in that there is no sense of coordination or planning of a unified scene. Each figure may have its own space but it may or may not even be the same way up as its neighbour.

Although the overall scene may not give the impression of being planned there is nevertheless some organization within the figures themselves. As we saw in Chapter 1, very young children have quite a good idea of the spatial arrangement of the eyes, nose and mouth even before they can draw these features for themselves. Since most children begin their human figure drawings with the head and its facial features this part of the drawing can serve as a cue for the orientation of the rest of the figure. The eyes, drawn side by side, form a horizontal axis and the nose and mouth are positioned below these, forming a vertical axis. The body and legs of the figure are drawn next, following on this vertical axis. The arms are attached on a horizontal axis, perpendicular to the body and legs. The resulting figure is upright on the page.

Since children often do not treat everything they draw on the page as part of an overall scene they may well rotate the paper in order to give themselves a new space for the next figure. And this may result in the figures being anchored to the baseline edge of each side in turn as is seen in Figure 8.1 (Eng, 1954).

Now, the fact that the axis of the figure is drawn perpendicularly to one of the edges of the paper may simply be accidental. During the drawing process the child may respond only to the internal cues of the figure itself and, in particular, to the axis suggested by the facial features which he has begun to draw; if the page is rectangular and is placed in alignment with the child's own body axes, the resulting figure will be upright even if he has not considered these external cues.

Figure 8.1: In this drawing by a child aged 3 years 6 months the page has been rotated so that each figure is anchored to a baseline.

This reliance on internal cues may explain the leaning figures which occur from time to time in children's drawings. Jacqueline Goodnow (Goodnow and Friedman, 1972) has suggested that these are the result of an initial slip at the beginning of the figure: if, by accident, the eyes have been drawn on a slant the child simply carries on drawing the figure perpendicularly to that axis and ignores the orientation of the page itself.

Goodnow asked children aged between 3 years 2 months and 6 years 7 months to finish an incomplete drawing – a circle with two eyes placed sideways in it (see Figure 8.2). She found that many of them, particularly the younger ones, drew the figure in alignment with the eyes, with the result that it was not upright on the page (see Figure 8.2a). Many of the older ones, however, redefined the figure in various ways: some drew the body upright but with the face looking to the side (see Figure 8.2b); others altered the meaning of the two eyes in the circle (see Figure 8.2c).

Norman Freeman (1980) also tested children on this kind of task, but he placed the axis of the eyes diagonally to the sides of the page. He found, as Goodnow did, that the younger children, tadpole drawers aged between 3 years 6 months and 4 years 3 months, were

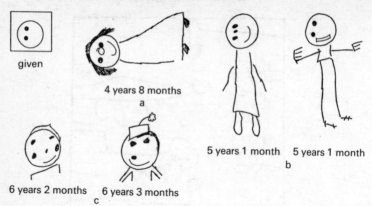

given

4 years 8 months
a

5 years 1 month 5 years 1 month
b

6 years 2 months 6 years 3 months
c

Figure 8.2: When asked to complete a figure with the eyes drawn 'sideways' very young children continue with this alignment (a); older children in contrast adapt the face in various ways so that the figure is upright on the page (b and c).

influenced by the internal cues of the figure and not by the sides of the page at all. This meant that they produced slanted figures.

Freeman had a more elaborate way of measuring the orientation of the figures than did Goodnow and was able to show that although many conventional drawers, aged between 6 years and 7 years 5 months, ended up with an upright figure they had actually started the body of the figure in alignment with the facial features, and, as the drawing progressed, they had swung the body and legs round in order to orientate the figure towards the bottom of the page.

I carried out a study similar to Freeman's (unpublished data) and like him found that the conventional drawers (6 years to 7 years 5 months) took account of the slanted face to begin with, but then began to orientate the figure towards the vertical. Whereas about half the children succeeded in rotating the figure round to the vertical, the other half ended up with a figure that still strikes the observer as slanted (see Figures 8.3 and 8.4). So, it seems that conventional drawers take account of both the internal cues of the figure *and* the external cues of the page, although they may be more or less successful in adapting the figure so that it is upright on the page.

We can conclude, then, that even very young children know how

Figure 8.3: Some children begin the figure in alignment with the diagonally placed eyes but then try to orientate the body to the vertical axis of the page; however, these two have ended up with slanting figures.

Figure 8.4: These two children have been successful in orientating a slanted figure to the vertical axis of the page.

the individual components can be spatially arranged to make a recognizable human figure. Their first figures may be somewhat randomly positioned on the page, but it is not long before most children draw them upright and it is perhaps through this experience that they get the idea that 'up on the page' also means 'up in the air'. Even when they are asked to complete pre-drawn heads which are out of alignment with the page, quite young children – certainly as young as 6 years old – will show considerable ingenuity in adapting their figures in order to make them obey the 'upright on the page' rule. Being able to take account of both the internal cues of the figure and the external cues of the page is really quite sophisticated be-haviour.

THE GROUNDLINE

Children can impose some organization on to their pictures by making use of a *groundline*. They may use one which is ready-made, such as the edge of the page, or one which is only implied, along which the figures are lined up in a row (see Figure 4.10 in Chapter 4), but they will typically draw a groundline in themselves (see Figure 8.5). Helga Eng's niece, Margaret, drew a groundline for the first time when she was almost 4 years 4 months old (1954). In over 5,000 children's drawings J. Wall (1959) found that only 1 per cent of 3-year-olds drew a groundline but by 8 years 96 per cent had drawn one. Children often begin their pictures by setting out both the groundline and the skyline; the action occurs in the space between these two reference points (Hargreaves, Jones and Martin, 1981). The whole drawing then looks much more like a unified scene and not merely like a scattering of separate objects (see picture on front cover).

The groundline is not always straight, nor is it always parallel to the bottom of the page. In Figure 8.6 for instance, the human figure and the flowers are firmly placed on the slopes of a hill; however, they are not upright on the page but perpendicular to the sloping groundline. There are many other examples in children's drawings

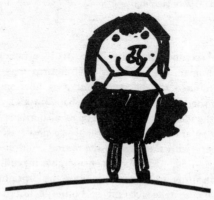

Figure 8.5: Amy, aged 5 years 8 months, has placed her figure firmly on a groundline.

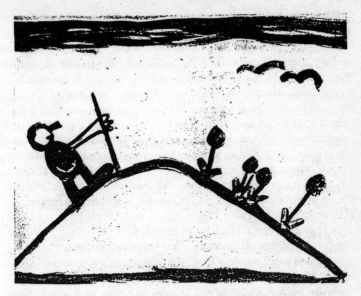

Figure 8.6: In *I am Climbing a Hill*, by a child aged 7 years, the human figure and the flowers have been drawn at right angles instead of vertically on to the sloping hillside.

of objects which are drawn perpendicularly to a baseline that itself is not parallel to the edge of the page. Chimneys, for instance, are frequently drawn on to a pitched roof-line in such a way that they appear to be in danger of toppling over (see Figure 8.7).

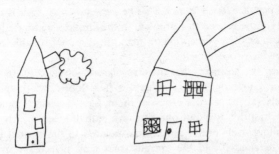

Figure 8.7: Amy, aged 5 years, has drawn the chimneys at right angles to the pitched roofs of her houses.

There are at least three explanations for this *perpendicular error*, although these are not necessarily mutually exclusive. One is that even if they want to children (and even adults) find it very difficult to draw upright figures when the baseline in the drawing is sloping; there seems to be some compelling tendency towards the perpendicular (I shall discuss the phenomenon again in Chapter 9). But, although there is plenty of evidence for a perpendicular bias, I don't believe that on its own it can account for children's errors in their spontaneous drawings. The reason is that, as Charles Crook (1985) has pointed out, in their spontaneous drawings children make very definite perpendicular errors, whereas in the tasks specially designed for research purposes their errors only *tend* towards the perpendicular. In copying an angle of 45 degrees on to an oblique baseline the average child in Andrew Ibbotson and Peter Bryant's study (1976) drew it at 58 degrees. We have to explain why children's *spontaneous* errors are so obviously perpendicular – at 90 degrees to the baseline.

A second explanation is in terms of children's 'real world' knowledge. They know that people, buildings, trees and flowers are normally perpendicular to the ground and they may simply over-generalize this knowledge and apply it to a sloping hillside; they may not step back in imagination to look at the overall scene. I think this explanation is rather improbable when we consider the responses of children in a number of studies where they have been asked to comment on pre-drawn pictures. For example, after they were shown pictures in which the chimney was either vertical or perpendicular to a sloping roof (Moore, 1986b; Perner, Kohlmann and Wimmer, 1984; Cox, unpublished data) even 4-year-olds said that they preferred the vertical chimneys and that the toppling chimneys looked peculiar (see Figure 8.8). The perpendicular error is therefore unlikely to be related to a problem in the children's knowledge about chimneys or their perception of them but is more probably related to the drawing process itself.

It may be, however, that the error is more obvious to the children in some contexts than in others. When John Elliott and Kevin Connolly (1978) asked a group of them, aged 4 years 6 months to 6 years 6 months, to point out, out of a pair of trees, which one was 'just falling over' nearly all of them pointed to the slanted tree; but when the slanted and the upright trees were placed on an oblique baseline, 40 per cent changed their judgement and said that the *upright* tree was the one which was falling.

Figure 8.8: Young children prefer vertical chimneys (a) and even though they draw toppling chimneys themselves they recognize that they look peculiar in other people's drawings (b).

A third explanation for the perpendicular error is that while they are drawing, children simply lose sight of the overall horizontal and vertical dimensions of the page. After they have drawn a pitched roof on to the house they may rotate the paper (either in reality or in imagination) so that the baseline becomes horizontal, and then draw the chimney perpendicularly to it. This process, perhaps coupled with a natural tendency towards the perpendicular, seems to me the most likely explanation for this curious feature in children's drawings.

Some intriguing data discussed by Norman Freeman (1983) show that children do not always make a perpendicular error when drawing verticals on to a slanted baseline; in fact, there seem to be some circumstances in which verticals slant *away* from the perpendicular and produce acute angles. When trees are drawn along the edges of a road which is receding into the distance, they should correctly be placed vertically, at an acute angle with the baseline. If the perpendicular bias were operating, then they would be drawn so that they appear to tip away from the road. And, indeed, Jean Piaget and Bärbel Inhelder (1956) report that this is exactly what happens (see Figure 8.9). In their study the children were asked to draw both the road and the trees and although the road they drew was straight the trees *did* tip away from its edges at a right angle. Freeman and Betts (cited in Freeman, 1983), in contrast, gave their 6-year-olds a converging road and drew in some of the trees alongside it. The

Figure 8.9: Children draw the trees perpendicular to the edges of the road if the edges of the road itself do not appear to converge.

children had to complete the drawing by adding an extra tree; interestingly, they tipped the tree towards the converging end of the road (see Figure 8.10), tilting it in the opposite direction to that predicted by the perpendicular bias.

There is evidence, therefore, that the perpendicular bias does not always operate in children's attempts to represent spatial relationships either in abstract copying tasks (see Chapter 9) or in pictures of real scenes. In Freeman's study it has clearly been masked or overridden. And the reason for this may be that the marked convergence of the sides of the road has encouraged the children to tip the trees in a similar fashion. That the depth of the scene is what is important in overriding the perpendicular error is supported by the fact that this tipping effect was more pronounced in those children who under-stood that the smaller trees were meant to be farther away in the scene.

Figure 8.10: When the edges of the road converge, children tip their trees towards the convergence.

THE AIR GAP

Children often refer to the space between the ground and the sky as 'the air'. David Hargreaves (Hargreaves, Jones and Martin, 1981) asked 6- to 7-year-olds to draw a picture containing a house, a bird and the sun. Typically, a groundline was drawn on which a house was standing; the bird flew in the air gap; the sun was drawn either in the sky or just below it in the air gap (see picture on front cover). Vicky Lewis (1990) has found that these air gap pictures are typically produced by children with an average age of 8 years 7 months.

Parents and teachers often protest that there *is* no gap between the sky and the ground and recommend that the child looks out of the window to confirm for himself the truth of this contention. Of course, when I am outside, if I look into the distance, the blue sky *does* come all the way down to the horizon, yet when I stand in the garden my feet are firmly on the ground and the sky is very definitely 'up there', directly above me; similarly, when indoors, my feet are on the floor and the ceiling is high above my head. Inside or out, nearly all objects *are* located in the air gap between the ground and 'up there'. The difference, then, is between how the scene appears when you look into it as an observer from a particular viewpoint and how it seems when you are acting in it yourself. The young child is not drawing the scene as he sees it from a particular viewpoint (Luquet's visual realism) but according to what he knows about the world (intellectual realism) as an active participant in it.

MULTIPLE GROUNDLINES

Sometimes children use *multiple* groundlines on the same page. In *Fruit Harvest* the artist has divided the scene into two (see Figure 8.11). Although they appear on the same page, these are really two separate scenes and each is delineated by its own ground- and skylines. In contrast, the two groundlines in Figure 8.12 *are* part of the same scene; whether intentional or not they give an effect of depth to the picture. We see the figures on the lower line as nearer to us whereas we see the farm and trees on the upper line as more distant. (Also note that in this picture the sky meets the horizon.)

Although the multiple groundlines solution coincides to some

extent with our visual experience of looking into the distance, there are problems. One is that unless the figures on the upper groundline are smaller than those on the lower we might misinterpret the spatial relationship and think that the upper figures are not further away

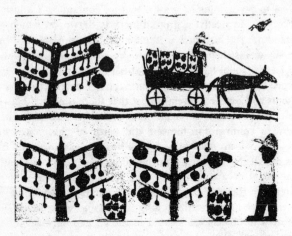

Figure 8.11: In *Fruit Harvest* two scenes, each with its own ground- and skyline, have been placed on the same page.

Figure 8.12: In this farm scene the figures have been arranged along two groundlines: the lower line is nearer and the upper line is at a distance from the observer.

but are simply higher up in the air. Another problem is that objects receding from us into the distance do not normally do so in neatly arranged parallel rows but can be at any angle to each other and to the observer.

FOLDING OVER

There are many occasions when the child is not satisfied with a scene depicted along one or more parallel groundlines. For example, if the figures are moving round in a circle, as they are in many

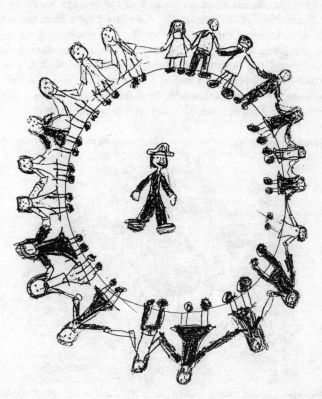

Figure 8.13: *The Farmer's in his Den* by Deborah, aged 9 years. In this example of folding over the figures have been laid out around a circular groundline.

children's games, the character of the game will be lost if the figures are lined up across the page. Deborah, aged 9 years, has drawn a circular groundline and all the figures radiate from it in Busby Berkeley fashion (see Figure 8.13). She has systematically turned the paper in order to draw each figure. Notice that those figures on the right-hand side have been moved further inside the circle, presumably because the circle itself had been drawn too close to the edge of the page.

Folding-over arrangements occur when the child is anxious to preserve the shapes on at least two planes at right angles to each other. If we took an aerial photograph of the scene, we would preserve the circular shape on the ground but lose the frontal view of the figures themselves; conversely, if we stood back from the group, we might preserve the frontal view of some figures but we would lose the circular shape of the group. The folding-over solution preserves all the information about the individual figures *and* the circular formation of the group even though the view as a whole is impossible. The adult artist who drew the scene of the Last Supper (see Figure 8.14) had some difficulty with this same problem.

Figure 8.14: In *The Last Supper* from a Syriac Gospel the artist has not maintained a single viewpoint for the whole scene.

Figure 8.15: In *Trees around a Pond*, by a child aged 7 years 3 months (a), and *Norfolk Ferry*, by a child aged 8 years (b), both children have used the folding-over solution.

There are many other examples of folding over (see Figures 8.15a and b). They occur typically when children draw houses on both sides of a road or river, or trees around a pond. Both the shape of the road, river or pond and the identity of the figures, trees and houses are preserved and, furthermore, so is the spatial relationship of each figure to its groundline. We observers must shift *our* viewpoint in order to work out all the spatial relationships and make sense of the scene.

The folding-over solution is not only confined to children. Figure 8.16 is an example from a tomb in Thebes painted in about 1400 B.C. Note also that the fish and the fowl in the pond are drawn in their canonical orientations (see Chapter 6). Figure 8.17 is another example of an adult's use of folding over in a map of the Shaker village of Alfred, Maine (USA) drawn in 1845 by Brother Joshua Bussell.

As they come to interpret pictures according to the criterion of a

Figure 8.16: Painting of a pond from a tomb in Thebes *c.* 1400 B.C. Note the similarities between this and the child's pond in Figure 8.15 (a).

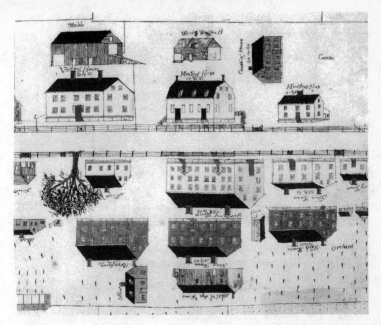

Figure 8.17: A map of the Shaker village of Alfred, Maine (USA) drawn by Brother Joshua Bussell in 1845.

unified viewpoint, children become dissatisfied with the folding-over solution and seek other means for dealing with the spatial depth problem. Whether the adult Egyptian and Shaker artists had a variety of means for dealing with this problem and had actually *chosen* the folding-over solution or not remains an open question.

PARALLEL OBLIQUE PERSPECTIVE

Around the age of 7 years or 7 years 6 months, children make a very useful discovery: a line drawn obliquely to the horizontal axis of the page will suggest depth. It is not long before they are beginning to draw objects such as houses and tables in oblique perspective. The front axis of a house is usually aligned with the horizontal dimension of the page and the side of the house is drawn at an angle;

Figure 8.18: The side of Amy's house has been drawn at an oblique angle to the front and is meant to indicate a change in plane.

the top and bottom edges of this side are drawn parallel to each other. The picture clearly indicates that the side of the house is meant to be in a different plane from the front face (see Figure 8.18).

The parallel oblique form is quite successful in giving the effect of depth. It also has other very clear advantages. A cube drawn in this style not only is identifiable as a three-dimensional object but also displays important and *defining* facts about the object: the front face is square and all the opposite edges in the figure are parallel. Similarly, in the case of a table, not only do we appreciate that the

Figure 8.19: The cube and table, drawn in parallel oblique perspective, give a 3-D impression of the objects even though they are not 'true' visual projections.

Figure 8.20: The identity of objects drawn in converging perspective can sometimes be ambiguous: do the sides of these objects really converge or is it merely a perspective effect?

surface 'cuts into the picture' but we also recognize that its opposite edges are parallel (see Figure 8.19).

As Rudolf Arnheim (1974) has pointed out, parallel oblique perspective depicts three-dimensional objects in a relatively unambiguous way: we have no doubt that the objects represented have rectangular surfaces. By contrast, if we show objects with converging lines, as in Figure 8.20, there is some ambiguity about their edges: do they really converge or is it just a perspective effect?

Children and adults have few if any problems in interpreting the parallel oblique system and it is perhaps not surprising that it is preferred in technical drawings in maths, science, architecture and

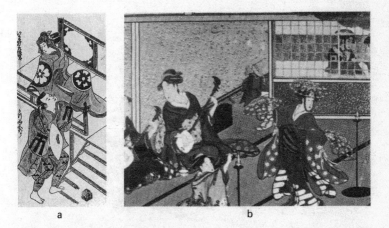

a

b

Figure 8.21: (a) *Scene with Two Actors,* anonymous, in the seventeenth century; (b) *Flower Festival at Yoshimara* by Utamaro (*c.* 1785). Japanese artists generally adopted parallel oblique perspective.

engineering. Margaret Hagen (Hagen and Elliott, 1976) found that most adults actually prefer this kind of drawing to the kind with more dramatically converging depth lines of the linear or converging perspective system. By the age of about 11 or 12 years most children have been taught the parallel oblique form, usually in relation to the cube (Cox, 1986, 1991), and most adults will draw objects like tables and cubes in this form if asked to draw from imagination. Indeed, many of them believe that these oblique views represent how we really do see these objects.

Of course, this system of perspective can be applied to a whole scene as well as to individual objects and it is characteristic of the art of many cultures, notably the Japanese from the seventeenth to the nineteenth century (see Figures 8.21a and b).

CONVERGING PERSPECTIVE

Despite the advantages of the parallel oblique system we tend to think of the linear or converging perspective system as more advanced and truer to the real appearance of the object. Although some of its principles were known long before the Italian Renaissance, it was

Figure 8.22: The perspectograph, sketched by Leonardo da Vinci, enabled the artist to maintain a fixed viewpoint in order to draw the apparent outlines of objects in a scene.

Figure 8.23: Albrecht Dürer's woodcut shows an artist using a Leonardo Window.

not until the fifteenth century that this system was used extensively. Leon Battista Alberti, in 1435, described his method of working as follows: 'First of all, on the surface on which I am going to paint, I draw a rectangle of whatever size I want, which I regard as an open window through which the subject to be painted is to be seen.' Indeed, if the picture surface *is* a window, artists can trace on to its surface everything that they see through it. In Leonardo da Vinci's sketch of a perspectograph the artist keeps a fixed viewpoint by looking through the peep-hole in the board close to him; he reaches round to draw the outlines of the object on to a sheet of glass (see Figure 8.22). Dürer's woodcut (see Figure 8.23) shows more clearly a variation of this device, sometimes called the 'Leonardo Window', and many other similar pieces of apparatus have been designed from time to time to help the artist, as, for example, Van Gogh's 'perspective frame' (see Figures 8.24a and b).

a

b

Figure 8.24: In his letter to his brother, Vincent Van Gogh made a detailed sketch of his perspective device (a) as well as a sketch illustrating its use (b).

146

One of the main characteristics of this method of drawing is that it confines the artist to a single, fixed viewpoint; the whole scene, whether it consists of a single object or of more, is depicted from that viewpoint and thus unified.

Of course, objects are also depicted from a fixed viewpoint in the system of parallel oblique perspective, but in *that* system they are not drawn *exactly* as they appear. When we trace around the contours of the objects we see, as recommended by the Renaissance artists, certain relationships become very obvious. Not only do the more distant objects appear higher up in the visual field than those nearer to us, but they also appear to *decrease in size*. This is also true of the component parts of a single object: the farther edge of a rectangular table, for example, is higher up in the visual field and also appears shorter than the nearer edge (see Figure 8.25); the other two sides of the table tend to converge and would join up at a *vanishing point* were we to continue drawing them in the distance. The table-top no longer appears rectangular but is more like a trapezium. By contrast, in parallel oblique perspective, because the depth lines remain parallel to each other, the size of more distant objects remains the same as that of nearer objects.

The diminution of size with distance acts not only on the front and back edges of the table but also on the nearer and farther parts of the side edges. The farther half of each side appears shorter than the nearer half, even though in reality the two halves are equal in length.

This effect of *foreshortening* is also well illustrated in the view of a train depicted in Figure 8.26b. We have no difficulty in recognizing this picture as that of a train but it is by no means obvious how the drawing has been constructed. The foreshortening renders a very different shape from the typical or canonical view we usually imagine

Figure 8.25: The foreshortened effect of a table drawn in converging perspective.

Figure 8.26: The size and shape of the carriage drawn in full-length view (a) are very different from those of the carriage drawn in converging perspective (b).

and might be tempted to draw (see Figure 8.26a). Note how the horizontal parallel lines of the carriage in the upper drawing converge into the distance in the lower one. Note also how the length of the carriage has been compressed into a fraction of its 'real' length.

It is probably easier to draw in perspective by using one of the peep-hole devices described by Leonardo. One problem with this method, however, is that it is actually difficult if not impossible to draw a whole scene from a particular viewpoint; if you focus on one spot you cannot see the edges which are peripheral; it is actually necessary to shift viewpoint from time to time. The whole scene can also be drawn according to the mathematical laws of perspective: once the distance between the object and the artist and his or her angle of view are known, the shapes and sizes of the surfaces and the angles and lengths of the edges can be worked out. A few artists are probably able to do this intuitively, but most will require formal tuition.

As well as these effects on the size and shape of objects, converging perspective also affects their clarity. This is not usually perceptible with objects near to us, but if we look into the far distance we see that the definition of objects is less clear the farther away they are.

Figure 8.27: The effect of distance can be achieved by varying the definition and tone of the line.

Although the strength of the tone can be varied in a drawing to suggest distance (see Figure 8.27), I shall not discuss the technique of tonal perspective in detail in this book. Instead, I shall concentrate on the convergence of edges and on the decrease in size with distance since most research has been concerned with these issues.

Converging into the distance

Because they have usually been shown how to draw a table or a cube in parallel oblique form children may simply continue to repeat this schema and not look carefully at the real object. So, when Norman Freeman (1980) asked a group of twenty 9- to 10-year-olds to draw a rectangular doll's table, instead of giving them a corner view, he placed the table directly in front of them. Over half the children (eleven) drew a rectangular form, a few (six) drew a parallel oblique, and fewer still (three) attempted to make the depth lines converge. In a previous similar study John Willats (1977) placed a full-sized table directly in front of a group of 5- to 16-year-olds and asked them to draw what they could see. He then graded the drawings into six classes, or stages, and found that they were related to the

Typical drawing class 1:
no projection system

Typical drawing class 4:
oblique projection

Typical drawing class 2:
orthographic projection

Typical drawing class 5:
naïve perspective

Typical drawing class 3:
vertical oblique projection

Typical drawing class 6:
perspective

Figure 8.28: John Willats classified 5- to 16-year-olds' drawings of objects on a table into six types.

children's chronological age. In the early stages (1, 2 and 3) up to the age of 9, the children drew the table in various rectangular ways; at the beginning of stage 4, around the age of 9 years, the parallel oblique form was introduced; and at stages 5 and 6, from the age of about 14, the depth lines were drawn converging (see Figure 8.28).

The same kind of pattern emerged when I presented some children and adults with a cube positioned so that only its top and front faces

were visible (1986). Most of the 7-year-olds drew a rectangular figure, and when prompted they limited themselves to two faces. If left unprompted, a large number of 12-year-olds drew an oblique three-sided form even though this solution was not appropriate; they included two faces only when prompted but still drew the depth lines of the top face as parallel obliques. Only the adults made these depth lines converge to some extent.

From these studies, then, we see that children below the age of 9 years use the rectangular form and that the parallel oblique form is starting to emerge when they are around 9 years, but that children do not begin to make the depth lines converge until very much later, in the early adolescent period.

Now, even if we as adults know that the edges of the table are supposed to converge as they become more distant from us, we may not readily *see* that they do. Objects that are relatively close to us

Figure 8.29: The edges of a long straight road seem to converge into the distance.

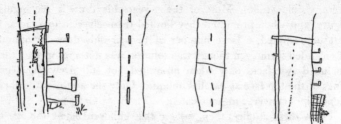

Figure 8.30: The edges of these roads, drawn by children aged 6 years 6 months to 7 years 11 months, are parallel.

may not exhibit a very pronounced perspective effect. It may be that the children in the studies mentioned above could not see the convergence or that they did not know that the sides are supposed to converge. However, in the case of, say, a long, straight road, the convergence is very clear (see Figure 8.29).

In order to find out how such a road would be drawn, Karen Littleton (1991) asked some children aged 6 years 6 months to 7 years 11 months, some adolescents and some adults to draw a road from imagination. Some more children of the same age, some adolescents and some adults were asked to draw a road 'going into the distance', again from imagination. Further groups were asked to draw an actual road. In all of these tasks the children drew parallel lines to represent the road (see Figure 8.30). Furthermore, they also selected a parallel form when given a set of ready-made pictures to choose from. The adolescents and the adults, in contrast, drew converging forms.

Littleton felt that the convergence of the sides of a road might be more striking in a photograph than in reality. She took a photograph of the road from the same position as that from which the groups had drawn it and this time asked them to copy the road from the photograph (see Figure 8.31). Although most of the children now made the sides converge, many of them still drew parallel sides. It is only when they were presented with a photograph taken from a very low angle so as to make the convergence extremely dramatic (see Figure 8.32) that they all made the sides converge in their own copies. All the adolescents and adults, on the other hand, made the sides of the road converge when asked to copy either of the photographs shown in Figures 8.31 and 8.32.

Figure 8.31: Many 6- to 7-year-olds were able to copy the converging edges of the road from this photograph but some drew parallel edges.

Figure 8.32: All the 6- to 7-year-olds who copied this photograph of a road drew converging edges.

As we have said before, children do not draw converging depth lines until quite late in their development. However, we know that the problem is not an inability to draw oblique lines, either in parallel or converging. If we ask young drawers to copy decontextualized figures, their performance is good. Littleton asked her children to copy converging obliques and all of them could do so. When Monica Lee (1989) asked 109 children between the ages of 4 and 8 years to copy a parallel oblique and a converging oblique figure (see Figure 8.33), they made very few errors. But when they were asked to copy a picture of a table, with its surface drawn in either one of these ways, they made a lot of mistakes and produced their usual schema for a table.

We also know that children have no difficulty in drawing converging obliques if these occur in the object itself. When I showed some 7- to 9-year-olds a wedge-shaped block they drew a picture in which the depth lines converged, whereas when I showed them a cube, they drew a rectangular form (1989). Their responses were the same when they had to choose from ready-drawn pictures.

So, if children as young as 4 years *can* produce converging obliques, why don't they use this solution when confronted with the problem of how to draw objects like a table, a road or a cube in depth? I think there are at least three reasons for this. First, the child's intention may be to display in his drawing what he *knows* about a particular object. If asked to draw a table, for example, he may want to show that it has a rectangular surface and that its opposite edges are parallel; so he draws a rectangle or, if he is older, a parallel oblique form. He may not even consider drawing the table as it looks, and therefore may not need to find a different solution.

A variation of this explanation is that the child may actually

Figure 8.33: Four- to 8-year-olds can copy these shapes, but if the shapes are incorporated into drawings of a table they begin to make errors.

intend to draw a realistic picture but finds his attempts pre-empted by a compelling urge to show what he knows about the object instead. Another variation is that, even if the child knows that there are other ways of drawing the object and even if he knows how to produce them, he may choose not to use them; he may prefer a solution which preserves more of the facts about the object rather than one which conflicts with what he knows.

The second reason why children may not resort to the converging obliques solution is a cultural one: since the parallel oblique form is widely used in our culture, in textbooks for example, and since children have often been taught this 'trick' by the age of 11 or 12 years (Cox, 1986 and 1991), they may believe that this *is* how objects such as cubes and tables actually look. We know that many adults think that the parallel oblique form of the cube is a correct converging perspective representation and are amazed to discover that it is not and that, in fact, if we have a corner view of a cube, no face appears as a square, no angle is a right angle, and no pair of opposite edges remains parallel (see Figure 6.20 in Chapter 6). For most practical purposes, however, the parallel oblique representation is perfectly adequate and there is no pressing need to change.

The third reason is that unless it is pointed out to them, children and adults may simply not notice that the edges of a table or the sides of a straight road *look* as if they converge in the distance. In fact, our perceptual system 'corrects' to some extent the optical effects of perspective, so that they are less obvious to us in reality than they are, say, in a photograph. In addition, in contrast to when we take a photograph we do not normally remain absolutely still and have one eye closed while looking at a scene. Because we tend to move about and have the advantage of stereoscopic vision, we get a more 'rounded' impression of objects than does a camera; the added information that we take in enables us to see beyond the restricted, snapshot image of the object and to perceive and recognize the object as a whole. In order to appreciate the shape an object presents to the camera or to the retina we have to inhibit this natural tendency to see beyond it, and this is a stage which, according to both Jean Piaget (Piaget and Inhelder, 1956) and John Flavell (1974, 1978) comes quite late in the development of the child. Whether children or adults, however, if we don't notice the perspective effects in a real scene, then we are unlikely to try to draw them even if the solution is already present in our graphic repertoire.

Decrease in size with distance

The effect of depth can be achieved not only by making the edges of objects converge in the distance but also by decreasing the size of individual objects. Many young children appreciate that some smaller objects in a picture appear to be in the distance. Of course, these smaller objects also tend to be higher up on the page so we don't know whether it is their smaller size or their height on the page (or both) which indicates to the children that they are meant to be further away.

Martin Nieland and I (unpublished data) presented some young drawers aged between 5 and 10 years and some adults with three pictures in which one figure of a boy was placed above another on the page. In one picture the figures were the same size and either both small (see Figure 8.34a) or both large (see Figure 8.34b); in another the higher figure was smaller than the lower one (see Figure 8.34c), and in a third picture the higher figure was larger than the lower one (see Figure 8.34d). The pictures were shown in random

Figure 8.34: In these four examples, which boy seems nearer to us and which is further away? It is the size of the figure rather than its position on the page which is more important.

order and held vertically in front of each observer so that both figures were in fact at the same distance from him. The question was: Which figure seems nearer and which seems further away?

When the upper figure was smaller than the lower one, as we expected, nearly all the adults and the children, even the youngest ones, selected it as the one further away and selected the lower one as the one appearing to be nearer. This did not surprise us because it is the adult convention to draw more distant objects both smaller and higher up on the page. When the two figures were the same size, there was only one conventional cue for distance – height on the page. In fact, the upper figure was not consistently chosen as being further away; both the adults and the children chose the upper and lower figures in roughly equal proportions. When the upper figure was larger than the lower one, the upper one was chosen as being nearer and the lower one as appearing further away. From these results it seems that the *size* of the object rather than its height on the page is the more important cue to its distance from the observer.

Of course, children's *understanding* of pictures is usually in advance of their ability to draw similar ones themselves, so we did not know whether those as young as 5 years of age would be able to indicate the distance between objects in their own drawings. Stern's 5-year-old son, for example, asked, 'How come painters can paint so it looks far away?' (Stern, 1909). The fact that a few children use multiple groundlines and in doing so are using height on the page rather than size as a cue to distance suggests that height might be important. On the other hand, when asked to draw one ball behind another one, 7-year-old Richard said to Karen Littleton (1991), 'The back ball's further away so I'll draw it littler', but when he actually drew the two balls he placed them side-by-side. We could not tell which of the two cues most young children might use.

In order to find out, Martin Nieland and I (unpublished data) asked some children and adults to construct a picture including two figures so that one figure appeared nearer and one further away. Although most of our 5- to 6-year-olds placed the figures side by side, they tended to choose a larger and a smaller figure. By the age of 7 to 8 years most of the children were selecting two figures of differing size *and* were placing the smaller one higher up the page; nearly all those who were still placing the figures side by side were, nevertheless, choosing two different sizes. Similar results were obtained with the adults.

It seems then that, by the ages of 5 to 6 years, children are using the size cue to indicate whether objects are nearer or further away from the observer, and by the ages of 7 to 8 years they are also placing more distant objects higher up the page. It is interesting that in this kind of task height on the page appears to be secondary to the size cue, especially when, as I discussed in Chapter 7, even 5-year-olds can draw two balls vertically on the page to indicate that one is behind the other in the scene.

There are at least two reasons why there is this discrepancy between the two tasks. First, I suspect that below the age of about 7 years children probably find it difficult to coordinate both cues and that they use the one which seems more appropriate for the particular task in hand. A task which emphasizes the distance of the objects from the observer may suggest to them the size cue, whereas one which emphasizes the spatial relationship between the objects may suggest the height on the page cue. Of course, it may be that the young child is capable of coordinating both cues but that he doesn't see the need to do so.

Another reason for the difference between the responses to these tasks is that in the ball-behind-another-ball task the farther ball *does* appear to be higher up in the visual field but does not appear to be significantly smaller than the nearer ball; thus, the height on the page cue is more likely to be used. In the figures task (Cox and Nieland, unpublished data) no model was presented and therefore these visual prompts were not available to the child; he was left to imagine how a closer and a more distant object might appear and was given no specification that these should be arranged along the observer's line of vision. It is perhaps not surprising that in this case the size cue springs to mind and that the figures are not necessarily arranged one above the other.

CONCLUSIONS

Although the drawings of very young children seem somewhat chaotic, with figures scattered all over the page in different orientations, it is not long before some sort of order is imposed and the figures are placed upright. An implied or an actual groundline is used to align the figures and usually is drawn horizontally across the page with the figures perpendicular to it. Sometimes, however, when

this groundline is sloping, as it is on a hillside or on a pitched roof, the figures are drawn at right angles to it and they appear to us to be toppling over. Although we know that children find it difficult to draw acute angles and have a tendency towards making them more perpendicular than they ought to be, the main explanation for these perpendicular errors is that children lose sight of the horizontal and perpendicular dimensions of the page and simply draw the figures on to the sloping baseline as if it were a horizontal one.

In addition to the groundline, many young drawers include a skyline to give a framework to their scene; the action takes place in the air gap between these two reference lines. In order to introduce a sense of depth into the scene some of them use multiple groundlines, placing higher up on the page those figures which are meant to be further away. The spatial layout of some scenes, however, is not easily accommodated by this arrangement and children may use the technique of folding over to show, for instance, all the figures in a round game or a frontal view of houses on both sides of a street.

The discovery that an oblique line across the page can be used to suggest depth is a useful one and children use it to show the change in direction of, for instance, the side of a house. The upper and lower depth lines are usually drawn parallel to each other. As well as suggesting the three-dimensionality of the object these oblique parallels also preserve some of the features of the real house. This is very popular not only among children but among adults, and is used extensively in all manner of textbooks.

Together with the adoption of the oblique parallel style to indicate the depth of objects children also use the height on the page cue to indicate the distance of the object from the observer: nearer objects are drawn lower down and distant objects are drawn higher up the page. By the age of 7 years they 'marry' this height cue with the size cue that they have already discovered and draw the higher object smaller than the lower one.

Most children do not readily adopt the style of linear or converging perspective in which the oblique depth lines converge towards a vanishing point; many adults also find this difficult. If they are to master this system which many regard as a great achievement, not only for the individual artist but also for the history of art, then they will almost certainly need both encouragement and formal tuition.

CHAPTER 9

Copy Cat!

In music or writing we don't expect the child to burst into spontaneous creativity without first having gone through the laborious process of mastering the basic techniques, and this often involves copying what the teacher does, whether it be playing a particular chord or correctly writing the letter 'b'. In fact, there is usually some element of copying involved in almost everything we have to learn. It is odd, then, that in art young children are expected to develop unaided in this way. Apart from providing the materials and perhaps suggesting and discussing a stimulating topic, many parents or teachers rarely give further help. They see their role in terms of providing encouragement but not of giving direct assistance in the drawing process itself. The child is expected to find her own way and this is what creativity is supposed to be all about. Not surprisingly, then, adults often express unease if children copy the way other people draw things, especially if they copy the cartoon characters from books or comics.

Despite these adult misgivings, however, children often *do* copy drawings, and it is my belief that this need not inhibit their creativity. After all, the greatest artists have routinely copied the work of the great masters who went before them. Understanding how others have achieved a certain effect hasn't prevented them from moving on and trying something different. Nevertheless, I hear you say, it may prevent other lesser mortals from doing so. But I suspect that without the experience of copying, other lesser mortals will not only fail to move on but they will not have got very far, artistically, in the first place. Although I would certainly not wish to reduce drawing to the level of copying alone, I do think that we can use children's copying ability in positive and constructive ways. By disapproving of their copying activities we may be closing the door on a very useful way of maintaining their interest in drawing and in widening their knowledge of the many ways in which things can be drawn. Far

from having a stifling effect on creativity, copying can be used to open it up.

I have mentioned copying from time to time in the preceding chapters. Researchers often give children copying tasks in order to check whether they have acquired the basic graphic skill to produce a certain figure. If they can copy a particular figure, then their failure to produce it in other drawing tasks can't be due to a lack of skill; there must be other reasons. In this chapter it is copying itself that I want to examine. If it is a skill, then like most skills it develops, and I shall discuss various studies which have traced this development.

WHAT COPYING INVOLVES

What I mean here by the term 'copying' is copying from another line drawing, not copying from a three-dimensional object. The two tasks are very different. Copying from a line drawing is sometimes referred to as *two-dimensional drawing* or as an *isographic task* (Mitchelmore, 1985). The copy (or the *isograph*) can be checked for accuracy by placing it on top of the model; the two should exactly match. Having said that, though, the copy is sometimes accepted as accurate even when it is smaller or larger than the model and may not be orientated the same way on the page; it is usually the preservation of the internal relationships in the model which is the main criterion for an acceptable copy. Copying from a three-dimensional object is sometimes called *three-dimensional drawing* or a *homographic task*; in this case it is not possible to check for accuracy by laying the copy on to the original model. The copies made in the homographic task will be much more variable than those produced in the isographic one.

Children can perceive the difference between simple geometric shapes, like a circle or a triangle, long before they can draw them. In fact, even 6-month-old babies can distinguish them and by 2 years of age children can identify squares and diamonds correctly (Bee and Walker, 1968; Maccoby and Bee, 1965). Many tests of development or of intelligence include items for children to imitate or copy and each task takes into account what they can be expected to do at a particular age. For example, a child can imitate a vertical or a

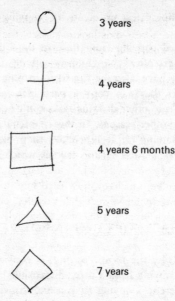

Figure 9.1: The ages at which most children can copy simple geometric forms from a drawing.

circular stroke at the age of 2 years, a horizontal stroke at 2 years 6 months and a cross at 3 years. In all these cases she must be able to witness the adult's *action* and should not be expected to copy from the adult's finished drawing alone. At the age of 3 years she can copy a circle from a ready-made drawing, at 4 years a cross, at 4 years 6 months a square and at 5 years a triangle, but it is not until she is 7 years that she can copy a diamond (see Figure 9.1).

Why does it take so long before a child can *draw* the shapes? Obviously she needs to have gained sufficient physical control over the pencil in order to make it produce exactly the kinds of marks she wants it to make. She also has to understand what 'copying' means, that she must reproduce the model as accurately as possible and make her drawing look exactly like it; copying may differ in this respect from the task of drawing a three-dimensional object, in which, as we have seen, she may not necessarily try to reproduce the model exactly.

Yet another reason why copying lags behind children's ability to

discriminate between shapes has to do with the way they analyse figures. When 2- and 3-year-olds look at objects they examine them *holistically*; in other words, they get a general impression and do not explore each feature of an object systematically (Zaporozhets, 1965). This general impression is sufficient for them to be able to sort out a variety of cut-out shapes into different piles. However, the process of copying a shape from a line drawing isn't holistic. Drawing is a *sequential* activity. Each shape has to be mentally divided into its constituent parts and each part then drawn in order (Maccoby, 1968). We might think of a square, for instance, as four separate straight lines; we have to decide where to start and what order to draw the lines in, and we have to draw each line in alignment with its 'partner' in the model, make sure that it is the correct length and that all lines meet each other at the correct angle. If someone shows us how to do this, we will at least have some clue as to how to go about it ourselves, but if we are presented with a ready-drawn square to copy we will have to work all this out from scratch.

Given all that copying actually involves, therefore, it is perhaps not surprising that it takes a long time for the child to master it. Some of the difficulty of the task demands can be alleviated by asking the child to construct her copy with matchsticks; Kevin Connolly (1968) found that his 5- to 6-year-olds constructed figures more accurately in this way than when they tried to draw them. Another tip is to place the model higher up on the page and allow the child to make her copy beneath it; in a number of different tasks this has proved more effective than when the model and the copy were side by side (Huttenlocher, 1967; Bryant, 1974; Anwar and Hermelin, 1982).

SINGLE LINES

A vertical line is probably fairly easy to draw because the child has only to stretch out her arm and pull the pencil towards herself. She has a 'natural' target to guide the line. In contrast, there is no such target to help her keep a horizontal line on course. Phyllis Berman (Berman, Cunningham and Harkulich, 1974) presented children aged between 3 years 10 months and 5 years 3 months with a vertical, horizontal or oblique line drawn on a circular card which in turn was placed on a circular table. When the card was removed the child had to draw the line on her own circular paper.

The vertical line was the easiest to reproduce correctly and the other two lines were equally difficult. When the study was repeated (Berman, 1976) with 3-year-olds using square cards instead of circular ones, the vertical and the horizontal lines were equally easy but the obliques were still difficult. Peter Bryant (1974) believes that verticals and horizontals are easier because there are normally plenty of vertical and horizontal background cues around – the edges of the paper, the edges of the table, etc. – to help the child perform the task; in contrast, there are few oblique cues. Bryant also found that obliques became easy to draw if the child was allowed to have a diamond-shaped page. The difficulty that the child may have in producing an oblique may not, therefore, be intrinsic but due to the fact that there are normally no helpful background cues to guide her drawing.

CIRCLES

Very young children quickly discover the wavy or spiralling possibilities of their scribblings (see Figure 9.2), and it has been suggested by Lauretta Bender (1938) and by Jean Piaget and Bärbel Inhelder (1956) that this movement is the precursor of the circle. The child

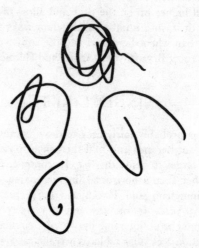

Figure 9.2: Some spiral scribbles drawn by Amy, aged 2 years.

copy of the circle

copy of the triangle

copy of the square

copy of the cross

a

copy of circle

copy of ellipse

copy of triangle copy of square

b

copy of circle

copy of ellipse

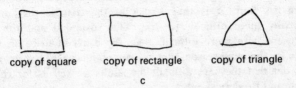
copy of square copy of rectangle copy of triangle

c

Figure 9.3: At first, young children use a circle when copying all closed forms (a); later curved and angular forms are distinguished (b); eventually, all shapes are distinguished more accurately (c).

learns to control the spiral so that the ends of the figure meet up and the shape is more radially symmetrical and not too elongated. Unlike the more complicated multi-sided figures, circles can be made in one smooth movement without the pencil having to be lifted at all during the process.

Both Piaget and Inhelder have argued that very young children don't make a distinction between the different shapes they are asked to draw other than noting whether they are open or closed. A circle, a square and a diamond are all the same thing to them, in the sense that they are all closed figures. They may be contrasted with shapes which are open, such as a horseshoe or a cross. Piaget calls this a *topological* distinction. According to his study, since the circle is the easiest shape to draw, young children may use it to represent *all* the closed shapes (see Figure 9.3a). However, when children begin to analyse the *Euclidean* properties of objects – their edges and angles, their relative distances, and so on – they start making distinctions between the closed shapes in their drawings. At first, a circle may be used for all curved shapes and a square for all angular forms (see Figure 9.3b); later, young drawers are able to show the distinction between a circle and an ellipse and between a square, an oblong and a triangle (see Figure 9.3c).

AN OBLIQUE PROBLEM

A shape such as a square or a triangle can be produced by drawing each line separately, lifting the pencil as each line is completed. Even if these shapes are drawn without lifting the pencil, however, it is necessary to change direction abruptly at the corners. Of course, for the square all the corners are right angles, whereas for the triangle they are not. Although the triangle has only three sides whereas the square has four, it is the *obliques* of the triangle that make it potentially more difficult to draw. The diamond and the tilted square are both more difficult than the conventionally orientated square for the same reason: they contain obliques (see Figure 9.4). It turns out that they are difficult for adults as well as for children (Laszlo and Broderick, 1985).

If oblique lines are easier to draw when the edges of the page are also oblique, it should follow that shapes containing obliques are easier to draw when matched by a surrounding frame. When Hossein

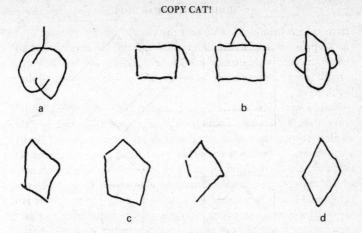

Figure 9.4: The developing child's attempts to copy a diamond shape.

Naeli and Paul Harris (1976) compared 4- to 5-year-olds' drawings of a square and a diamond on a circular, square or diamond-shaped page, they found that there was no difference in the errors when the background was circular, but that the square was easier to draw than the diamond in a square background and the diamond easier to draw than the square in a diamond background (see Figure 9.5). These researchers carried out a further study in which 4-year-olds were asked to place a cut-out shape on their page to match the one in the model; the results were similar to those obtained in the first study with pencil and paper tasks.

In most studies of these framework effects, the shape of the child's page has been the same as that of the page of the model to be copied. Norman Freeman (Freeman, Chen and Hambly, 1984) set out to discover, with a group of 5-year-olds, whether it was necessary to have them matching or whether, in fact, the accuracy of the child's drawing was influenced more by one than the other. As in the Naeli and Harris study, the children were asked to copy a square or a diamond which was drawn on a circular, square or diamond-shaped page. The paper used for the copy was either square or diamond-shaped. It emerged that what mattered for the accuracy of the drawing was the shape of the *child's* paper, not that of the paper the model was actually drawn on. For instance, a diamond was copied just as accurately whether the model paper was diamond-shaped or not, as long as the child's

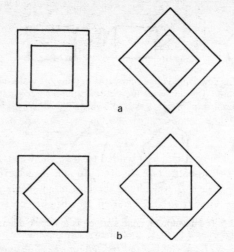

Figure 9.5: Squares and diamonds are easier to draw if the background is compatible (a), but more difficult if the background is incompatible (b).

paper was diamond-shaped, but a diamond in a diamond-shaped frame was difficult to copy if the child's paper was a square. This shows us that the effect of the background cue is greater at the production stage – at the time when children actually start to draw – than at the stage when they perceive or encode the shape of the model.

ANGLES

As well as studying children's ability to copy closed figures such as the circle and square, researchers have also examined their ability to copy angles. This research endeavour came about partly as a result of investigations into the way that children draw the level of the water in a tilted bottle – basically a homographic task. In this famous Piagetian task (Piaget and Inhelder, 1956), children were shown a bottle a quarter full of coloured water. They were then asked to draw the water-level on some outline drawings of the bottle at various angles of tilt. It was not until the age of at least 7 or 8 years that they drew the water-level horizontal regardless of the bottle's

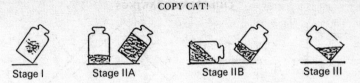

Stage I Stage IIA Stage IIB Stage III

Figure 9.6: The developing child's attempts to draw the water-level in a tilted glass bottle. The stages mentioned correspond approximately to the following ages: I: 4 to 5 years; II A: 5 to 6 years; II B: 6 to 7 years; III: 7 to 8 years upwards.

orientation. Younger children tended to draw the water-level parallel to the base of the bottle (see Figure 9.6), and Piaget explained their mistake as a failure to understand the idea of an absolute horizontal. Even if they know that the water in an upright container lies flat, they assume that this relationship between the water and its container remains fixed even when the container is tilted.

Of course, with a normal straight-sided bottle, a line drawn parallel to the base will also be perpendicular to its sides and it is therefore not possible to tell which cue – the base or the sides – the child is using to draw her water-level line. Douglas Sommerville and I (1988) were able to tease apart these cues by presenting children with a pair of glass mugs: one was a conventional container on a tilted surface and the other was a slanted mug on a horizontal surface (see Figure 9.7). When they drew the water-level on to some outline pictures, 5- to 6-year-olds and, to a lesser extent, 7- to 8-year-olds were orientating the lines in relation to the *sides* rather than to the base of the container. As a result, their lines were in fact more perpendicular (to the sides) than they should have been.

When the bottle is tilted, children must make the line of the water-level meet the oblique sides at an acute angle. But can

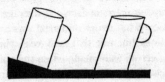

Figure 9.7: Using a straight-sided mug on a tilted surface and a slanted mug on a horizontal surface, Sommerville and Cox (1988) were able to show that children draw the water-level perpendicular to the sides rather than parallel to the base.

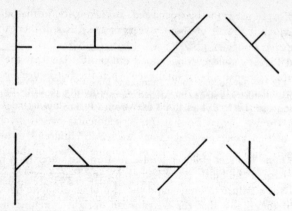

Figure 9.8: Children can copy the figures on the top line correctly because the shorter line is perpendicular to the long baseline. When they try to copy the figures on the line below, 5- to 6-year-olds tend to draw the shorter line more perpendicular than it ought to be.

children below about the age of 8 draw a line on to an oblique baseline? If they can't do this, even if they know that the water-level remains horizontal in a tilted bottle they will not be able to demonstrate that knowledge. In order to test this ability Andrew Ibbotson and Peter Bryant (1976) 'decontextualized' the task and presented 5- to 6-year-olds with a number of different angles to copy (see Figure 9.8). A shorter line was drawn at 90 or 45 degrees on to a longer baseline which itself was in a vertical, horizontal or oblique orientation. On the children's response card, the baseline was already drawn and they were simply required to copy the shorter line on to it. The children copied the 90-degree figures more accurately than the 45-degree figures. The errors with the 45-degree figures tended to be towards the *perpendicular*; in fact, the average child drew the line at about 58 degrees. The errors occurred more with the horizontal and oblique baselines but not so much with the vertical baselines. The same kinds of errors were made when the children were asked to use a straight piece of wire for the shorter line instead of drawing it and when the line had to be copied inside a rectangle.

Rüvide Bayraktar (1985) gave children various cues to see if these would prevent the *perpendicular bias*. However, even when strong cues, such as making the edge of the paper parallel to the line to be

copied, were used, the bias persisted. Bayraktar found that although the bias tends to fade at about 7 years of age it is still there to some extent even among adults.

Had Piaget's children understood the general law that the water-level always remains horizontal even when the bottle itself is tilted, they would nevertheless have had some difficulty in drawing it this way because the level had to be drawn on to the sloping sides of the bottle. In fact, it may be that the perpendicular bias is involved in many of the rather peculiar things we see in children's drawings – the figures placed at right angles to a sloping hillside or the chimney drawn at an alarming angle on to a pitched roofline. As I mentioned in Chapter 8, however, these perpendicular errors are much more pronounced in meaningful tasks than in decontextualized, abstract ones, which suggests that the perpendicular bias only partly explains them. Furthermore, errors do not always occur. Norman Freeman's (1983) study of the way children draw trees on to a road receding into the distance didn't involve copying but it shows us that even 6-year-olds are not always affected by the perpendicular bias; in his task the bias was towards drawing an *acute* angle (see Figure 8.10 in Chapter 8). So, although there may be a perpendicular bias in abstract tasks, other factors, such as the children's knowledge of the spatial relationship they are trying to depict, may override it.

PLANNING

As I mentioned earlier in this chapter the way we copy a line drawing may depend on the way we analyse its component parts. The *planning decisions* we make include the 'dissection' of the figure into separate lines, the orientation of each line in order to match the one in the model, the starting point and the ending point of the line, the angle at which one line meets the next, and so on.

Some of the 'rules' for the way we go about forming a simple geometric figure or a letter of the alphabet seem to be consistent across many cultures and are evident before the child has actually been shown how to form her letters (Goodnow, 1977). For example, there is a tendency to start at the top of a figure and, to a lesser extent, on the left. When children are asked to draw a cross they typically draw the vertical stroke first in a top-to-bottom direction and then the horizontal stroke from left to right (see Figure 9.9a).

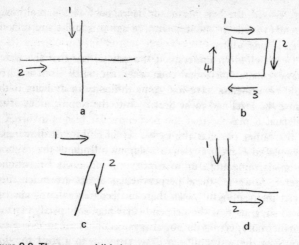

Figure 9.9: The young child chooses the 'top-to-bottom and left-to-right' rule (a) *or* the 'threading' rule (b and c) when copying simple shapes, letters and figures. In some cases the two rules are compatible (d).

Another rule which children frequently adopt is that of *threading*, that is drawing around the shape from beginning to end without lifting the pencil; for instance, they typically begin a square at the top left and proceed in a clockwise direction (see Figure 9.9b). Often, as with the cross and the square and with figures such as the number '7' (see Figure 9.9c), the two rules are incompatible and children must choose one or the other. Some shapes, however, such as the letter 'L', allow both rules to be applied (see Figure 9.9d).

When children come to learn how to form their letters, the sequence of strokes or the path of some letters may conflict with their 'natural' rules. In the case of the circle this does not seem to present a problem: whereas pre-school children tend to draw their circles in a clockwise direction, schoolchildren readily adopt the anticlockwise motion that is used to write the rounded parts of many letters in our alphabet. However, many of the typical errors in children's writing and copying of letters can be explained by a conflict of rules (Goodnow and Levine, 1973). Although they frequently confuse 'b' and 'd' and 'p' and 'q', it is in fact the second letter in each pair, the 'd' and the 'q', which is more problematic. These letters are reversed two to three times more often than are the

'b' and the 'p'. If you follow the rule 'start at the top with the vertical and then proceed from left to right', you are more likely to copy the 'b' and 'p' correctly but to run into problems (usually reversals) with the 'd' and 'q'. Children often overgeneralize this rule and apply it even to these deviant cases. Jacqueline Goodnow (1977) suggests that practice in tracing over these letters may help, but only if the starting point and direction of each stroke are made clear to the child.

Pia Broderick and Judith Laszlo (1988) have investigated the planning demands that drawing squares and diamonds makes on 5- to 11-year-olds by giving the children copying tasks in which the demands have been reduced to a greater or lesser extent (see Figure 9.10). In Task A, for instance, the child is asked to copy the upper figure; a pair of parallels is already provided and she has only to add two lines in order to complete the figure. This task turns out to be quite easy for all children. The starting and the ending points are given and an angle does not have to be negotiated when two adjacent lines meet. Although the task demands are a little greater in Tasks B

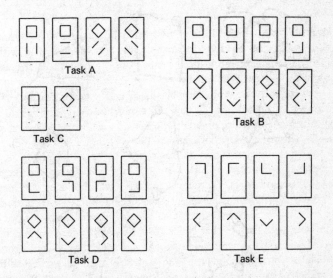

Figure 9.10: In these five tasks the children were required to copy the upper figure in each case in the space provided below. The demands of the task can be reduced to a greater or lesser extent according to the amount of help given. Task A, for example, is quite easy, whereas Task E is much more difficult.

and C, they are not appreciably more difficult than in Task A, since the starting and ending points are given. When the child has to plan her own ending point (Task D) or both the starting and the ending points (Task E) as well as to negotiate a 90 degree angle, the copying performance is much reduced. It is also perhaps not surprising that there is less accuracy with the diamond than with the square, since the paper provided has a rectangular framework.

Colleen Rand (1973) taught some 3- to 5-year-olds to draw five shapes: they were shown how to copy the shapes first by drawing dots (or small circles) where the corners should appear and then by connecting them up (see Figure 9.11). As in Broderick and Laszlo's study, these dots provided the cues for the starting and ending points of each line. This training proved to be very effective in that the children made better copies of both the trained shapes and some new shapes. The improvement wasn't simply the result of extra motor practice, because in an earlier study when Rand (1971) gave some other children extensive practice at tracing shapes this didn't

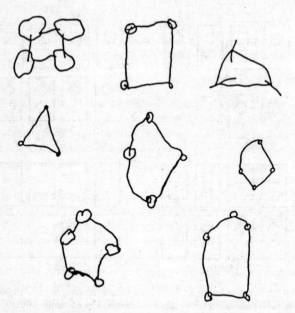

Figure 9.11: Young children's copying performance improved when they first circled the corners of the figures.

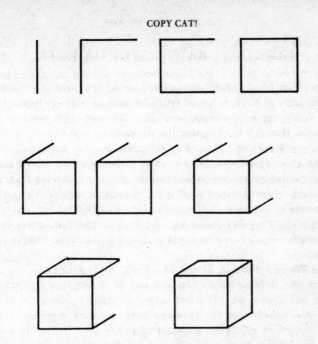

Figure 9.12: This sequence of steps in the drawing of a cube shows the order in which adults add each line.

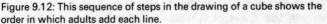

improve their copying ability. In fact, it wasn't even necessary for them to practise the dot technique themselves; those who were shown the technique but were not allowed to practise it themselves during this training also improved their copying. Clearly, the dot technique shows children a way of dealing with the shape in a sequential way.

Bill Phillips (Phillips, Inall and Lauder, 1985) gave groups of older children, aged between 6 years 10 months and 7 years 9 months, different kinds of training in copying figures such as a cube. He found, as Rand had done, that it didn't matter whether children were taught how to draw the sequence of lines themselves or whether they simply observed the way that adults drew them; both methods were effective. In contrast, children who were asked to look at a sequence of ready-made drawings (see Figure 9.12) did not improve their copying performance. To improve their own copies, it seems necessary for the children at least to see the sequence of lines being drawn.

COPYING DRAWINGS OF OBJECTS

When we are asked to copy from a line drawing of a three-dimensional object, such as a cube, we ought to be dealing with an isographic task – copying a two-dimensional line drawing. The problem is, however, that if we recognize the drawing as representing a real object our knowledge of the way that this object is structured may influence or inform the way we draw it. In other words, we may convert an isographic task into a homographic one – copying from an imaginary three-dimensional object. In spite of the fact that the depthlines of the cube in the model actually converge we may not perceive that they do because we have made assumptions about how they ought to go rather than looking closely at the actual lines in the model.

Bill Phillips (Phillips, Hobbs and Pratt, 1978) gave 6- to 7-year-olds a line drawing of a cube and one of a non-representational figure (see Figure 9.13) to copy; before the children started to draw they were asked what the drawings were meant to represent. The cube was drawn much less accurately than the other figure; although their copies looked more like the model than their drawings from memory, children nonetheless tended to draw the faces of the cube as squares whereas they preserved the acute angles in the meaningless figure. These results show that if children can encode or describe to themselves what the object in the model is, then this will guide the way they draw and they will be less inclined to observe the angles in the model itself. Vanessa Moore (1987) replicated these findings with 7- and 9-year-olds; in her study even when the children were not asked what the figures represented, the cube was drawn less accurately than the other figure.

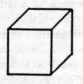
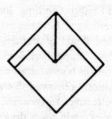

Figure 9.13: Six- to 7-year-olds draw the cube less accurately than the non-representational figure.

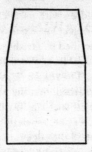

Figure 9.14: When copying this figure, young children emphasize the convergence of the upper part if they are told it is a *shape* or a *house*, but they make the upper part more rectangular if they are told it is a *building block*.

Sometimes, as in the case of the cube, what the line drawing is meant to depict is fairly obvious, especially when it is the oblique view that is presented. By naming a less familiar line drawing we can also suggest how it might be seen although, of course, we can't automatically assume that the children will accept our description or that they will keep it in mind while they do their drawing. In one of my studies I gave 6- to 9-year-olds the line drawing depicted in Figure 9.14 to copy, calling it in turn a *shape*, a *house* or a *building block* (1989). The majority of the children made the top part of the figure converge whatever it was called, but more of them emphasized the convergence of the lines when it was called a house than when it was called a shape, and there was a tendency towards making the lines parallel when the figure was called a building block.

Similar results were obtained by Monica Lee (1989) when she asked 4- to 11-year-olds to copy a diamond and a trapezium (see Figure 8.33). These were copied more accurately when they were not named than when the children were told that they depicted the tops of tables. The errors were consistent with how the children normally drew a table-top either from imagination or when copying a line drawing of a table: the younger ones tended towards the rectangular and the older ones towards parallel obliques. Karen Littleton (1991) also found that although 7-year-olds could copy a pair of converging obliques quite accurately, they tended to make the lines parallel when they were told that the figure depicted a road. As far as I know, all these naming-and-copying tasks have involved naming *converging* obliques; I do not know of any studies

which have presented children with parallel obliques but have labelled them with the name of an object known to display converging obliques.

The studies I have described so far show that children's knowledge about the characteristics of objects may interfere with their copying of a drawing of those objects. The reason is, as Bill Phillips (Phillips, Inall and Lauder, 1985) has explained, that the way the children describe the object to themselves conflicts with the line drawing to be copied. In the case of the line drawing of a cube, for example, if we see the drawing as a real object, we know that all the edges are either vertical or horizontal and all the angles are right angles; it is this description based on 'real-world' knowledge that the child seems to be working from. In order to copy the line drawing more accurately, however, a two-dimensional description, for instance, 'the top left-hand line is an oblique, joining the horizontal line beneath it at an acute angle' would actually be more useful. It is this kind of description which artists are encouraged to generate (see Chapters 10 and 11), even when viewing a real three-dimensional scene, and which is likely to produce a realistic picture.

CONCLUSIONS

The ability to copy even a very simple geometric form is actually very complex. Even when the young child understands that she has to reproduce the drawing exactly as it appears, there are many decisions to make in the planning of the drawing. She has to dissect the shape mentally into component parts and she has to decide where to begin, and then what route to take in order to bring together all the components in the correct spatial configuration. If they are given help in these various aspects of the task, children can make considerable improvements in their copying ability.

It is perhaps not surprising that some shapes are easier to draw than others; shapes with oblique lines in them are notoriously tricky. Traditionally it was thought that obliques were simply inherently difficult and that this difficulty was what accounted for the developmental delay in children's copying of shapes such as the triangle and the diamond. More recently, however, it has been found that although this delay is real enough, the difficulty results largely from a lack of helpful cues on the page. Whereas the child can follow the horizontal and vertical edges of the page when she draws a square, there are no helpful cues like this when she wants to draw a

diamond; in fact, the cues are not only unhelpful, they actually militate against the successful creation of a diamond. If we presented children with diamond-shaped pages, they would have far fewer problems in drawing diamonds!

As well as relying consciously or otherwise on the cues provided by the page, children often exhibit a perpendicular bias. This means that when they want to draw an acute angle they tend to make the angle more perpendicular than it ought to be. Although its occurrence has not been fully explained, this bias has been implicated in many interesting errors that children make both in the specially designed tasks used in research studies – such as the drawing of the water-level in a tilted glass bottle – and in their spontaneous drawings – figures which appear to be falling off a hillside and chimneys toppling off the sides of a sloping roof.

Children's copying of figures can also be affected by the identity of the figure itself. If the figure is a drawing of an object well known to the child – a house, for example – then she is less likely to look carefully at the lines and angles of the particular line drawing she is required to copy and more likely to construct her drawing in the way she normally draws this object. A *meaningless* figure, on the other hand, will be copied much more accurately because the child will attend more closely to what she actually sees.

The value of copying is often underrated, yet there are many occasions when children are required to make a careful and accurate copy, for example when learning to form the letters of the alphabet, when copying a diagram from a textbook, and so on. Many older children also begin to look at and copy the work of other children and of adult artists in order to widen their drawing repertoire and to draw more realistic pictures. It seems to me that we should not undervalue their skill in doing this but that we should foster it and consider ways of using it for creative ends.

CHAPTER 10

Exceptional Children

Clearly, some children are more interested in drawing and draw more than others and some are more talented than others. No doubt there are a number of different factors influencing these individual differences – inborn aptitude, personality, encouragement from family and school, and so on. When my 4-year-old daughter's friend Aidan came to play he was usually very keen to spend time 'doing drawings'; his pictures were boldly conceived, detailed and carefully drawn. Amy's work, in contrast, was more slapdash; her preference was for rough-and-tumble and make-believe games. Since a talent for drawing and an interest in spending time on it are likely to be related, I can confidently predict that Amy's future career will not be in art; unfortunately, I cannot be so sure about Aidan's future, since a child who performs outstandingly at an early age is not necessarily destined to become an artist.

In this book I have generally avoided the term 'art' when discussing children's drawing ability. This is because many people would not regard children's drawings as art and I sympathize with this view. If we regard art as the deliberate depiction of a scene in such a way as to bring about a specific feeling or emotion in the observer, then we must seriously question whether children are capable of this. The particular expression on the face of a child's figure that we admire may actually only be accidental; he may not have intended it and may not be able to reproduce it again. Unlike a 'true' artist, the child artist may not be intent on communication at all; he may simply be drawing for himself.

TALENTED CHILDREN

Despite the fact that not all children talented at drawing will become artists we can nevertheless pick out those who do show some degree

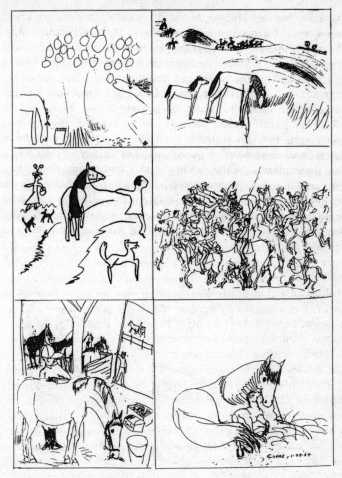

Figure 10.1: These drawings of horses were produced by a talented girl between the ages of 5 and 11 years.

of technical talent, and this can be recognized, as illustrated in Figure 10.1, by the age of about 11 years (Lark-Horovitz, Lewis and Luca, 1973). Interestingly, although many teachers decry any formal attempts to teach children how to draw in a realistic way, it is often precisely this aptitude which is supposed to determine whether they have any talent for art.

Usually, but not always, artistically talented children are above average in intelligence and many are of very high intellectual ability. Like most children, they probably go through an early schematic phase of drawing but their development is accelerated. They show a willingness and interest in drawing new topics and trying out different media, and an interest in adult techniques. They have a richer store of schemas as well as more curiosity about how objects actually look. Their pictures reflect not only a more detailed observation of these objects but also a greater flexibility in depicting the various postures and movements of the figures. The fluidity of their line is more pronounced as is their ability to vary its boldness or subtlety. Their use of space and of composition is advanced: they often use multiple groundlines when other children use only one and, later, are interested in the challenge of depicting groups of figures when other children may avoid the problem by reducing the number of objects in the picture.

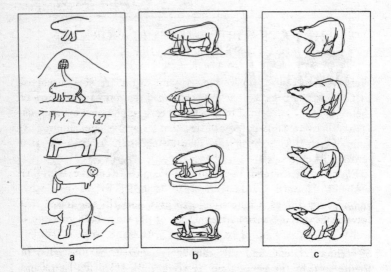

Figure 10.2: Drawings from memory over a three-year period by an average 8-year-old child (a), an average 12-year-old child (b) and a talented 13-year-old child (c). All ages are those at the beginning of the three-year period. In columns b and c the first drawing is reproduced each time in heavy outlines and the following ones are superimposed over it.

As well as having a vivid imagination the artistically talented child also has a very good visual memory. In fact, Betty Lark-Horovitz (in Lark-Horovitz, Lewis and Luca, 1973) has argued that visual memory is probably the most necessary factor for both drawing and art. She allowed some 6- to 15-year-olds to observe a ceramic polar bear for about three minutes as it was slowly rotated in front of them. The model was then taken away and shortly afterwards, and at various times over the next three years, the children were asked to produce a drawing of it (see Figure 10.2). It was clear that over time the average children had lost their fleeting visual memory of the model bear and had to think about the way a polar bear is supposed to look. Most of the talented children, in contrast, held on to their image of the bear to a remarkable extent and were able to reproduce details such as the texture, the turn of the head and the slight curve of the body. However, even though a good visual memory and artistic talent are related we can't assume that one actually implies the other; nevertheless, by giving children practice at remembering how things look we might be able to improve their drawing skill.

THE EXTRAORDINARY ART WORK OF CHINESE CHILDREN

Westerners have been amazed to see some of the art work produced by Chinese children. At first it was assumed that only the pictures of the particularly gifted had been selected for international exhibitions. It has become apparent, however, that even average children in China reach a very high level of drawing ability and do so at a remarkably early age.

Ellen Winner (1989) went to the People's Republic with her husband, Howard Gardner, in 1987 in order to discover why, among other things, Chinese children draw so well. She found that the mastery of the various techniques of drawing, both traditional and Western (see Figures 10.3, 10.4, 10.5, 10.6 and 10.7), is taken as seriously in China as is the mastery of calligraphy. Calligraphy training begins as soon as the children start school with a forty-minute lesson each week. They learn how to sit, how to hold the brush, how to mix the ink with water to achieve the right tone for each kind of stroke. In a typical lesson the teacher draws a character on the blackboard. She also holds up a large version of the character

Figure 10.3: A traditional Chinese flower painting by a 6-year-old child.

Figure 10.4: A traditional Chinese shrimp painting by an 8-year-old Chinese child.

Figure 10.5: *Children Holding Umbrellas*, a prize-winning Western-style painting by a 9-year-old Chinese child.

drawn on card in black ink and the same character is in the child's own textbook. Next, the teacher demonstrates how to form each stroke by painting on to the blackboard with a big brush dipped in white paint. She tells the children how to hold the brush, how to start each stroke slowly and with force and then increase the speed and use less pressure at the end. She also demonstrates how *not* to make the strokes, namely with uniform speed and thickness. The children then begin to trace over the characters in their textbooks.

All art work in China is taught in a similar way and there is a uniform curriculum which all teachers must use. There is clearly a right way and a wrong way to draw and paint just as there are right and wrong ways to form the characters in calligraphy. After showing her class a videotape of penguins in their natural habitat, a teacher said to her class, 'Today, you will learn how to draw a penguin.' First, she showed them how to place four points on the page, for the top, bottom and sides of the body, and then how to connect up the points with a line. Next, she demonstrated the correct and incorrect ways to draw the head. The eye, the wings and the feet were added

Figure 10.6: A Chinese 6-year-old's Western-style painting.

and, finally, the black parts were coloured in. The children were then allowed to draw their own penguins with both the teacher's model and an identical one in their textbook available (see Figure 10.8). They were also allowed to draw the background from imagination, although this was criticized if they drew flowers since, as the teacher said, 'There are no flowers at the South Pole.'

All the lessons are based on the copying of schemas provided by the teacher and the textbook. What these children are learning, then, is to draw from drawings; this isographic task – drawing from a two-dimensional model – is easier than trying to draw from a three-dimensional model (see Chapter 9). Gradually children build up a large repertoire of schemas and can then put them together to compose a picture, and this constitutes the imaginative aspect of the task. What counts as creativity is a new way of combining old schemas, rather than alterations to the schemas themselves. There is no expectation and no encouragement to draw from life; children are not encouraged to look around them to notice the colours, shapes and composition of the landscape. What is valued is the faithful reproduction of certain two-dimensional schemas in certain styles.

Ellen Winner wanted to know if the children could generalize

Figure 10.7: *Apples* by a Chinese 6-year-old.

from what they had learned and apply their knowledge to new subjects. She decided to ask some 6-year-olds, who had mastered a traditional Chinese style of painting shrimps, crabs and fish, to draw an unfamiliar object in this style. She showed them her young son's baby stroller, which few Chinese people would have seen before, let alone learned to draw. The teachers were horrified when they saw what was going on and tried to talk Winner out of it, arguing that the children would not know what the stroller was and therefore not be motivated to draw it, and that they would no doubt fail. Contrary to their teachers' expectations, however, the pupils were very intrigued by this new task and set to work to draw from life. Although they did not depict the stroller in the same style that they had used for the traditional subjects, they nevertheless drew it in a very detailed and realistic way. In fact, according to Winner they displayed far more skill than 6-year-old American children would have done. This shows that in spite of the set of rigid rules for drawing certain schemas that they had learned, their interest in drawing real objects had not been squashed; they were actually able to bring their extraordinary graphic skill to bear on a new problem.

Many Westerners will be impressed by the work that the Chinese

CHILDREN'S DRAWINGS

南极企鹅

1.利用作业纸中的长椭圆形，
按左边步骤图，描画出企
鹅形象的铅笔稿。

2.用先勾线(黑色笔)后涂色
的方法，并企鹅形象画完
整。

Figure 10.8: *The Penguin Lesson*, from a Chinese primary-school textbook.

children produce but horrified at the rigidity of the teaching approach, since there seems to be very little room for self-expression and creativity. Eventually, the Chinese argue, children will have gained sufficient skill to be able to be, in some cases, truly creative and original. Indeed, they believe that one must have skill in order to be creative. Winner points out that pre-school children in Western societies belie this claim: they have little skill but much creativity. Surely, the two cultures can learn a lot from each other. The Chinese could introduce more freedom into their system by presenting the children with visual problems – such as drawing two figures, one near and one far away – and encouraging them to try out their own solutions. The West, in turn, might do well to adopt some of the Chinese expectations of discipline and basic technique in our approach to drawing; all too often in the West, Winner argues, art education is 'playtime with no inherent structure'. By fusing the two approaches, we should be able to encourage children in both cultures to attain a high level of technical proficiency *and* to retain and express their own creative ideas.

CARTOON DRAWINGS

Whereas some of the more talented children in our society develop realistic ways of drawing from life, others, as I mentioned in Chapter 9, adopt the technique of drawing cartoon figures. Cartoon-like features are evident in the 7-year-old's picture in Figure 10.9. This technique has not been developed from observing real people and objects but has been directly or indirectly copied from other drawings, in comics or films.

A teenage boy called Anthony, studied by Brent and Marjorie Wilson (1977), produced a phenomenal number of pictures in the style of the Marvel comics (see Figure 10.10); having assimilated the style, he could draw a figure from any conceivable angle. Whether or not he had copied the style slavishly to begin with, he could certainly use it in a flexible and creative way.

Howard Gardner (1980) describes another boy, Stuart, aged 11, who also became extremely adept at drawing cartoon figures (see Figure 10.11). When Stuart became dissatisfied with the way he drew hands, for instance, he pored over a few books until he found a suitable solution. The skilful copying or assimilation of a cartoon style is an impressive achievement which many of us will envy, but this doesn't *necessarily* mean that other forms of drawing will be produced as successfully. Despite being able to draw his figures in an impressive

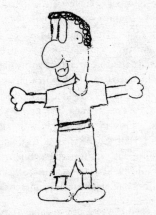

Figure 10.9: *Big Brother*, by a boy aged 7 years, has cartoon-like qualities.

Figure 10.10: Cartoon figures in the Marvel comics style drawn by a teenage boy called Anthony.

Figure 10.11: Stuart, aged 11 years, has invented a whole world of hobbit-like cartoon characters.

Figure 10.12: Stuart's life drawings are not particularly impressive.

range of expressions and postures, Stuart was not particularly good at drawing from life, as his attempts at drawing a telephone and a stapler show (see Figure 10.12). His skill in the essentially two-dimensional graphic world of cartoons gave him no particular advantage when it came to finding ways of depicting actual three-dimensional objects.

CHILDHOOD DRAWINGS OF GREAT ARTISTS

Unfortunately, the early drawings of great artists are rarely available for us to make judgements about their childhood performance. Those which have been preserved generally exhibit the same kind of

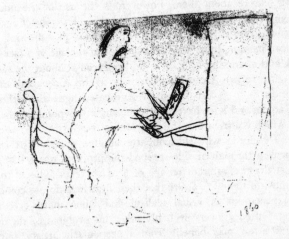

Figure 10.13: A drawing produced in 1860 by the American painter John Sargent when he was 4 years old.

Figure 10.14: *Lady with a Parasol* drawn by Paul Klee when he was 4 or 5 years old.

childish, schematized figures as the drawings of other children, although the former will have been produced at an earlier age. One striking feature about them, however, is the use of the line as an occluding contour, showing the outer extent of an object against its background (see Chapter 2). This is illustrated in a drawing by the American painter, John Sargent, executed at the age of 4 (see Figure 10.13), and in another by Paul Klee, produced at about the same age (see Figure 10.14). A contoured drawing at this early age is unusual, since most 4- to 5-year-olds draw segmented figures. Furthermore, both Sargent and Klee have adopted a single viewpoint for the whole scene, which is also rare in children of this age.

Those children who subsequently became great artists seem to have broken through or side-stepped the problem phase that begins for most drawers around the age of 8 to 10 years. This is the time when most of them are aware that their drawings do not come up to their expectations of visual realism and when many give up on drawing. Gifted drawers probably solve this problem by themselves, although a few may benefit from a particularly artistic family or school environment.

DRAWING WITH THE RIGHT SIDE OF THE BRAIN

In the late 1950s and early 1960s Roger Sperry (1964) demonstrated that the two halves of the brain tend to specialize in different kinds of thinking: the left is concerned with language-based thinking whereas the right is concerned with visual-spatial thinking. Both halves are involved in high-level cognitive functioning and can work together or separately; there can also be some crossover between the two kinds of thinking. The left side of the brain develops over a longer prenatal period than does the right side and usually ends up being larger and generally more dominant. Betty Edwards (1986) claims that the reason why most of us draw so badly is that we depend on the left hemisphere when analysing a scene – we are in *L-mode*. We describe the scene to ourselves by naming and categorizing what we know about the objects in it, and this knowledge is often in conflict with the way the scene actually looks. If we see a cube, for example, and think of it as a three-dimensional object, it becomes rather difficult to draw because we know that it extends into a third dimension that has no equivalent on our piece of paper; having classified the object as a cube we may then produce our usual schema for it without paying any attention to how this particular cube actually looks. As we have seen in preceding chapters, our knowledge of the cube's properties gets in the way of drawing it as it looks because we tend to see beyond the immediate visual image.

In *R-mode*, by contrast, we don't consider what the objects in the scene actually are – a cube, a house, a person's arm, or whatever; instead, we look at their shapes and edges and at how these features relate to one another spatially to form the whole visual configuration. If, when we look at a cube, we imagine that we are looking at a photograph or a drawing of an object we have not encountered before, it is easier to see the shape of its surfaces and the angles at which its edges appear to meet each other: the surfaces are no longer squares and the angles are no longer right angles. In R-mode, then, language-based descriptions of three-dimensional objects don't get in the way; we can have access to what we see much more directly, retaining a flat, visual impression which is easier to translate on our two-dimensional drawing paper. Thus, we mentally convert a homographic task into an isographic task (see Chapter 9).

Presumably good drawers naturally adopt this R-mode way of seeing. But the trick can be learned even by adults who claim to be fairly hopeless at drawing. In Chapter 11 I shall be looking at some of Edwards's techniques for helping people to draw by seeing things in the 'right' way. A number of researchers have put forward a similar idea about the ways we process information. Allan Paivio (1971) for example, like Edwards, has also argued for two distinct modes, *imaginal* and *verbal*. Although there are arguments against this *dual-coding* system (e.g. Olson and Bialystock, 1983), it is quite useful in that it has clear practical applications for helping us to draw more skilfully.

AUTISTIC CHILDREN

In spite of the fact that most talented drawers are average or above average in intelligence, there are some anomalous cases. One of the most famous is that of Nadia, a 6-year-old girl studied by Lorna Selfe (1977). Nadia was the second of three children born to Ukrainian émigré parents living in Nottingham (UK). Whereas the other two children in the family developed normally and were bilingual, Nadia was clumsy, slow, almost mute and uncooperative; she spent a great deal of time simply staring into space. She attended a school for severely mentally handicapped children and it eventually became apparent that she was autistic.

The vast majority of autistic children are below the normal range of intelligence and most, if not all, of their abilities are lower than those of normal children. Only a very small minority of all autistic children display extraordinary abilities; there have been fewer than 100 cases reported in the past 100 years. Most of these have shown exceptional ability to reproduce music or to make mathematical calculations (Park, 1978; Treffert, 1989); very few have had exceptional drawing ability.

Nadia's mother brought along to the clinic some drawings which Nadia had been producing since the age of 3 years 6 months. Even these early drawings (see Figure 10.15) were developmentally very advanced: note the profile of the figure, the use of the chin line as an occluding contour and the general fluidity of the lines. Later drawings, such as the pair of crossed legs drawn when she was 6 years 8 months, show not only occluding contours, but also foreshortening

Figure 10.15: Nadia's early drawings, produced at the age of 3 or 4 years, show some evidence of the use of a line as a contour.

Figure 10.16: These crossed legs drawn by Nadia at the age of 6 years 8 months show occluding contours, foreshortening and shading.

and shading (see Figure 10.16). These drawings would have been unusually advanced for a normal child, but for someone with Nadia's handicaps they were almost unbelievable.

Most of Nadia's drawings were not from life but from her memory of things she had seen, usually pictures in books. She would often study a book illustration for many weeks before drawing it herself. Although she did not refer to the original while making her own drawing, her first attempts were usually fairly faithful to the original, but variations soon crept in and she would alter the detail or the orientation of a figure (see Figures 10.17 and 10.18). This flexibility of the graphic image suggests that she was not slavishly copying some eidetic or photographic memory of the original. Apparently her eidetic memory was very good, but she could obviously manipulate the images in order to produce different and convincing views of the object. Unlike even many skilled artists she was able to begin the drawing at any point, break off and complete another section and eventually join up the whole image so that the parts fitted perfectly together.

Nadia performed very well on a variety of tests of visual imagery.

Figure 10.17: Nadia's drawings of a fairground horse originally seen in a book were produced when she was between 3 years 5 months and 4 years.

She was very skilled at accurately copying a picture, even when the original was taken away, and would reproduce accurately not only the 'positive' shapes, such as a square and a circle, in a picture but also the 'negative' shapes of the background. Problems arose, however, when she was confronted with tests involving naming and classifying things. Although she could remember exactly how a set of things looked in a scene and could match a picture of an object to a picture of its silhouette, she could not sort pictures into different object-classes. She failed, for instance, to identify a picture of a

Figure 10.18: Nadia's drawings of a cockerel originally seen in a book were produced when she was 6 years 4 months.

deck-chair as belonging to the same class of objects as one of an arm-chair.

This discrepancy gives us a clue as to why Nadia could draw such extraordinarily realistic pictures. Normally, when we look at a scene we receive a retinal image of it, but we quickly interpret the scene and recognize the objects in it as 'a chair', 'a person', and so on. As we have seen, however, our 'natural' tendency to describe a scene in these terms often hinders our ability to draw it; in order to draw it in a realistic way, we need to see the scene as a two-dimensional

configuration of shapes and lines. In Betty Edwards's terms, we need to be in R-mode not in L-mode, and most of us need to make a special effort to get into R-mode.

Nadia's very poor performance on language and classification tasks suggests either that she had some damage to the part of her brain involved in this kind of classification process or that, for some reason, this process did not automatically start to operate. Whereas most people's ability to think visually is hindered by their classification of the objects they see, perhaps this didn't occur in Nadia's case because the ability to classify was either not there or inaccessible. Thus, since she was unable to classify objects, the classification process could not affect the way she saw the model.

Of course, a full explanation of Nadia's extraordinary ability is no doubt much more complex than this. Many mentally handicapped children have difficulty in classifying objects but do not compensate for this with an improved talent for visual-spatial tasks. There may well be other mentally handicapped, non-gifted autistic and normal children who are right-brain dominated but cannot produce the kinds of pictures that Nadia drew. According to R.N. Haber (1979),

Figure 10.19: Nadia's drawings became less realistic and more childlike as she grew older and her language skills improved. This drawing of a man was produced when she was about 9 years 6 months.

Figure 10.20: Detailed drawings of buildings produced by the 11-year-old Stephen Wiltshire: (a) *The Circus, Bath* and (b) *The Lloyd's Building*.

for instance, about 10 per cent of young children have good eidetic memories, but this alone does not make them into talented drawers. So, even if we speculate about some underlying common cause for Nadia's talent and that of other autistic artists, we must also recognize that there may well be other specific reasons why a particular individual has developed an exceptional ability and why this ability takes the form that it does.

While in therapy Nadia was encouraged to develop language. Interestingly, as her language skills improved her extraordinary drawing ability declined (see Figure 10.19). Presumably, she began to think about objects in a different way: instead of seeing them as abstract patterns she now saw them as particular kinds of objects – a horse, a cockerel, a person – and this description of what they really were informed the way she drew them. Whether Nadia would have developed language in time without the aid of therapy we cannot tell, but the long-term language deficits of most autistics suggest that she would not have done. However, an improvement in language may not necessarily lead to an inevitable decrement in drawing ability. As Glyn Thomas and Angèle Silk (1990) have pointed out, the development of language by another famous autistic child-artist, Stephen Wiltshire (1987), did not seem to diminish his ability to produce amazingly detailed drawings of buildings (see Figure 10.20). Just as ordinary adults can learn to switch into R-mode for the purposes of accurate drawing even when L-mode is their usual and preferred way of processing information, so, presumably, can Stephen Wiltshire.

CONCLUSIONS

Although there is more to art than technical skill, those children who display some degree of skill in drawing are more likely than others to develop an interest in becoming artists. A talent for drawing can often be spotted by the age of 11 years, as the childhood drawings of a number of famous artists show. These talented children tend to be above average in intelligence, the development of their drawing ability is accelerated compared with that of other children and they seem to possess a very good visual memory. They are interested in trying out different media, in drawing new topics and in learning about adult techniques of representation. Whereas the average child

usually balks at the problems posed by visual realism the talented child treats this issue as a challenge and relishes the problem-solving exercise it presents.

In Western cultures those talented children who are interested in drawing develop their skill in different ways. Some teach themselves how to draw by adopting a cartoon style derived from comics and cartoon stills and build up a phenomenal repertoire of figures in different poses. Others develop the knack of drawing from life; they learn to switch to a different mode of seeing, seeing the scene not as a set of three-dimensional objects but as a flat, two-dimensional pattern of lines and shapes to be copied on to the page. Betty Edwards has called this way of seeing *R-mode* because there is some evidence that the right side of the brain is involved. There are a few well-documented cases of autistic children who have sidestepped the usual developmental progression of drawing and have been able to draw realistic pictures from the beginning. These children have a very good visual memory for detail and are able to reproduce exactly what they see. It may be that their disability enables them to switch more easily to R-mode or even that their disability prevents them from seeing the world in any other way.

As we have seen, some talented and highly motivated drawers teach themselves the technical skill of drawing; however, far more children could acquire greater technical expertise through formal tuition. Although educational practice in China seems to us to be unduly restrictive, it enables even quite average children to produce astonishingly good drawings. We do not have to adopt the same practices as the Chinese, but by mounting a programme that is more structured than what we have at present we could generate in our children more enthusiasm for drawing, as well as more creativity and more satisfaction.

CHAPTER 11

How We Can Help

Most parents note with excitement and satisfaction the milestones marking the development of their children – the first steps, the first words, and so on. Children's first scribbles are often greeted with equal excitement and many parents treasure their offspring's early pictures. Before they start school just about all children in our society have scribbled on a piece of paper and, all too often, on other, forbidden, surfaces as well. At nursery or at school, drawing will be encouraged. It is generally reckoned to be a very important activity in that, first of all, it is supposed to develop children's motor control over the pencil or crayon and this presumably facilitates the forming of letters and figures later on; and secondly, along with other art and craftwork, drawing is deemed to be instrumental in developing children's imagination and creativity. Yet, despite the ubiquitous children's pictures which adorn both the walls of their classrooms and their workbooks, drawing is rarely an activity which is taught in any planned or conscious way.

DRAWING IN THE CURRICULUM

Before the Second World War schoolchildren routinely received specific instructions on how to draw. E.A. Branch wrote a series of books for teachers with such titles as *Imaginative Drawing*, *The Second Book of Imaginative Drawing* and *The Book of Pencil Drawing* (all published by Evans Brothers, London, but now out of print). For a lesson entitled 'A Landscape with Simple Figures' the pupils are instructed to watch their teacher draw a landscape (see Figure 11.1) using charcoal on a large sheet of white paper. The teacher's picture is then put away and the children are directed to draw their own landscapes, using pencil, and to illustrate 'some such poetic idea as: "The ploughman homeward plods his weary way"'. The book

Figure 11.1: *A Landscape with Simple Figures*. A page from an early
twentieth-century teacher's manual, *The Book of Pencil Drawing* by E.A.
Branch.

warns the teacher of the kinds of fundamental errors which children
are most prone to make (see Figure 11.1 B, C and D) and emphasizes
that in the correct drawing 'the front of the road occupies the whole
width of the picture, and the distant end of it vanishes away to a
point right far back on the horizon' (see Figure 11.1 A). The teacher

is expected to 'correct all really stupid blunders'! Such exercises strike us now as extremely rigid and unimaginative, not to say authoritarian. Nevertheless, they probably did help children to grasp some of the basic skills required to draw a tolerably satisfactory picture.

The movement towards a less formal approach and an emphasis on 'free expression' in children's art work came about over a long period of time. In 1911 James Riddel, writing on the teaching of drawing in *The Teacher's Encyclopaedia*, objected to a current idea that children should be left to their own devices in order to develop originality. He could not see why drawing should be singled out in this way and not music or grammar, for example: 'The kind of originality which would be developed in the great mass of the people, if left to themselves in such subjects, is not much to be desired, neither is it in drawing.'

But, gradually, over the early decades of the twentieth century a romantic view of children's innate creativity, which, it was argued, should not be inhibited or corrupted by the formal teaching of adult artistic conventions, emerged. Viktor Löwenfeld (1957), for instance, appealed to teachers: 'Don't impose your own images on a child. Never give the work of one child as an example to another. Never let a child copy anything.' Brent Wilson (1985) points out the fallacy of this romantic vision, asserting that, in fact, the development of all our abilities comes about through the interaction – the give and take – of our genetic inheritance *and* the environment we find ourselves in. According to him, we can't be totally isolated from the 'corrupting' images around us. Even if we don't receive formal tuition in how to draw, we will still absorb something of the conventions we find around us – from adult images or from other children's work. In some so-called primitive cultures, for example, the images that children see may be fewer than in our Western multi-media societies. As a result, these children's graphic repertoire may be much more limited, giving them in turn more limited means of expressing their ideas and feelings. The message that Wilson wants to put across is that the possibility of an untainted development of artistic originality is a myth; graphic development and culture are inextricably linked.

In Western societies the legacy of the romantic view of childhood, particularly with regard to art education, lives on. For many years the teaching of drawing has been a very sensitive issue; indeed, many

would say that there should be no teaching of drawing. Not all teachers take this view, of course; in fact, since children are not expected to achieve a particularly high standard of drawing skill in our schools many teachers have not given much thought to the issue at all. In children up to about the age of 8 years the approach that prioritizes creativity over formal teaching is not problematic. Although there are individual differences in children's interest and ability to draw, most of them are willing to draw, and get enjoyment from it. Problems begin to occur from about the age of 8 to 10 years. Then, as we have seen before, children start to become dissatisfied with their work and they substitute rather detailed and fussy drawings for their former bold and more confident efforts; reliance on ruled lines and on the eraser is much in evidence.

As their interest seems to be flagging at the end of their primary school years, and as many children are all too aware of the fact that they can't draw, it seems to me quite appropriate that we should introduce more structured, if not formal, teaching of drawing. This idea is certainly not new: Earl Barnes in 1892 and Georg Kerschensteiner in 1905 both advocated adult intervention when children are about 9 years old. In fact, I think it inappropriate to adopt a *laissez-faire* policy with even younger children and I would like to see teachers involved in setting all children more challenging drawing tasks and discussing with them how different objects might be drawn.

PRACTICAL SUGGESTIONS FOR THE VERY YOUNG

Parents who delight in books usually raise children who also like to look at and read books. Similarly, parents who enjoy tinkering with engines and encourage their offspring's curiosity in them often raise children who are knowledgeable and enthusiastic about engines too. Enthusiasm and interest are important ingredients for any kind of learning and children find participating in an activity with a parent particularly beneficial. 'Do as I do' rather than 'do as I say' really does work. Parents do not have to know all the answers; parent and child can find things out together and often it is more fun that way.

The most basic thing that you can do to encourage tiny children to draw is to provide them with the materials – paper and crayons, felt-pens or pencils, blackboard and chalks – and to demonstrate what

can be done with them. If the children see that you are enjoying yourself and producing something interesting, they will want to have a go too. They may not have the motor control to manipulate a drawing implement until nearly the end of their first year, but there is no reason why you shouldn't introduce them to the drawing materials before then, as long as your expectations are not too high. You can draw different kinds of lines – vertical and horizontal, straight, wavy or curly – string them across the page or turn them round into spirals. Enjoy yourself making patterns; it is surprising how many different effects you can produce. Your child may simply enjoy watching, but it is more than likely that she will want to join in.

When she is more skilled at managing a drawing implement, introduce a copy-cat game: you draw a particular sort of line and the child copies you on the same piece of paper or on her own piece. Later, introduce the game of 'taking a line for a walk'. It is fun. The line can go straight or round bends or sharp corners, up hill and down dale and then back home again. Older children still like to do this and they can colour in fields or, if they can draw objects, add embellishments like animals, trees and houses.

Many teachers favour the use of thick, brightly coloured crayons and seem to shun the use of the pencil, claiming that it is dull and more difficult for the child to manage. In fact, children do manage to draw with a pencil rather more quickly than might be expected. The pencil also has advantages over the crayon, one of the most important being the amount of fine detail that can be achieved with it; for this reason, the figures that children draw in pencil are likely to be more advanced developmentally. It is possible to buy chubby pencils that are easy to handle but nevertheless have a finer point than a crayon.

Young children are delighted to see recognizable objects, such as people and animals, appearing 'magically' on the page. Don't be self-conscious about your own meagre efforts at drawing these. Also don't be offended if your child promptly scribbles all over them! She probably wants to have a go too, but her skill is not as advanced as yours. What she may be able to do, however, is to add on parts to an incomplete human figure, so leave out a leg or an arm and ask her to draw it in. It is easier if one limb is already drawn; later, leave out the facial features, both arms or both legs, and see if she can draw them in (see Figure 11.2).

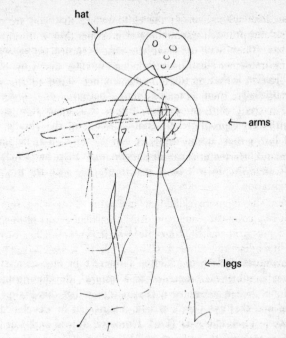

Figure 11.2: At the age of 1 year 11 months, Amy 'completed' a pre-drawn figure by adding a hat, some arms and some legs.

Whereas many researchers and art educators believe that it is essential for the child to go through the early stages of scribbling and making shapes before moving on to representational drawing, the evidence is not conclusive (see Chapter 1). Older children who have not had the opportunity to draw and who have developed their manual skills by other means move to representational drawing very rapidly indeed. Children, therefore, will not be artistically deprived if they have not engaged in all these early drawing activities, and older children should not be made to go laboriously through them just for the sake of it.

It is often difficult to pinpoint the first representational figure because, as I discussed in Chapter 1, a completely unrecognizable figure may be confidently named by the child as 'Mummy' or 'a cat'. By 'representational' we usually mean the first drawing that we, as adults, recognize. Nearly all children, even those with quite serious

learning difficulties, draw representational figures at some point between the mental ages of 2 and 4 years. Many of these early drawings are difficult to decipher and there are conflicting views about whether we should ask the child directly about her drawing; one objection is that we might be forcing her to put a meaning on to an essentially non-representational pattern or configuration. M.J. Parsons (1987), in contrast, argues that, apart from providing her with the appropriate materials, discussing the child's work is probably the most useful thing we can do. As well as helping us to understand her picture, the discussion may help her to clarify for herself what she doesn't know and to grapple with the problems of representation.

THE TEACHER'S ROLE

The eventual decline of children's interest in and competence at drawing is sometimes regarded as a *natural*, developmental trend, but Henry Schaefer-Simmern (1948) argues that there is no natural decline and that everyone's artistic talents can be developed at any age. Betty Lark-Horovitz (Lark-Horovitz, Lewis and Luca, 1973) agrees with this view and puts the blame on social pressures and on art education. My understanding of what she is saying is, first of all, that we do not place great importance on doing well at art – compare this with our attitude to the promotion of numeracy and literacy – and, secondly, that we do not give sufficient help to children who claim they cannot draw or who actively seek our help in making a satisfactory drawing.

Lark-Horovitz also emphasizes the importance of expression and creativity in children's pictures; indeed, she argues that 'the teacher must make sure that all that is taught serves creative ends'. Nevertheless, at the same time she stresses that teachers should not go overboard in adopting an uncritical stance and an 'anything goes' attitude. According to her, when an 8-year-old complains that she can't make her horse 'look right' it is inappropriate to give her, or draw for her, a quick and easy solution; at the other extreme, it is also quite unhelpful to tell her to use her imagination or to do her best. There is a fertile middle ground on which the problem can be acknowledged and discussed and the child can be helped towards a genuinely creative solution. There may be times, especially with

older children, when it is very constructive to show them exactly how other artists have managed to produce a certain effect; this can be done without conveying the message that there is only one correct way that this effect could have been achieved. Sensitive and fruitful handling of the problem will depend to a great extent on the teacher's understanding of the developmental characteristics of children's drawing. However, since we do not rate the attainment of a high level of drawing skill as of major importance in our society, teachers are probably not as well informed about these characteristics as they are about those of other core curriculum subjects.

BETWEEN 3 AND 8

During the early school years up to the age of about 7 or 8, children draw fairly readily and do not usually show dissatisfaction with their work. This unproblematic state of affairs should not, however, lead teachers to be uncritical or unchallenging. As we have seen before, their criticisms and challenges must be presented in a constructive and interesting way. I shall discuss as examples two topics which regularly come in for criticism from adults and older children: one is the young child's drawing of the human figure and the other is her organization of the scene she is depicting.

Although there are very wide individual differences among children who are beginning to produce representational drawings and in the rate at which they develop, as far as we know nearly all of them produce tadpole figures (see Chapter 3) before they go on to drawing the more conventional human form. Some severely mentally handicapped children and adults do retain the tadpole form, but parents and teachers should not be worried if their normal children carry on with it for a year or so before moving on. In fact, it may be important for some children to over-practise specific forms before their drawing evolves. Retention of the tadpole form during the ages of 3 to 5 years is not particularly unusual, although by the age of 5 most normal children will have dropped it.

Many parents, teachers and especially older children often criticize and even ridicule tadpole figures. I have heard that in some nurseries and schools teachers have tried to make 'helpful' comments such as, 'But, your arms don't come out of your head!' I am not sure what the children make of this, especially if their tadpoles *are* meant to

represent both a head and a body. I suppose they must go away feeling both censured and confused. The thing is, as M.J. Parsons suggests, we must not jump to conclusions about their drawings but we must ask the children to tell us about them. It may turn out that the body really is missing and that the arms really are attached to the head. Does this matter? At this stage my inclination would be not to intervene very much since, in most cases, children will eventually change the way they draw their figures of their own accord. One thing I would definitely avoid is teaching children how to draw stick figures, mainly because, as W. Krötzsch pointed out (1917), the stick figure may become more of a hindrance than an aid when they want to move on to the more usual segmented form. As many researchers have noted, in Western cultures stick figures rarely occur in young children's drawings; when they do occur they have usually been copied from adults.

Even though their figures appear in static and frozen postures, the subject matter of children's pictures often involves movement; older children sometimes put in 'movement lines', borrowed from cartoons, to indicate the movement of a figure or a vehicle. A challenge can be presented by simply asking the children to draw a person running or kicking a ball. Many recognize that their skill in this respect is very limited but we can discuss with them what the problem is, how real bodies look when they are engaged in these activities, and how they might adapt their figures accordingly. Because they will have worked out the solution themselves, albeit with much encouragement and discussion, the children's creativity will not be stifled and their interest as well as their graphic repertoire will have been extended.

Just as the tadpole drawer may be perplexed at criticism of her figures the older child of 6 to 8 years may be confused by criticisms of the air gap in her pictures. Many adults are quick to point out that the sky meets the horizon and that there is no gap in between the two. Without any further constructive discussion of the problem, however, the child may have no idea what to do: after all the air gap seems to her to be a very useful device. If she draws the groundline and then colours the part above it blue, her subsequent figures, superimposed on this background, may not show up. Conversely, filling in the background after drawing the figures would be tedious and might also detract from the clarity of the figures. Criticism of a phenomenon like the air gap is therefore really not very helpful unless some discussion of the issue takes place along with some

constructive negotiation between the adult and child about workable solutions.

At this young age children usually draw best what most interests them. The subject matter for a picture might come from their own imagination or may arise from some activity such as a visit to see a fire-engine or a trip to feed the ducks in the park. In fact, children can be encouraged to be interested in almost anything – the shape of a vase, the pattern on a leaf, the spreading of a fan.

Grant Cooke (1986), an advisory art teacher in Kingston (UK), has developed with the help of local schoolteachers a very stimulating way of introducing young children to some of the basic drawing conventions without sacrificing their scope for creativity and self-expression. Any quite ordinary topic might be chosen as the basis for a lesson with 6- to 7-year-olds. If 'frying an egg' is the chosen topic, the teacher actually brings a small electric cooker into the classroom and asks the pupils to imagine that she doesn't know how to fry an egg and to tell her how it should be done. After this she switches on the cooker and fries the egg, guided by the children's instructions.

Figure 11.3: Six- to 7-year-olds' drawings of the 'frying an egg' topic.

She then invites them to help her to make a drawing of the cooker on the blackboard. During this process the teacher deliberately misinterprets some of the instructions in order to elicit corrections from the pupils and to make it necessary for her to erase and alter her own drawing.

A number of things are going on here. First of all, the teacher is doing a drawing herself and in so doing is providing a role model. Secondly, she is encouraging the children to look at the real cooker and to use this information to inform the drawing. Thirdly, it is clear that there is no single, teacher-directed way of doing the drawing; the final product is arrived at through negotiation and interaction between the teacher *and* the pupils. Further benefits involve the children's facility with language and their communicative abilities. Finally, the children are asked to draw someone frying an egg; it can be the teacher herself or anyone else they choose. The now cool cooker is left in a prominent position so that they can inspect it if they wish, but the teacher's drawing is wiped from the blackboard so that they cannot simply copy it. Figure 11.3 shows some of the delightfully detailed pictures that were produced.

Another topic, this time involving an element of fantasy, is 'the magic bicycle'. Having placed a bicycle up on a table for all to see, the teacher invites her 5- to 6-year-olds to help her draw it on the blackboard. Again the children are active participants in the drawing process, both enjoying and learning from the 'mistakes' she makes. At the end of the exercise the teacher 'discovers' a crumpled piece of paper in the bicycle basket and hands it to a child to put in the wastebin. But the paper bears a message, 'I am a *magic* bike and I can help you!'. This discovery leads to a discussion about the ways in which the bicycle might be magic, and the children are finally asked to draw an adventure they might have on their very own magic bicycle (see Figure 11.4).

It is difficult to allow one's imagination and creativity full rein if you don't know how to draw ordinary objects. As Norman Freeman (1980) aptly points out, 'children are not simply creatures expressing their essence through drawing, they are also novices who are learning how to draw'. Although all children would easily recognize a cooker and a bicycle they normally find them difficult to draw. In fact, bicycles are notoriously difficult for adults to draw too. Now, if children are struggling with the technicalities of drawing the basic objects of the story they may not have any 'mental energy' left for

Figure 11.4: Five- to 6-year-olds' drawings of a magic bicycle.

the imaginative aspects of the picture. The advantage of Cooke's approach is that it directly addresses the conceptual difficulty of drawing these objects; children are encouraged to think about the shapes of the individual components and about how these might be put together sequentially to make a representational drawing. This is an interesting and instructive exercise in itself, but a further benefit is that the burden of how to draw a particular object is lifted and the children are then free to incorporate it into their expressive and imaginative work.

AFTER 8

The kinds of lessons discussed above can be continued with older children, but more and more challenges can be introduced. For instance, children can be encouraged to consider the partial occlusion of one object by another in a viewer-centred way. This can be done through the hiding games I discussed in Chapter 7 as hiding conveys

the message that part of the scene is not visible and should not, therefore, appear in the drawing.

Another challenging exercise is to encourage young drawers to think about the many different views we have of an object and about the problems these pose for depiction. This will encourage them to become flexible in their visual thinking and to break out of the stereotyped mould. You might ask the child to draw her friend from the front, the back or in profile, or to draw a doll's house from the front or from a corner view. The problems of distance can be introduced by setting up scenes or showing photographic slides in which diminution of size is a key factor. Slides are ideal for this purpose as they give a much greater impression of distance than would otherwise be possible within the confines of the classroom.

These exercises should present the children with problems and provoke a great deal of discussion. The issue of how an object might be drawn is an interesting challenge. There will come a point for nearly all young drawers, however, when they are really stuck and need specific guidance. This may occur over the problems of proportion – of the human figure, for instance – or of perspective – particularly in relation to buildings. By adolescence most children's ideas about what they want to draw far outstrip their drawing skill. If they are not to give up their interest in drawing, they must be able to obtain some satisfactory rewards for their efforts. Telling a child to go and look at an object closely is rather vague advice and will not necessarily help her to draw it realistically as it does not tell her *how* to look at it.

Some children, and their parents, turn to 'how to draw' books (e.g. Deacon, 1984) in order to solve their graphic problems. Although the advice these provide can be very useful (see Figure 11.5), not all children can apply what they have gleaned from them when they then go on to draw a scene on their own. Whereas they may understand and become quite skilled at drawing the *idealized* proportions of the human face, for instance, they may not be able to adapt the proportions successfully when they want to draw a real person. The consequence is either that their drawings are rather stereotyped, in line with the principle they have learned, or that, realizing that they can't apply what they have learned to non-ideal cases, they give up altogether.

Betty Edwards (1986), teaching art in the 1960s, could not understand why her students couldn't just look at a scene and draw exactly

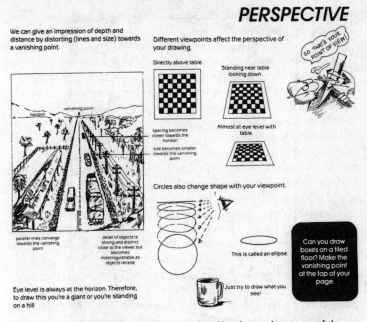

PERSPECTIVE

We can give an impression of depth and distance by distorting (lines and size) towards a vanishing point.

Different viewpoints affect the perspective of your drawing.

SO THAT'S YOUR POINT OF VIEW!

Directly above table.

Standing near table looking down.

horizon

vanishing point

spacing becomes closer towards the horizon

size becomes smaller towards the vanishing point

Almost at eye level with table.

Circles also change shape with your viewpoint.

parallel lines converge towards the vanishing point

detail of objects is strong and distinct close to the viewer, but becomes indistinguishable as objects recede

This is called an ellipse.

Can you draw boxes on a tiled floor? Make the vanishing point at the top of your page.

Eye level is always at the horizon. Therefore, to draw this you're a giant or you're standing on a hill

Just try to draw what you see!

Figure 11.5: The advice in 'how to draw' books can be very useful.

what they saw. To her it was easy: you just looked and drew what was right out there in front of your very eyes. When she gave this advice to the students, however, they would retort, 'I *am* looking, but I can't draw it.' Baffled and frustrated, she tried something unusual: she asked them to make a copy of a master drawing which was presented upside down. This model remained upside down and the students' own drawings were to be upside down too. To everyone's surprise, including her own, all the drawers made very good copies, better than they would have done if the model had been the right way up. This led Edwards to speculate on why it is so difficult to draw a meaningful subject and to find ways of helping students draw what they see. As we have seen in Chapter 10 she concluded that in order to draw three-dimensional objects realistically we need to get into a two-dimensional mode (or R-mode) of looking at them – seeing objects as a configuration of lines and shapes on a flat surface. There are a number of different tips for helping us to do this, the upside down exercise being one of them. Another technique for

Figure 11.6: Sometimes a more realistic picture emerges if we draw the spaces around the object rather than the object itself.

getting away from our knowledge about objects is to draw the 'negative' spaces around an object instead of the object itself. If we concentrate on getting the exact shape of these spaces right, the object seems to take care of itself (see Figure 11.6).

The most useful and one of the most concrete ways of getting into a two-dimensional mode is to use one of the devices suggested by the great masters, like, for example, the Leonardo Window (see Figures 8.22–4, Chapter 8). This involves placing a clear sheet of plastic on a window and then closing one eye and tracing the outlines of what we see outside on the sheet – for instance, the contours of buildings. When I did this at my office window I found that the perspective

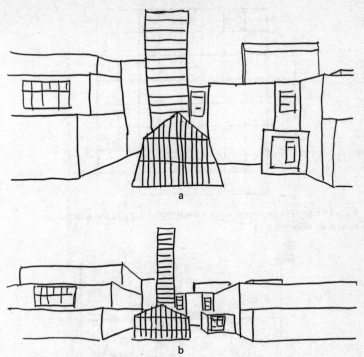

Figure 11.7: My first attempt to draw the buildings seen from my office window (a) and the more pronounced perspective effect when I traced the outlines of the buildings onto a clear plastic sheet (b).

effect I obtained was much more pronounced than when I had simply looked out of the window and tried to draw what I saw in the normal way (see Figure 11.7).

A problem with this method, of course, is that we don't always want to draw a scene out of a window! However, Edwards recommended that her students should carry around with them an *imaginary* window, a device similar to that recommended by Dürer (see Figure 8.23, Chapter 8), so that whichever way they turned there would always be an imaginary clear sheet of plastic in front of their eyes. The sheet would be marked out with a grid and there would be a small circle drawn in the centre (see Figure 11.8). In order to draw a scene the students should imagine they are looking at it through

Figure 11.8: Your drawings will be more realistic if you use a real or an imaginary sighting grid.

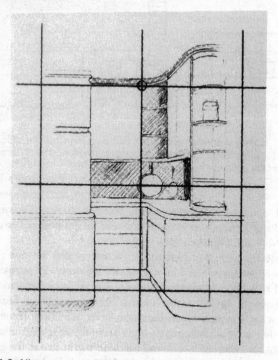

Figure 11.9: Align your eye with the circle on the grid and a point in the scene itself.

a b

Figures 11.10: Eleanor McCulley designed a mobile sighting grid (a) shown here in use by a student (b).

this grid and align one eye (the other being closed) with the small circle and the part of the scene to be drawn (see Figure 11.9). They should then transfer the two-dimensional line or shape they have seen on the grid on to their piece of paper. One of Edwards's students, Eleanor McCulley, actually constructed a mobile contraption consisting of a grid, attached to the elongated peak of a baseball cap, which was supposed to hang in front of the artist's face (see Figures 11.10a and b).

You can make your own simple grid, as Edwards describes, from a rigid piece of clear plastic measuring about 9 by 12 inches. Mark a grid of one-inch squares on it using a ruler and a felt-pen. Draw a small circle in the centre of the grid at a point where two grid lines cross. The grid is now ready for use. When you have selected the scene you want to draw you should lightly mark your paper with horizontal and vertical lines and tape it down on to a board so that it doesn't move. Now, hold up the grid at arms' length, close one eye, and align the other with the small circle in the centre of the grid and a chosen area in the scene. In this way the grid can be brought back into the correct position for each sighting of the scene. Viewing the

Figures 11.11: Students' 'before' (left) and 'after' (right) drawings. The first drawings were produced before instruction and the second drawings approximately twelve weeks later after a course of instruction.

Figure 11.12: A student's drawings of the American flag over a three-week period.

scene through the grid will help you to draw all the verticals in the scene; they should be in line with the verticals on the grid. You will also be able to work out the correct angle for all the other edges in the scene by comparing them with the horizontals and verticals on the grid.

After quite a lot of practice you may be able to dispense with these techniques and devices and be able to switch into a mode of seeing any scene as a two-dimensional image. Such a mode isn't just the preserve of the artistically gifted; many famous artists, including Leonardo, Dürer and Van Gogh, have not considered the use of mechanical devices beneath their artistic dignity – so why should we?

Betty Edwards shows us some examples of her students' work before any instruction and then again some weeks later (see Figures 11.11 and 11.12). She says that none of the students considered themselves to be artistically talented. Nevertheless, their comments seem to show that they have learned something more than stereo-typed drawing tricks. As one of them puts it, 'I just seem to be looking at things differently – in some way, *thinking* differently.'

It may be objected that the approach Edwards is advocating isn't really drawing, but just copying. As she says, however, in some sense *copying what you see* is exactly what learning to draw from life actually means. I am also aware that many readers will argue that

221

there is too much emphasis in this book on acquiring basic techniques and not enough on the expression of emotions and feelings, which is what great art is supposed to be about. I make no apology for this. I am not suggesting that art is no more than the acquisition of technical skill. What I *am* saying is that technical skill is a fundamental basis for most, if not all, great art. Indeed, without some degree of technical skill there would be no art at all.

Bibliography

Alland, A. (1983) *Playing with Form*, New York: Columbia University Press.

Allik, J. and Laak, T. (1985) 'The head is smaller than the body: but how does it join on?', in Freeman, N.H. and Cox, M.V. (eds.) *Visual Order: The Nature and Development of Pictorial Representation*, Cambridge: Cambridge University Press.

Anwar, F. and Hermelin, B. (1982) 'An analysis of drawing skills in mental handicap', *Australian and New Zealand Journal of Developmental Disabilities*, 8, pp. 147–57.

Arnheim, R. (1974) *Art and Visual Perception: A Psychology of the Creative Eye. The New Version*, Berkeley and Los Angeles: University of California Press.

Baldwin, J.M. (1903) *Mental Development in the Child and the Race*, second edition, New York: Macmillan.

Barnes, E. (1892) 'A study of children's drawings', *Pedagogical Seminary*, 2, pp. 455–63.

Bassett, E.M. (1977) 'Production strategies in the child's drawing', in Butterworth, G. (ed.) *The Child's Representation of the World*, New York: Plenum Press.

Bayraktar, R. (1985) 'Cross-cultural analysis of drawing errors', in Freeman, N.H. and Cox, M.V. (eds.) *Visual Order: The Nature and Development of Pictorial Representation*, Cambridge: Cambridge University Press.

Bee, H.L. and Walker, R.S. (1968) 'Experimental modification of the lag between perceiving and performing', *Psychonomic Science*, 11, pp. 127–8.

Bender, L. (1938) 'A visual motor *Gestalt* test and its clinical use', *New York American Orthopsychiatric Association Research Monograph*, 3.

Berman, P.W. (1976) 'Young children's use of the frame of reference in construction of the horizontal, the vertical, and the oblique', *Child Development*, 47, pp.259–63.

Berman, P.W., Cunningham, J.G. and Harkulich, J. (1974) 'Construction of the horizontal, the vertical, and oblique by young children: failure to find the "oblique effect"', *Child Development*, 45, pp. 474–8.

Bremner, J.G. and Moore, S. (1984) 'Prior visual inspection and object naming: two factors that enhance hidden feature inclusion in young children's drawings', *British Journal of Developmental Psychology*, 2, pp. 371–6.

Broderick, P. and Laszlo, J.I. (1988) 'The effects of varying planning demands on drawing components of squares and diamonds', *Journal of Experimental Child Psychology*, 45, pp. 18–27.

Bryant, P. (1974) *Perception and Understanding in Young Children: An Experimental Approach*, London: Methuen.

Burt, C. (1921) *Mental and Scholastic Tests*, London: King and Son.

Clark, A.B. (1897) 'The child's attitude towards perspective problems', in Barnes, E. (ed.) *Studies in Education*, 1, Stanford: Stanford University Press.

Connolly, K.J. (1968) 'Some mechanisms involved in the development of motor skills', *Aspects of Education*, 7, pp. 82–100.

Cooke, G. (1986) *Drawing and Talking with Infants*, Royal Borough of Kingston: Brycbox Arts in Education.

Costall, A. (1989) 'Another look at Luquet: stages in our understanding of children's drawings', presented at the British Psychological Society's Developmental Section Annual Conference, University of Surrey, Guildford, 8–11 September.

Cox, M.V. (1978) 'Spatial depth relationships in young children's drawings' *Journal of Experimental Child Psychology*, 26, pp. 551–4.

Cox, M.V. (1981) 'One thing behind another: problems of representation in children's drawings', *Educational Psychology*, 1, pp. 275–87.

Cox, M.V. (1985) 'One object behind another: young children's use of array-specific or view-specific representations', in Freeman, N.H. and Cox, M.V. (eds.) *Visual Order: The Nature and Development of Pictorial Representation*, Cambridge: Cambridge University Press.

Cox, M.V. (1986) 'Cubes are difficult things to draw', *British Journal of Developmental Psychology*, 4, pp. 341–5.

Cox, M.V. (1989) 'Knowledge and appearance in children's pictorial representation', *Educational Psychology*, 9, pp. 15–25.

Cox, M.V. (1991) *The Child's Point of View*, second edition, Hemel Hempstead, Herts.: Harvester/Wheatsheaf.

Cox, M.V. and Howarth, C. (1989) 'The human figure drawings of normal children and those with severe learning difficulties', *British Journal of Developmental Psychology*, 7, pp. 333–9.

Cox, M.V. and Martin, A. (1988) 'Young children's viewer-centred representations: drawings of a cube placed inside or behind a transparent or opaque beaker', *International Journal of Behavioural Development*, 11, pp. 233–45.

Cox, M.V. and Parkin, C.E. (1986) 'Young children's human figure drawing: cross-sectional and longitudinal studies', *Educational Psychology*, 6, pp. 353–68.

Craddick, R.A. (1963) 'Size of Halloween witch drawings prior to, on and after Halloween', *Perceptual and Motor Skills*, 16, pp. 235–8.

Crook, C. (1985) 'Knowledge and appearance', in Freeman, N.H. and Cox, M.V. (eds.) *Visual Order: The Nature and Development of Pictorial Representation*, Cambridge: Cambridge University Press.

Darwin, C. (1877) 'A biographical sketch of an infant', *Mind*, 11, pp. 286–94.

Davis, A.M. (1983), 'Contextual sensitivity in young children's drawings', *Journal of Experimental Child Psychology*, 35, pp. 478–86.

Deacon, J. (1984) *The Drawing Book*, Gosford, New South Wales: Ashton Scholastic.

DiLeo, J.H. (1973) *Children's Drawings as Diagnostic Aids*, New York: Brunner/Mazel.

Dix, K.W. (1912) *Körperliche und geistige Entwicklung eines Kindes, 2. Die Sinne*, Leipzig: Haase.

Earl, C.J.C. (1933) 'The human figure drawing of feeble-minded adults', *Proceedings of the American Association of Mental Deficiency*, 38, pp. 107–20.

Edwards, B. (1986) *Drawing on the Artist Within*, Glasgow: Fontana/Collins.

Elliott, J.M. and Connolly, K.J. (1978) 'The effect of visual frame of reference on a judgement of plane stimulus orientation by children', *Perception*, 7, pp. 139–49.

Eng, H. (1954) *The Psychology of Children's Drawings*, second edition, London: Routledge and Kegan Paul.

Eysenck, S.B.G. (1965) *Junior Eysenck Personality Inventory*, London: University of London Press.

Fenson, L. (1985) 'The transition from construction to sketching in children's drawings', in Freeman, N.H. and Cox, M.V. (eds.) *Visual Order: The Nature and Development of Pictorial Representation*, Cambridge: Cambridge University Press.

Flavell, J.H. (1974) 'The development of inferences about others', in Mischel, T. (ed.) *Understanding Other Persons*, Oxford: Blackwell.

Flavell, J.H. (1978) 'The development of knowledge about visual perception', in Keasey, C.B. (ed.) *Nebraska Symposium on Motivation*, Lincoln: University of Nebraska Press.

Fox, T. and Thomas, G.V. 'Does the importance of the topic affect the size of children's figure drawings?', unpublished manuscript, University of Birmingham.

Freeman, N.H. (1972) 'Process and product in children's drawing', *Perception*, 1, pp. 123–40.

Freeman, N.H. (1975) 'Do children draw men with arms coming out of the head?', *Nature*, 254, pp. 416–17.

Freeman, N.H. (1977) 'How young children try to plan drawings', in Butterworth, G. (ed.) *The Child's Representation of the World*, New York: Plenum Press.

Freeman, N.H. (1980) *Strategies of Representation in Young Children*, London: Academic Press.

Freeman, N.H. (1983) 'Picture-plane bias in children's representational drawing', *Australian Journal of Psychology*, 35, pp. 121–34.

Freeman, N.H., Chen, M.J. and Hambly, M. (1984) 'Children's different use of alignment cues when encoding and when producing a match-to-target', *British Journal of Developmental Psychology*, 2, pp. 123–7.

Freeman, N.H., Eiser, C. and Sayers, J. (1977) 'Children's strategies in producing 3-D relationships on a 2-D surface', *Journal of Experimental Psychology*, 23, pp. 305–14.

Freeman, N.H. and Hargreaves, S. (1977) 'Directed movements and the body-proportion effect in pre-school children's human figure drawings', *Quarterly Journal of Experimental Psychology*, 29, pp. 227–35.

Freeman, N.H. and Janikoun, R. (1972) 'Intellectual realism in children's drawings of a familiar object with distinctive features', *Child Development*, 43, pp. 1116–21.

Gardner, H. (1980) *Artful Scribbles: The Significance of Children's Drawings*, London: Jill Norman.

Gardner, R.A. and Gardner, B.T. (1978) 'Comparative psychology and language acquisition', in Salzinger, K. and Denmark, F. (eds.) *Psychology: The State of the Art, Annals of the New York Academy of Sciences*, 309, pp. 37–76.

Gesell, A. (1925) *The Mental Growth of the Pre-school Child*, New York: Macmillan.

Gibson, E. (1969) *Principles of Perceptual Learning and Development*, New York: Appleton-Century-Crofts.

Golomb, C. (1973) 'Children's representation of the human figure: the effects of models, media, and instruction', *Genetic Psychology Monographs*, 87, pp. 197–251.

Golomb, C. (1981) 'Representation and reality: the origins and determinants of young children's drawings', *Review of Research in Visual Art Education*, 14, pp. 36–48.

Golomb, C. and Barr-Grossman, T. (1977) 'Representational development

of the human figure in familial retardates', *Genetic Psychology Monographs*, 95, pp. 247–66.

Goodenough, F.L. (1926) *The Measurement of Intelligence by Drawings*, New York: World Books.

Goodenough, F.L. and Harris, D.B. (1950) 'Studies in the psychology of children's drawings: II. 1928–1949', *Psychological Bulletin*, 47, pp. 369–433.

Goodenough, F.L. and Tyler, L.E. (1959) *Developmental Psychology: An Introduction to the Study of Human Behavior*, New York: Appleton-Century-Crofts.

Goodnow, J. (1977) *Children's Drawing*, London: Fontana/Open Books.

Goodnow, J. (1978) 'Visible thinking: cognitive aspects of change in drawings', *Child Development*, 49, pp. 637–41.

Goodnow, J. and Friedman, S. (1972) 'Orientation in children's human figure drawings', *Developmental Psychology*, 7, pp. 10–16.

Goodnow, J. and Levine, R.A. (1973) '"The grammar of action": sequence and syntax in children's copying', *Cognitive Psychology*, 4, pp. 82–98.

Graewe, H. (1935) 'Das Tierzeichnen der Kinder', *Zeitschrift für Paedagogische Psychologie*, 36, pp. 251–6, 291–300.

Guillaumin, J. (1961) 'Quelques faits et quelques réflexions à propos de l'orientation des profils humains dans les dessins d'enfants', *Enfance*, 14, pp. 57–75.

Haber, R.N. (1979) 'Twenty years of haunting eidetic imagery: where's the ghost?', *The Behavioral and Brain Sciences*, 2, pp. 583–629.

Hagen, M.A. (1976) 'Development of ability to perceive and produce pictorial depth cue of overlapping', *Perceptual and Motor Skills*, 42, pp. 1007–14.

Hagen, M.A. (1985) 'There is no development in art', in Freeman, N.H. and Cox, M.V. (eds.) *Visual Order: The Nature and Development of Pictorial Representation*, Cambridge: Cambridge University Press.

Hagen, M.A. (1986) *Varieties of Realism: Geometries of Representational Art*, Cambridge: Cambridge University Press.

Hagen, M.A. and Elliott, H.B. (1976) 'An investigation of the relationship between viewing condition and preference for true and modified linear perspective with adults', *Journal of Experimental Psychology: Human Perception and Performance*, 2, pp. 479–90.

Hargreaves, D.J., Jones, P.M. and Martin, D. (1981) 'The air gap phenomenon in children's landscape drawings', *Journal of Experimental Child Psychology*, 32, pp. 11–20.

Harris, D.B. (1963) *Children's Drawings as Measures of Intellectual Maturity*, New York: Harcourt, Brace and World.

Hartley, J.L., Somerville, S.C., Jensen, D. von Cziesch and Eliefja, C.C. (1982) 'Abstraction of individual styles from the drawings of five-year-old children', *Child Development*, 53, pp. 1193–214.

Henderson, J.A. and Thomas, G.V. (1990) 'Looking ahead: planning for the inclusion of detail affects relative sizes of head and trunk in children's human figure drawing', *British Journal of Developmental Psychology*, 8, pp. 383–91.

Hochberg, J. and Brooks, V. (1962) 'Pictorial recognition as an unlearned ability in a study of one child's performance', *American Journal of Psychology*, 75, pp. 624–8.

Hurlock, E.B. and Thomson, J.L. (1934) 'Children's drawings: an experimental study of perception', *Child Development*, 5, pp. 127–38.

Huttenlocher, J. (1967) 'Discrimination of figure orientation: effects of relative position', *Journal of Comparative and Physiological Psychology*, 63, pp. 359–61.

Ibbotson, A. and Bryant, P.E. (1976) 'The perpendicular error and the vertical effect in children's drawing', *Perception*, 5, pp.319–26.

Israelite, J. (1936) 'A comparison of the difficulty of items for intellectually normal children and mental defectives on the Goodenough drawing test', *American Journal of Orthopsychiatry*, 6, pp. 494–503.

Ives, S.W. (1980) 'The use of orientations in children's drawings of familiar objects: principles versus percepts', *British Journal of Educational Psychology*, 50, pp. 295–6.

Ives, S.W. and Houseworth, M. (1980) 'The role of standard orientations in children's drawings of interpersonal relationships: aspects of graphic feature marking', *Child Development*, 51, pp. 591–3.

Ives, S.W. and Rovet, J. (1982) 'Elementary school children's use of construction rules in drawings of familiar and novel objects: a cross-cultural replication', *The Journal of Genetic Psychology*, 140, pp. 315–16.

Ives, S.W., Wolf, D., Fucigna, C. and Smith, N.R. 'Origins of Graphic Representation at Ages Two and Three', unpublished manuscript, Wheelock College Graduate School, Boston. Mass.

Kellogg, R. (1970) *Analyzing Children's Art*. Palo Alto, Calif.: Mayfield.

Kennedy, J.M. and Ross, A.S. (1975) 'Outline picture perception by the Songe of Papua', *Perception*, 4, pp. 391–406.

Kerschensteiner, G. (1905) *Die Entwicklung der Zeichnerischen Begabung*, Munich: Carl Gerber.

Koppitz, E. (1968) *Psychological Evaluation of Children's Human Figure Drawings*, London: Grune and Stratton.

Krötzsch, W. (1917) *Rhythmus und Form in der freien Kinderzeichnung*, Leipzig: Haase.

Lark-Horovitz, B., Lewis, H. and Luca, M. (1973) *Understanding Children's Art for Better Teaching*, Columbus, Ohio: Merrill.

Laszlo, J.I. and Broderick, P.A. (1985) 'The perceptual-motor skill of drawing', in Freeman, N.H. and Cox, M.V. (eds.) *Visual Order: The Nature and Development of Pictorial Representation*, Cambridge: Cambridge University Press.

Lee, M. (1989) 'When is an object not an object? The effect of "meaning" upon the copying of line drawings', *British Journal of Psychology*, 80, pp. 15–37.

Lewis, V. (1990) 'Young children's painting of the sky and the ground', *International Journal of Behavioural Development*, 13, pp. 49–65.

Light, P.H. and MacIntosh, E. (1980) 'Depth relationships in young children's drawings', *Journal of Experimental Child Psychology*, 30, pp. 79–87.

Littleton, K.S. (1991) 'The Representation of Depth in Children's Drawings', unpublished DPhil thesis, University of York.

Löwenfeld, V. (1939) *The Nature of Creative Activity*, New York: Macmillan.

Löwenfeld, V. (1957) *Creative and Mental Growth*, third edition, New York: Macmillan.

Löwenfeld, V. and Brittain, W.L. (1964) *Creative and Mental Growth*, New York: Macmillan.

Luquet, G.H. (1913) *Les Dessins d'un enfant*, Paris: Alcan.

Luquet, G.H. (1927) *Le Dessin enfantin*, Paris: Alcan.

Maccoby, E.E. (1968) 'What copying requires', *Ontario Journal of Educational Research*, 10, pp. 163–70.

Maccoby, E.E. and Bee, H.L. (1965) 'Some speculations concerning the lag between perceiving and performing', *Child Development*, 36, pp. 365–77.

Machover, K. (1949) *Personality Projection in the Drawings of the Human Figure*, Springfield, Ill.: C. C. Thomas.

Machover, K. (1951) 'Drawing of the human figure: a method of personality investigation', in Anderson, H.H. and Anderson, G.L. (eds.) *An Introduction to Projective Techniques*, Englewood Cliffs, N.J.: Prentice-Hall.

Maitland, L.M. (1895) 'What children draw to please themselves', *The Inland Educator*, 1, pp. 77–81.

Major, D.R. (1906) *First Steps in Mental Growth*, New York: Macmillan.

Mann, B.S. and Lehman, E.B. (1976) 'Transparencies in children's human

figure drawings: a developmental approach', *Studies in Art Education*, 18, pp. 41–8.

Marr, D. (1977) 'Analysis of occluding contour', *Proceedings of the Royal Society*, London, B, 197, pp. 441–75.

Märtin, H. (1939) 'Die Motivwahl und ihr Wandel in der freien Zeichnung des Grundschulkindes', *Zeitschrift für Paedagogische Psychologie*, 40, pp. 231–41.

Matthews, J. (1984) 'Children drawing: are young children really scribbling?' *Early Child Development and Care*, 18, pp. 1–9.

Matthews, J. (1989) 'How young children give meaning to drawing', in Gilroy, A. and Dalley, T. (eds.) *Pictures at an Exhibition: Selected Essays on Art and Art Therapy*, London: Tavistock/Routledge.

Matthews, J. (1991) 'The genesis of aesthetic sensibility', in Paine, S. and Court, E. (eds.) *Drawing, Art and Development*, London: NSEAD and Longman.

McCarty, S.A. (1924) *Children's Drawings*, Baltimore: William and Wilkins.

McElwee, E.W. (1934) 'Profile drawings of normal and subnormal children', *Journal of Applied Psychology*, 18, pp. 599–603.

Millar, S. (1975) 'Visual experience or translation rules? Drawing the human figure by blind and sighted children', *Perception*, 4, pp. 363–71.

Mitchelmore, M.C. (1978) 'Developmental stages in children's representation of regular solid figures', *Journal of Genetic Psychology*, 133, pp. 229–39.

Mitchelmore, M.C. (1985) 'Geometrical foundations of children's drawing', in Freeman, N.H. and Cox, M.V. (eds.) *Visual Order: The Nature and Development of Pictorial Representation*, Cambridge: Cambridge University Press.

Moore, V. (1986a) 'The use of a colouring task to elucidate children's drawings of a solid cube', *British Journal of Developmental Psychology*, 4, pp. 335–40.

Moore, V. (1986b) 'The relationship between children's drawings and preference for alternative depictions of a familiar object', *Journal of Experimental Child Psychology*, 42, pp. 187–98.

Moore, V. (1987) 'The influence of experience on children's drawings of a familiar and unfamiliar object', *British Journal of Developmental Psychology*, 5, pp. 221–9.

Morris, D. (1962) *The Biology of Art*, London: Methuen.

Naeli, H. and Harris, P. (1976) 'Orientation of the diamond and the square', *Perception*, 5, pp. 73–8.

Olson, D.R. and Bialystock, E. (1983) *Spatial Cognition*, Hillsdale, New Jersey: Erlbaum.

Paget, G.W. (1932) 'Some drawings of men and women made by children of certain non-European races', *Journal of the Royal Anthropological Institute*, 62, pp. 127–44.

Paivio, A. (1971) *Imagery and Verbal Processes*, New York: Holt, Rinehart and Winston.

Papadakis, E.A. (1989) 'Development of Children's Drawings in Relation to Gender and Culture', unpublished PhD thesis, University of Birmingham, UK.

Park, C. (1978) Book review of *Nadia – A Case of Extraordinary Drawing Ability in an Autistic Child*, *Journal of Autism and Childhood Schizophrenia*, 8, pp. 457–72.

Parsons, M.J. (1987) *How We Understand Art*, Cambridge: Cambridge University Press.

Partridge, L. (1902) 'Children's drawings of men and women', *Studies in Education*, 2, pp. 163–79.

Perner, J., Kohlmann, R. and Wimmer, H. (1984) 'Young children's recognition and use of the vertical and horizontal in drawings', *Child Development*, 55, pp. 1637–45.

Phillips, W.A., Hobbs, S.B. and Pratt, F.R. (1978), 'Intellectual realism in children's drawings of cubes', *Cognition*, 6, pp. 15–33.

Phillips, W.A., Inall, M. and Lauder, E. (1985) 'On the discovery, storage and use of graphic descriptions', in Freeman, N.H. and Cox, M.V. (eds.) *Visual Order: The Nature and Development of Pictorial Representation*, Cambridge: Cambridge University Press.

Piaget, J. and Inhelder, B. (1956) *The Child's Conception of Space*, London: Routledge and Kegan Paul.

Rand, C.E.W. (1971) 'The Development of Copying Skill in Drawing: A Perceptual versus Cognitive-Organizational Problem', unpublished PhD thesis, Stanford University.

Rand, C.E.W. (1973) 'Copying the drawing: the importance of adequate visual analysis versus the ability to utilize drawing rules', *Child Development*, 44, pp. 47–53.

Reith, E. (1988) 'The development of use of contour lines in children's drawings of figurative and non-figurative three-dimensional models', *Archives de Psychologie*, 56, pp. 83–103.

Ricci, C. (1887) *L'arte dei bambini*, Bologna: N. Zanichelli.

Riddel, J. (1911) 'On the teaching of drawing', in Laurie, A.P. (ed.), *The Teacher's Encyclopaedia*, 1, London: Caxton.

Roback, H.B. (1968) 'Human figure drawings: their utility in the clinical

psychologist's armamentarium for personality assessment', *Psychological Bulletin*, 70, pp. 1–19.

Rouma, G. (1913) *Le Langage graphique de l'enfant*, Brussels: Misch and Thron.

Schaefer-Simmern, H. (1948) *The Unfolding of Artistic Activity: Its Basis, Processes and Implications*, Berkeley and Los Angeles: University of California Press.

Scott, L.H. (1981) 'Measuring intelligence with the Goodenough-Harris drawing test', *Psychological Bulletin*, 89, pp. 483–505.

Sechrest, L. and Wallace, J. (1964) 'Figure drawings and naturally occurring events: elimination of the expansive euphoria hypothesis', *Journal of Educational Psychology*, 53, pp. 42–4.

Selfe, L. (1977) *Nadia – A Case of Extraordinary Drawing Ability in an Autistic Child*, London: Academic Press.

Sommerville, D. and Cox, M.V. (1988) 'Source of error in the Piagetian water-level task', *Perception*, 17, pp. 249–54.

Sperry, R.W. (1964) 'The great cerebral commissure', *Scientific American*, 210, pp. 44–52.

Stern, W. (1909) 'Die Entwicklung der Raumwahrnehmung in der ersten Kindheit', *Zeitschrift für angewandte Psychologie*, 3, pp. 412–23.

Swensen, C.H. (1957) 'Empirical evaluations of human figure drawings', *Psychological Bulletin*, 54, pp. 431–66.

Swensen, C.H. (1968) 'Empirical evaluations of human figure drawings: 1957–1966', *Psychological Bulletin*, 70, pp. 20–44.

Taylor, M. and Bacharach, V.R. (1981) 'The development of drawing rules: metaknowledge about drawing influences performance on nondrawing tasks', *Child Development*, 52, pp. 373–5.

Taylor, M. and Bacharach, V.R. (1982) 'Constraints on the visual accuracy of drawings produced by young children', *Journal of Experimental Child Psychology*, 2, pp. 311–29.

Thomas, G.V. and Silk, A.M.J. (1990) *An Introduction to the Psychology of Children's Drawings*, Hemel Hempstead, Herts.: Harvester/Wheatsheaf.

Thomas, G.V., Chaigne, E. and Fox, T.J. (1989) 'Children's drawings of topics differing in significance: effects on size of drawing', *British Journal of Developmental Psychology*, 7, pp. 321–31.

Thomas, G.V. and Tsalimi, A. (1988) 'Effects of order of drawing head and trunk on their relative sizes in children's human figure drawings', *British Journal of Developmental Psychology*, 6, pp. 191–203.

Treffert, D.A. (1989) *Extraordinary People*, London: Bantam Press.

Wall, J. (1959) 'The Base Line in Children's Drawings of Self and its

Relationship to Aspects of Overt Behavior', PhD dissertation, The Florida State University.

Wallach, M.A. and Leggett, M.I. (1972) 'Testing the hypothesis that a person will be consistent: stylistic consistency versus situational specificity in size of children's drawings', *Journal of Personality*, 40, pp. 309–30.

Willats, J. (1977) 'How children learn to draw realistic pictures', *Quarterly Journal of Experimental Psychology*, 29, pp. 367–82.

Willats, J. (1985) 'Drawing systems revisited: the role of denotation systems in children's figure drawings', in Freeman, N.H. and Cox, M.V. (eds.) *Visual Order: The Nature and Development of Pictorial Representation*, Cambridge: Cambridge University Press.

Willats, J. (1987) 'Marr and pictures: an information-processing account of children's drawings', *Archives de Psychologie*, 55, pp. 105–25.

Wilson, B. (1985) 'The artistic tower of Babel: inextricable links between culture and graphic development', *Visual Arts Research*, 11, pp. 90–104.

Wilson, B. and Wilson, M. (1977) 'An iconoclastic view of the imagery sources in the drawings of young people', *Art Education*, 30, pp. 5–11.

Wilson, B. and Wilson, M. (1984) 'Children's drawings in Egypt: cultural style acquisition as graphic development', *Visual Arts Research*, 10, pp. 13–26.

Wiltshire, S. (1987) *Drawings*, London: J.M. Dent.

Winner, E. (1982) *Invented Worlds: The Psychology of the Arts*, Cambridge, Mass.: Harvard University Press.

Winner, E. (1989) 'How can Chinese children draw so well?', *Journal of Aesthetic Education*, 23, pp. 41–63.

Wolf, D. and Perry, M.D. (1988) 'From endpoints to repertoires: Some new conclusions about drawing development', *Journal of Aesthetic Education*, 22, pp. 17–34.

Zaporozhets, A.V. (1965) 'The development of perception in the preschool child', in Mussen, P.H. (ed.) 'European research in cognitive development', *Monograph of the Society for Research in Child Development*, 30 (serial no. 100), pp. 82–102.

General Index

Figures in italics refer to illustrations.

Name Index